IMAGES
of America

SPOTSYLVANIA
COUNTY

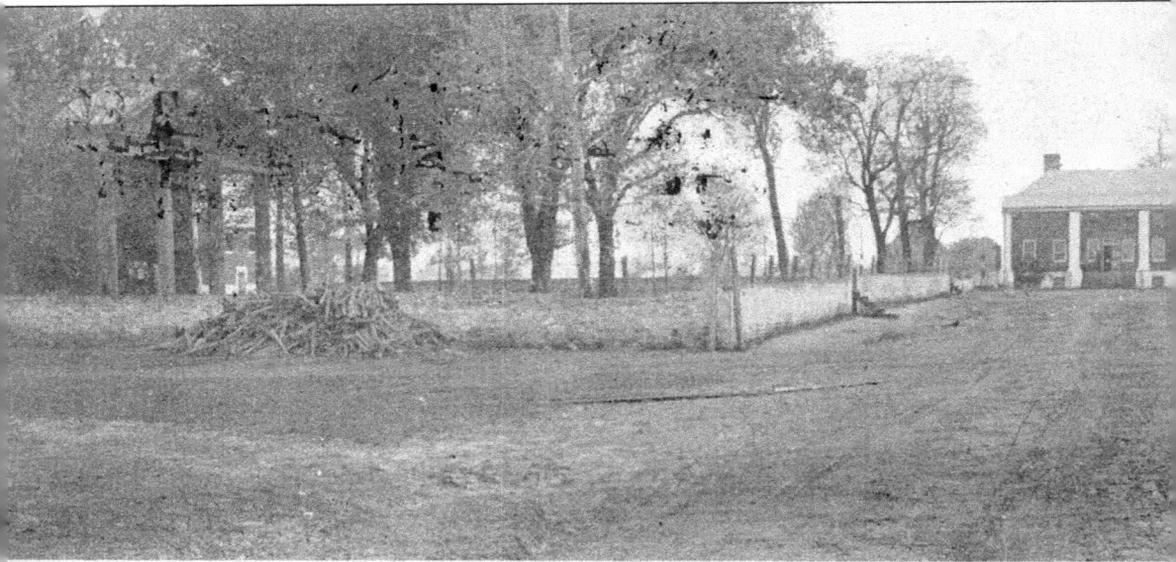

COURT HOUSE AND HISTORIC HOTEL, SPOTSYLVANIA, VA.

When Robert Saulsbury Garey visited the Spotsylvania Courthouse area in October 1909, he sent this postcard to his mother, Vashti, who was back home in Denton, Maryland. Garey notes that the area was "quite an interesting place." Garey's father served in the Union army during the Civil War but had not seen action in Virginia. (Courtesy of John Cummings.)

ON THE COVER: A US National Park Service (NPS) historian provides information to battlefield visitors in this 1936 photograph of the Chancellorsville Contact Station, which is located near the site where Gen. Stonewall Jackson was wounded. Four of these similarly built cabins served the interpretive needs of visitors until the 1960s, when the cabins were replaced by more modern visitor center facilities. (Courtesy of Fredericksburg and Spotsylvania National Military Park.)

IMAGES
of America

SPOTSYLVANIA
COUNTY

John F. Cummings III

ARCADIA
PUBLISHING

Copyright © 2011 by John F. Cummings III
ISBN 9781531654719

Published by Arcadia Publishing
Charleston, South Carolina

Library of Congress Control Number: 2010941811

For all general information, please contact Arcadia Publishing:
Telephone 843-853-2070
Fax 843-853-0044
E-mail sales@arcadiapublishing.com
For customer service and orders:
Toll-Free 1-888-313-2665

Visit us on the Internet at www.arcadiapublishing.com

*For Karen, who sees to it that the wheels keep
turning even on a bumpy road*

CONTENTS

ACKNOWLEDGMENTS

I could not have begun to tell this story without the generosity of my good friends at the National Park Service. My sincerest thanks must go to Noel Harrison, Eric Mink, Don Pfanz, John Hennessy, Russ Smith, Greg Mertz, Frank O'Reilly, Mac Wychoff, and Chuck Lochart. They have all been encouraging to my studies and endeavors and are exemplary as public historians and guardians of our material culture. Special recognition must be awarded to the research work of National Park Service intern Liesbeth Neisingh. In March 2000, Neisingh assembled much of the park's documentation focusing on the largely overlooked Civilian Conservation Corps (CCC) era from the files of the National Archives.

I can not omit the kindnesses of these friends who believe in what I aim for: James and Ellen Anderson, Ed Bell, Robert Szabo, Terry Thomann, Tom Quigley, Chris Conti, Valerie Schlang, and Julie Bell. I am especially grateful to Patrick Sullivan for sharing with me his family's extensive archives.

And to the following people I will always be indebted: John and Saundra Cummings and my mother in heaven, Mary Feril Cummings.

Images in this volume appear courtesy of the following individuals and organizations: Anne Haskins (AH), Catherine Powell Miller (CPM), Donald Houck (DH), Ed Bell (EB), Emily Powell (EP), Julie Bell (JB), John Cummings (JFC), Kathleen Colvin (KC), Library of Congress (LC), Linda Duffy (LD), National Park Service (NPS), Spotsylvania County government (SCG), Urla Row (UR), and Valerie Schlang (VS).

INTRODUCTION

One would think a community as steeped in history as Spotsylvania County would have long embraced a proactive policy of good stewardship toward the landscape and material culture that defines it. However, the effects of the 1860s left major scars that affected the very fabric of the region socially and economically. Thus, an understandable resentment toward this past lingers. One former planning director for the county went so far as to assert that he "hated the Civil War," an indictment to the hindrance he felt it placed on him "doing his job." The area's history was an obstacle to moving Spotsylvania County forward, he would assert. Underlying this, an unwritten philosophy seems to prevail and influence the shaping of the county by its elected officials.

Had it not been for that redefining, tragic era of the Civil War, preceded by a burgeoning industrial muscle-flexing, Spotsylvania County could certainly have passed through history as a typical, rather insignificant community in the overall drama of the Virginia commonwealth, and residents might have been just as happy with that. Certainly, any community is rich in the individual family histories of the population that makes up its social, economic, and political being. But these genealogies on their own, under otherwise uneventful circumstances, would leave no profound impact on the collective record. Numerous family names have been here since the early days of land grants, yet for the most part, their effect remains not more than place markers on the maps used to guide warring factions across the landscape during the Civil War.

A substantial indigenous population called the Spotsylvania County area home prior to the settlement of Europeans. Evidence of their existence is plentiful, turning up on nearly every disruption of soil across the county today.

In the early 18th century, the enterprising brashness of the county's namesake, Alexander Spotswood, set in motion an industrious footing for the region but one that would diminish almost as fast as it reached its zenith.

During its formative years and throughout the Colonial era, Spotsylvania County consisted of large land tracts connected by rolling roads that facilitated the transportation of bounteous quantities of tobacco, the cash crop that defined Virginia's primary economic substance in that epoch. Later on, and less effectual, was a rash of gold mines dotting the landscape, one of the most noteworthy being the Whitehall Mine near modern-day Shady Grove Corner.

Today, at the northeasternmost point of the county lies the city of Fredericksburg. Prior to becoming an independent city in 1879, Fredericksburg was the commercial mecca of Spotsylvania County, thanks to its prime access to water transportation initially and to railroad later. Fredericksburg connected other East Coast ports to commerce arriving from the interior. Tragically, Fredericksburg's major importance to commerce was eclipsed by the heavy hand of war, a four-year drama that would take a significant toll on the entire constituency well into the 20th century.

On the eve of the Civil War sesquicentennial (2011–2015), Spotsylvania County remains a conflicted community struggling with cultural amnesia. Much of the conflict is directly related to the debilitating war waged over its soil a century and a half earlier and compounded by an influx

of "deracinated Yankees" and "come here's." For many old-timers, that attitude is a carryover from a community in defeat wrecked by the Union army. That attitude exudes a heritage symbolic of financial hardships, with the remaining vestiges of war an impediment to moving on.

Exacerbating the situation is a love-hate relationship with the National Park Service (NPS), the administrators of four Civil War battlefields in the county. On one hand, the NPS is largely resented for controlling more than 8,000 acres of non-taxed property; on the other hand, it is continually sought out to provide programs outside its own purview to interface with travelers in search of heritage tourism. Increasingly, additional resentment toward the NPS is manifest in the unfounded belief that personal property rights are being assailed, or at least hindered, by the so-called outsiders who are trying to preserve significant historic sites from the bulldozers of the modern world. Many longtime residents view this as a sign of continued oppression by the federal government.

In the 21st century, progress in Spotsylvania has been largely defined by tax-revenue dollars. In a clamor for more taxable rooftops, Spotsylvania's haphazard planning system has pitted open space and quality of life against unsustainable, inflating property values, as evidenced by many new, sprawling subdivisions.

One such development, Lee's Parke, situated off the first leg of the newly blazed Spotsylvania Parkway, required the clear-cutting of vast tracts of trees, leaving only those that stood within resource protection areas, the many creeks and streams that were once an asset to property. The barren landscape was then covered with large "McMansions" along streets named for the trees that once stood in the area: Yellow Birch Drive, Silver Maple Lane, Basswood Drive, and so on.

The fast pace of the growth strained existing infrastructure, affected nearby Massaponax Creek, and ended in a costly ordeal for the county. The Spotsylvania Board of Supervisors roundly pointed to staff for not having aggressively advised of conditions that might have foretold the pending crisis. New development went on unabated regardless. Much of the development consisted of houses valued well outside the means of longtime residents and built on subdivided farmland that had lost its appeal after generations of family ownership. Surprisingly, affordable housing developments were discouraged, as if a deliberate effort was being made to alter the demographic makeup of the county. Half-million-dollar houses became the trend of new development.

Because Spotsylvania is located within the 50-mile radius around Washington, DC, known as the National Capital Region, land costs inflated and drove up the price of housing. Within 10 years, property values in Spotsylvania County doubled and then receded, leaving a wake of foreclosures and an engorged inventory of massive, empty houses. Little solace could be found in the housing bust as a national crisis, save for Spotsylvania not being alone in the aftermath and global repercussions rippling in time.

However, even in the good times, Spotsylvania's tourism market was continually neglected as a source of viable revenue despite being a top-ranked moneymaking industry elsewhere in the state. The county's board of supervisors expressed a desire to attract visitors but was resistant to committing a dedicated and sufficient means of funding because they felt overshadowed by the City of Fredericksburg and its perceived stranglehold on the tourism market. Much of what Spotsylvania County devised rhetorically and in official planning eventually fell back to a reliance on the National Park Service to provide programs and inertia.

In the summer of 1988, the board of supervisors pondered the wisdom of constructing an independent visitor center along the Interstate 95 corridor. A structure and a dedicated staff would be needed to administer the facility and serve as a representative in the commonwealth's collective efforts. The task of examining the options fell to the Spotsylvania County Department of Economic Development. Again, a hesitance to commit county funds to advertise private businesses was shown.

Frustrations among members of Spotsylvania's tourism industry continued to ferment into the winter of the following year. The Fredericksburg Visitor Center, located in the heart of that city's tourism district, was resistant to allowing Spotsylvania-based businesses space on its brochure racks. It was a true us-versus-them mentality. This once more forced Spotsylvania officials to

consider building an autonomous visitor center. At their December 12, 1989, meeting, the board of supervisors authorized the county administrator to sign a lease for an economic development office and tourism center in the Southpoint development on Route 1 near the former Massaponax exit on Interstate 95.

In the spring of 1990, county administrator Kimball Payne urged the board of supervisors to implement the county's tourism program in time for the fast-approaching tourism season. With considerable groundwork required before the Southpoint facility could be opened, Payne was anxious to see the neophyte tourism coordinator "take advantage of seminars and other opportunities" that were scheduled that spring and early summer. Payne had selected for the position former administrative secretary Bonnie Smith. The tourism center remained on schedule and opened that September.

Four years later, the board of supervisors authorized the production of a tourism video and allocated $17,000 toward the project. This video would serve as a welcoming tool to those coming to the new visitor center. In 1996, an increase in the Transient Occupancy Tax (TOT) was proposed to fund the county's strained tourism and economic development budgets. Predictably, tourism-related businesses expressed great concern and spoke out against the increase, stating it would have a negative effect on tourism, resulting in their inability to compete in the area. After a comparison report was conducted of regional lodging rates, the board of supervisors dispelled these concerns and voted to increase the TOT from two to five percent.

The board of supervisors first proposed the establishment of a tourism commission on August 13, 1996. Members of the staff were directed to devise a recommendation on the "composition and mission of such an organization."

The Virginia Civil War Trails program designated nine interpretive signs to be added to its driving tour through Spotsylvania in 1997. The following year, the Spotsylvania County Landowners Association, a property rights advocacy group, began to question the benefit of tourism to the county. This started an ongoing debate that focused heavily on the Route 3 corridor between Salem Church and the Orange County line 11 miles to the west. Some of the property owners along Route 3 advocated heavy development from Fredericksburg to Culpeper, which was 35 miles away.

In 2000, one of the battlefield preservationists' most public battles focused on the 781-acre Mullins Farm on Route 3, where historians maintained the opening shots of the Battle of Chancellorsville were exchanged on May 1, 1863. A large developer from Northern Virginia wanted to rezone the property and build a utopian community named the Town Of Chancellorsville. The proposed community would have included 2,000 homes and 2.2 million square feet of shops and office space.

Numerous organizations formed a coalition to block the development project. The action commenced on a hot July day in 2002 with a press conference spearheaded by the Civil War Preservation Trust (CWPT). A long, protracted debate ensued, but in March 2003, the board of supervisors voted to deny the rezoning after unprecedented opposition turned out during several public community hearings. A year and a half after the Spotsylvania County Board of Supervisors denied rezoning, local builders Tricord Homes purchased the eastern half of the farm. Their development plan offered significant preservation of open space along Route 3 and an age-restricted community with a 500-bed continuing-care retirement center on the northern 87 acres of the farm, which during the Civil War remained wooded and unimproved. A proposed restoration of the period tree line would screen the houses and retirement facility, thus protecting a significant pastoral viewshed.

In May 2003, the Spotsylvania Courthouse Tourism and Special Events Commission was created as the brainchild of Salem district supervisor Gary Jackson and cosponsored by Lees Hill district supervisor Mary Lee Carter. The commission consisted of citizen-appointees, some of whom had been vocal opponents of the Town of Chancellorsville project. They hit the ground running with the enthusiasm of ushering in a new, proactive approach toward the responsibility and advantages of promoting the tourism industry.

The November 2003 election demonstrated a desire for change with particular emphasis on limiting growth to manageable levels. "Smart Growth" became the mantra. Traffic congestion

along the major corridors of the primary settlement district had prompted a major outcry. The Salem Church intersection was a textbook example of unbridled commercial expansion with minimum sensitivity to historic sites and ever-increasing vehicular traffic. Among the voices seeking to mandate change was the Committee of 500. Pulling resources from the private sector without a particular party leaning, the varied backgrounds of the membership made for a robust agenda. Candidates for the board of supervisors, who generally tend to shy away from party affiliation, took interest in the Committee of 500 agenda as the political action committee devised its criteria for endorsements in the election. It was within this final month of the election year that the lame-duck session of the board of supervisors would tip the scales against the Town of Chancellorsville. Public sentiment had reached critical mass, and election results were a paramount concern. Election night ushered in a changing of the guard in Spotsylvania County.

The tourism commission's first major project was the county-financed 140th Anniversary Commemorative Reenactment of the Battle of Spotsylvania, held at Belvedere Plantation in May 2004. Designed to emphasize a stronger educational approach than typical "powder-burner" reenactments, this event featured a quarter-mile section of re-created earthworks with log revetments. The labor for this construction was provided by a crew from the County Public Works staff.

Despite praise from both spectators and reenactment participants, the break-even event missed out on several long-term goals that could have produced beneficial aftereffects. An award-winning production company had been retained for the event to provide three short promotional videos, the longest intended to replace the 1994 video shown at the visitor center. Two shorter spots were designed for mass mailing and cable television exposure. The finished products, however, languished in the offices of the tourism department and were not given enough exposure to justify the cost. Further shortfall came with a lackluster attempt to market commemorative merchandise. Spotsylvania County invested in T-shirts, mugs, medallions, and pins itself rather than licensing the rights to a private enterprise.

During the months following the reenactment, district supervisor Gary Jackson directed the Spotsylvania County Economic Development and Tourism offices to seize on the momentum generated and capitalize on the marketing potential. Two public meetings were held to invite input from residents, and a great deal of data was assembled. No exploitation of these results was forthcoming, and the crest of the wave receded back to the abyss.

In its 2005 list of most endangered Civil War sites, the CWPT declared the entire county of Spotsylvania as being at continued risk from the dangers of urban sprawl and uncontrolled growth. In the midst of the seemingly endless housing boom, a concerted effort was being made to control growth to two percent in the county, but some rezoning projects had made it onto the books before the downsizing goal became sacrosanct. By all appearances, nothing had changed, and despite the goal of limiting development, construction seemed invigorated.

In 2006, Toll Brothers, a national builder, helped in the preservation of the western half of the Mullins Farm site, preserving a total of more than two miles of contiguous battlefield land along the historic corridor.

Battlefield preservation within Spotsylvania County enjoyed a banner year in 2006. That year, the 208-acre Slaughter Pen Farm, the last vast expanse of the Fredericksburg Battlefield remaining in private hands, went on the market. The land was prime for extensive commercial development. Once again stepping in, Tricord Homes offered to buy the property and sell it to the CWPT, without profit, for the unprecedented cost of $12.5 million.

What does the future continue to hold for the story of our past?

In the spring of 2011, County Administrator Doug Barnes indicated the county was ramping up its tourism efforts, and plans for a new museum facility at the Courthouse Village were in motion.

One

A COLLECTIVE EXPERIENCE

The history of Spotsylvania County must be considered from two directions. The first from the west, where in 1714, Alexander Spotswood himself would establish a frontier fort named Germanna. Although no longer within the current borders of the county, Germanna is significant in that it was built as a buttress to protect settlers living within the colony from Native American incursions east of the Blue Ridge Mountains. It also served as a point to launch expeditions to explore the vast depths of the untamed wilderness. For Spotswood personally, it was the hub of an 83,000-acre private empire he would amass. Spotsylvania County was officially established in 1720, two years before Spotswood would leave the office of royal governor.

The other significant approach to Spotsylvania is from the east, where the town of Fredericksburg was chartered in 1727 along the banks of the Rappahannock River. Although an independent city today, the importance of Fredericksburg to the history of Spotsylvania is without question. Raw material and finished goods from the county would make their way to Fredericksburg for shipment coastally and to international destinations.

Fredericksburg would continue to be the allure of Spotsylvania County. Emerging unscathed from the Revolutionary War, the town took on greater importance when Washington, DC, became the nation's new capital. Coach lines made Fredericksburg a perfect overnight accommodation on the way to points south, particularly Richmond. But when the railroad replaced the coach as the transportation of choice in 1842, Fredericksburg was suddenly reduced to a whistle stop.

Nurtured by a Fredericksburg Water Power Company canal that was fed by a crib dam on the Rappahannock River, small industries became the economic saving grace of the decade preceding the Civil War. Out in the countryside, tobacco still held sway.

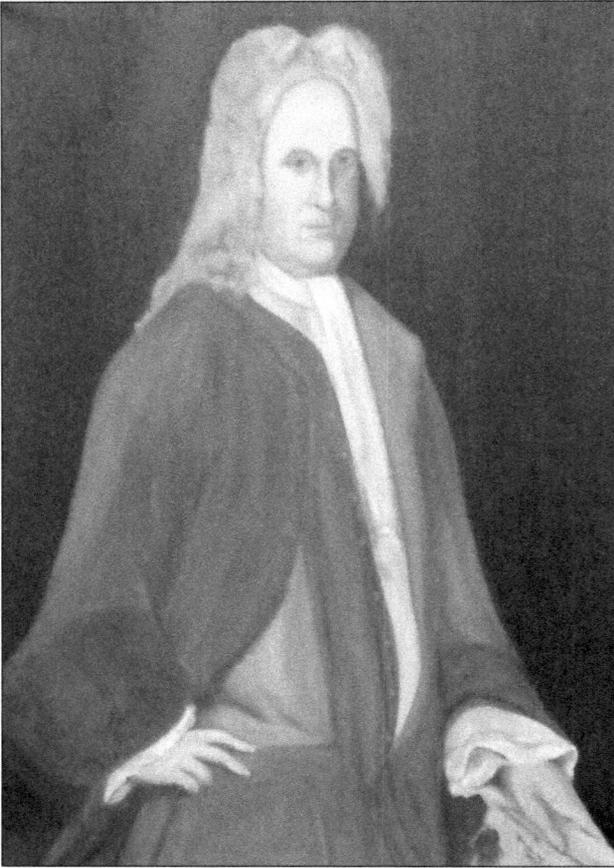

Alexander Spotswood, an aggressive early governor of Virginia, saw potential in the region that would bear his name. He acquired vast tracts of land for his enterprises. The Tubal Furnace enterprise he established would set a standard of industriousness for the colony. Spotswood was a man of high adventure and enterprising zeal. He built a shipping port where Massaponax Creek meets the Rappahannock River and established a postal system at New Post, Virginia. (Courtesy of SCG.)

The Catharine Furnace, similar to Spotswood's enterprise, was another example of the earnestness with which the inhabitants sought to tame the frontier and generate substantial fortunes from the raw materials found in abundance. It is estimated that nearly 400 acres of trees were consumed each year to provide enough charcoal for the smelting process. (Courtesy of JFC.)

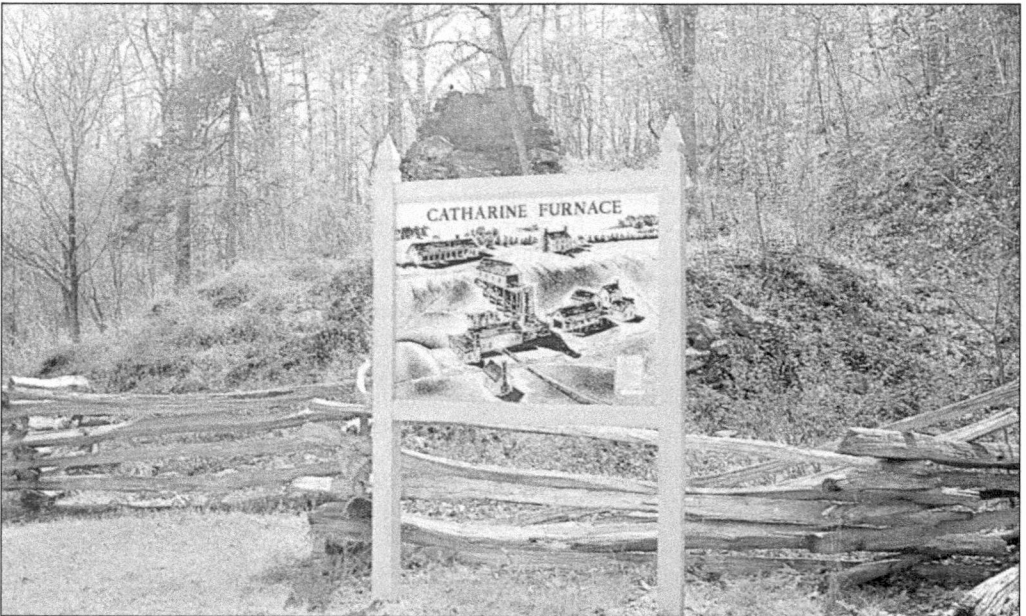

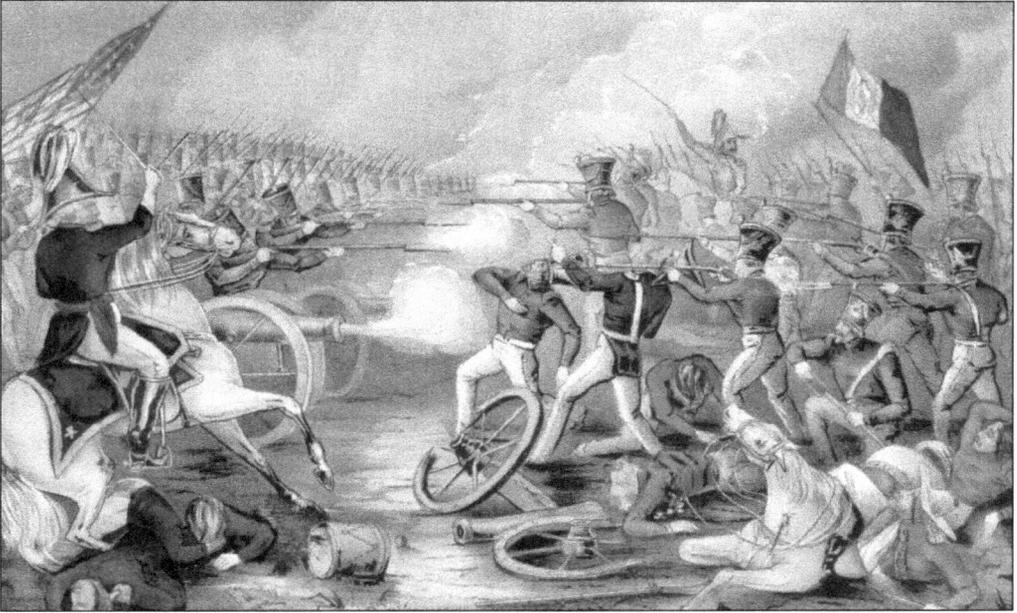

The Spotswood Furnace operated for some 55 years in the mid- to late 18th century, but then its story seems to go cold. Interestingly, in the 1840s, the site provided foundry facilities used by the United States government. Cannons used in the Mexican-American War were produced at this facility, as seen in the fanciful illustration above. (Courtesy of LC.)

Mathew Fontaine Murray was born in 1806 near the Catharine Furnace. Nicknamed the "Pathfinder of the Seas" for his extensive studies in oceanography, he was appointed superintendent of the Naval Observatory and head of the Depot of Charts and Instruments. At the outbreak of the Civil War, Murray resigned as a US Navy commander and cast his allegiance with the Confederacy. He resided for a time in Fredericksburg. (Courtesy of LC.)

The falls of the Rappahannock River supplied power for the industry that took root in and around Fredericksburg. This photograph from 1907 shows an inquisitive gentleman venturing out onto the rocks dotting the swift waters. He is possibly near the site of Thorton's Mill, which was built in 1720. In 1854, a dam was constructed to divert water into power canals that coursed across the western extreme of the town and back into the river about three miles downstream. (Courtesy of JFC.)

This postcard from 1908 shows the Rappahannock River below the dam, looking south from Hunter's Island. Near here in 1750, James Hunter built the large Hunter Iron Works facility. Although located in Stafford County, Hunter's facility was a prime example of the regional tenacity and patriotism that helped supply the Continental forces of Virginia during the Revolutionary War. (Courtesy of JFC.)

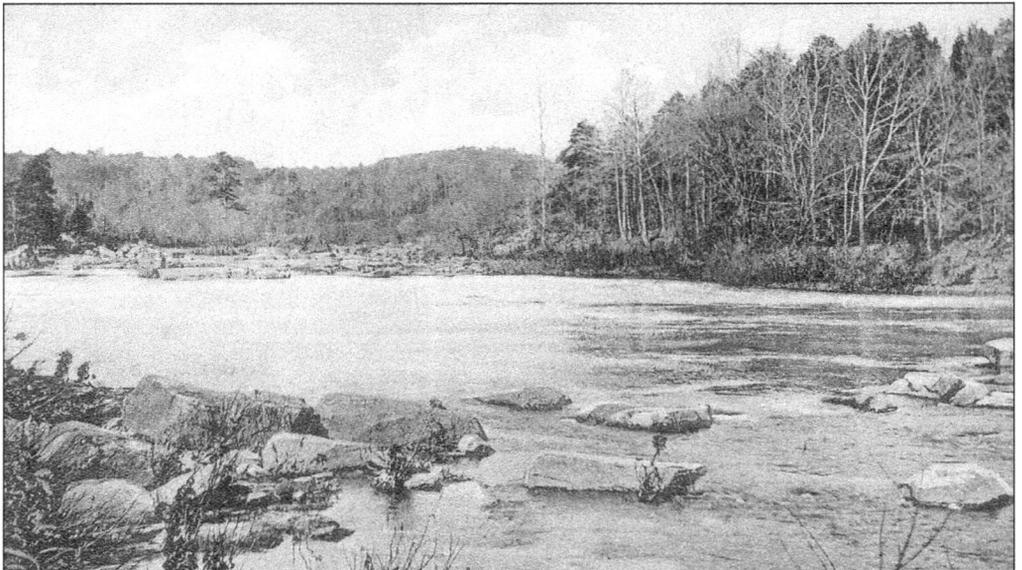

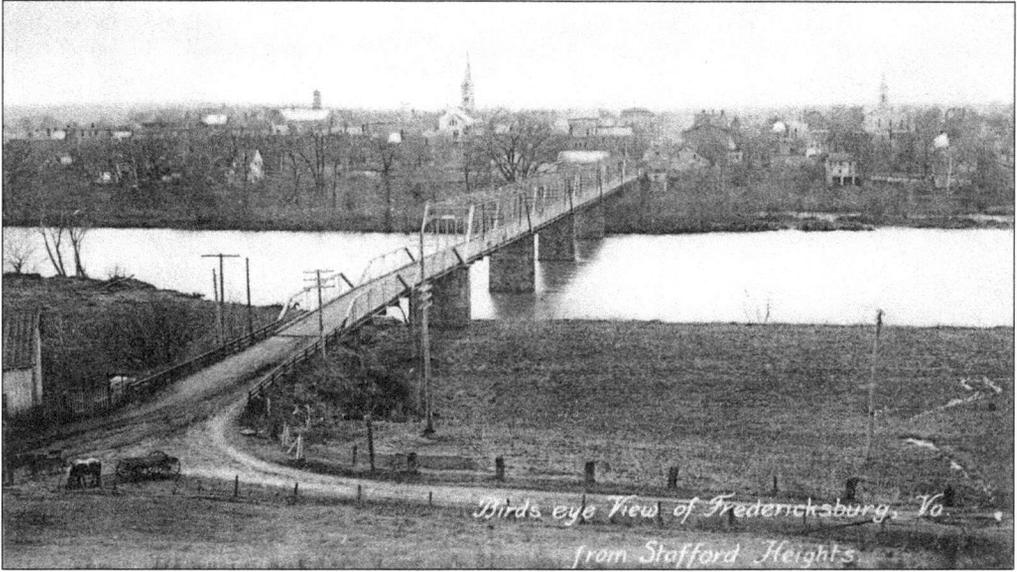

The Rappahannock River turns southeast below the fall line. Its calm waters provided an ideal inlet for seagoing vessels to load and offload rich cargo. This was the strength that became the city of Fredericksburg. This postcard from 1910 shows the city from Chatham Heights, looking westward. In the 1700s, Fredericksburg was a foothold to the expanding frontier, first seen in 1608 by Capt. John Smith of Jamestown fame. (Courtesy of JFC.)

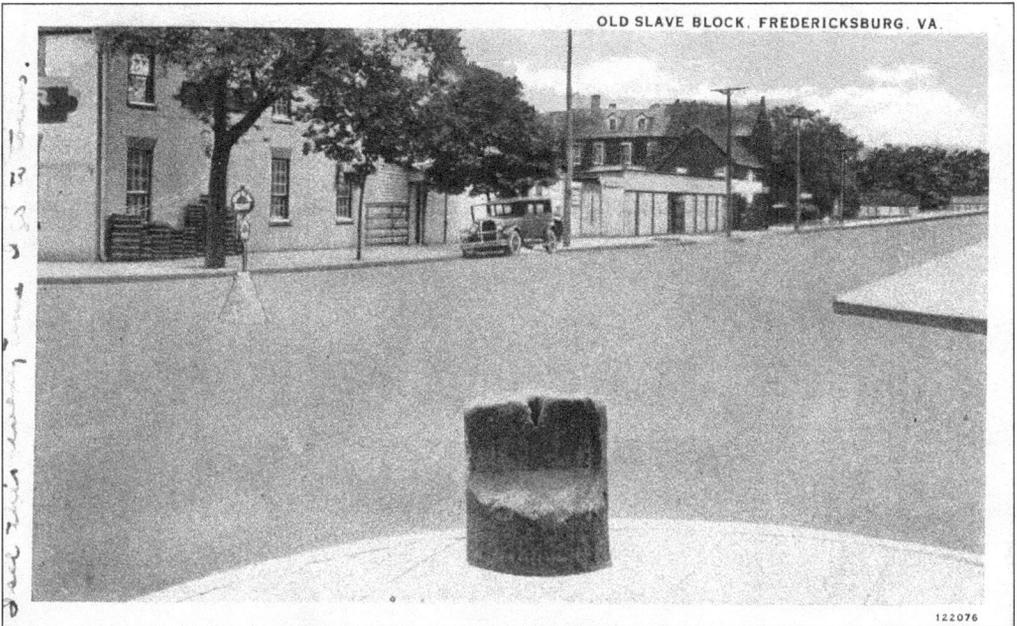

As with the entire new nation that sprang from the British Colonies, one economic engine cast a pall over the land. Slavery became the muscle for much of the Spotsylvania's prosperity, and by 1860, essentially half of the population was enslaved. Preserved to this day at the corner of Charles and William Streets, this slave auction block stands as a monument to the inhuman practice. (Courtesy of JFC.)

15

George Washington spent much of his youth in and around Fredericksburg, living just over the river at Ferry Farm in Stafford County. Legend says that Ferry Farm is where Washington chopped down the cherry tree and threw a silver dollar across the Rappahannock River. His brother Charles owned a tract of land in Spotsylvania County. Called Rose Mount today, it is located north of the Ni River on Route 208. (Courtesy of JFC.)

The Mary Washington House at 1200 Charles Street in Fredericksburg was purchased for her by son George Washington in 1772. Here, she spent her last years and died in 1789. Prior to his inauguration that year as the nation's first president, Washington visited his mother here to receive her blessings. That meeting was the last time they would be together. (Courtesy of JFC.)

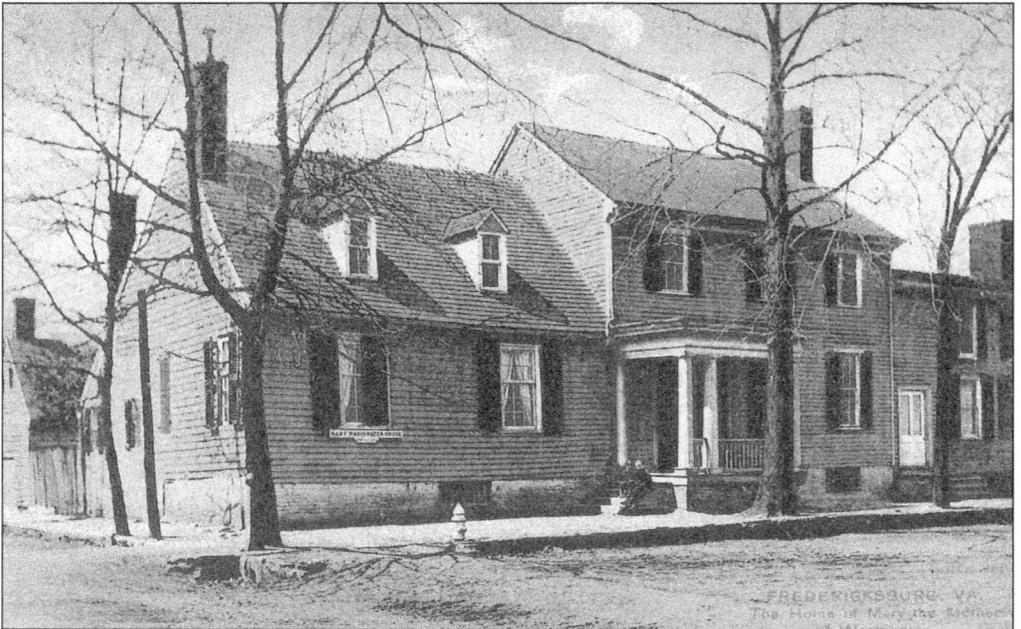

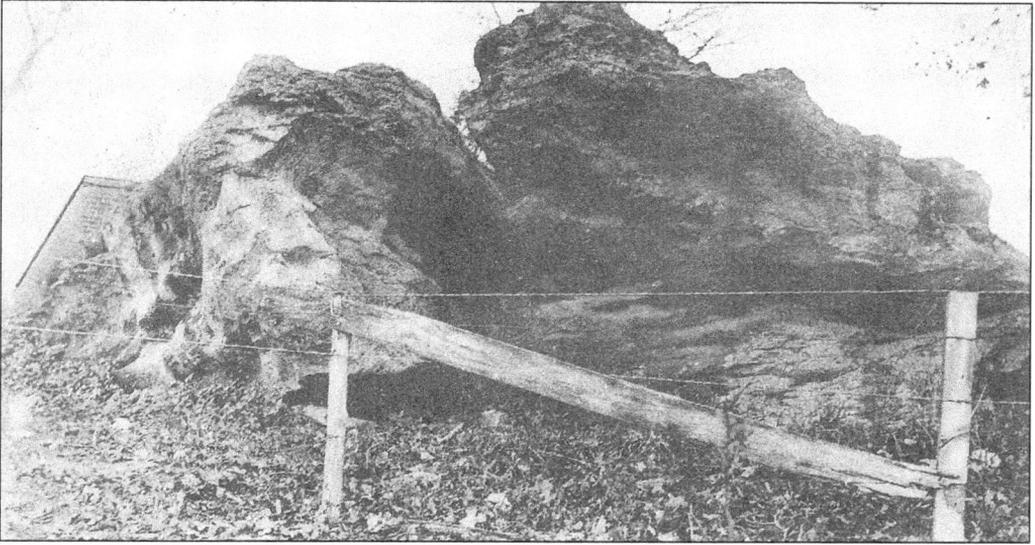

When not entertaining visitors over tea or spending time in her garden, Mary Washington would retire to this outcropping of rock on her daughter's Kenmore estate. Known today as Meditation or Oratory Rock, it is said that Mary would read her Bible from this perch and meditate. She had expressed a desire to be buried nearby. (Courtesy of JFC.)

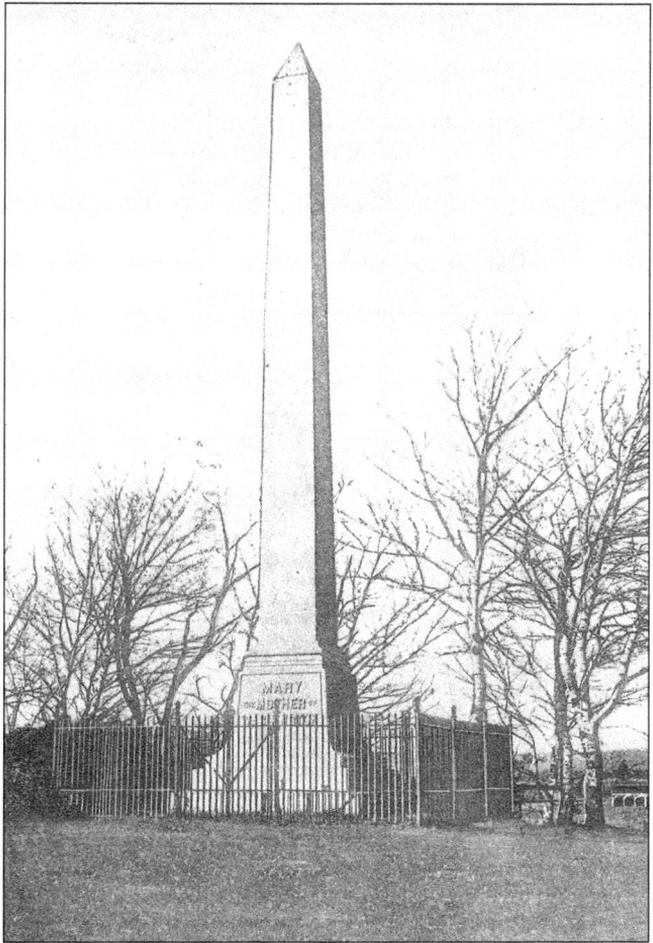

Just 25 yards from Meditation Rock stands this monument, the final resting place of Mary Washington and the second such memorial to be placed here. The original, dedicated in 1833 by Pres. Andrew Jackson, was never completed. It lay scarred and neglected by the time of the Civil War and continued to weather with the shaft lying prone by the base until May 10, 1894, when Pres. Grover Cleveland dedicated its replacement. (Courtesy of JFC.)

This is the Masonic Lodge No. 4 as it appeared in 1910. It is associated with the initiation of George Washington into the Masons in 1752, but he would not have known this structure in his lifetime. The lodge building at 803 Princess Anne Street dates to 1816. In Washington's day, the members of the Fredericksburg Lodge would meet in local taverns. At one time, members helped raise money to build a school on this site with the stipulation that the lodge would use the second floor as the school's official meeting place. As with many structures in town, the lodge was used as a hospital during the Battle of Fredericksburg in December 1862. Bloodstains can still be found on the floorboards. (Both courtesy of JFC.)

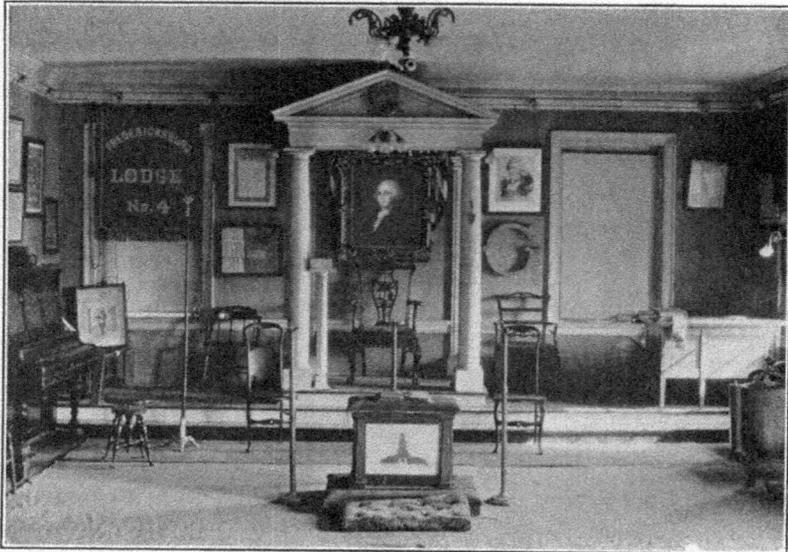

WASHINGTON'S MOTHER LODGE

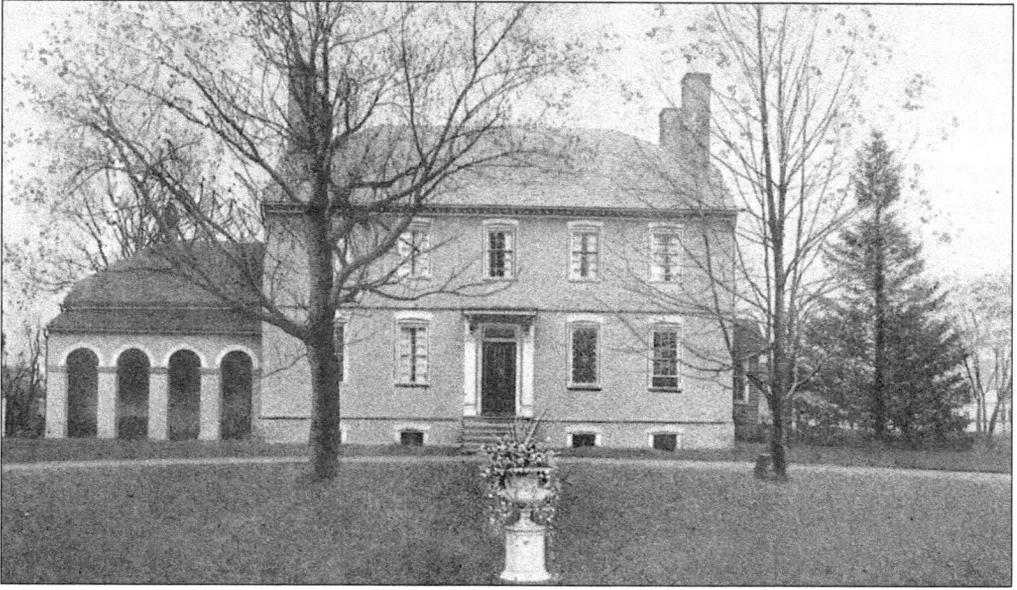

Kenmore, seen here in an early postcard, was the home of George Washington's sister Betty, and her husband, Fielding Lewis. Besides being a home, it was once the headquarters of a 1,300-acre estate that has long been subdivided. Nearby are the grave of Mary Washington and her beloved retreat site, Meditation Rock. (Courtesy of JFC.)

George Washington's brother Charles once owned the property at 1304 Caroline Street. Presented today as the Rising Sun Tavern by Preservation Virginia (originally the Association for Preservation of Virginia Antiquities), the structure is one of Fredericksburg's most popular attractions. The building dates to 1760 and became a tavern around 1792, twelve years after Charles moved from Spotsylvania County. (Courtesy of JFC.)

Some time between 1784 and 1786, George Weedon, who was a Revolutionary War general, innkeeper, and early mayor of Fredericksburg, built the Sentry Box at 133 Caroline Street as his residence. Built in a dominating position overlooking the Rappahannock River, it was severely damaged by Union artillery during the Battle of Fredericksburg in December 1862. It has been beautifully restored today and is still a private residence. (Courtesy of JFC.)

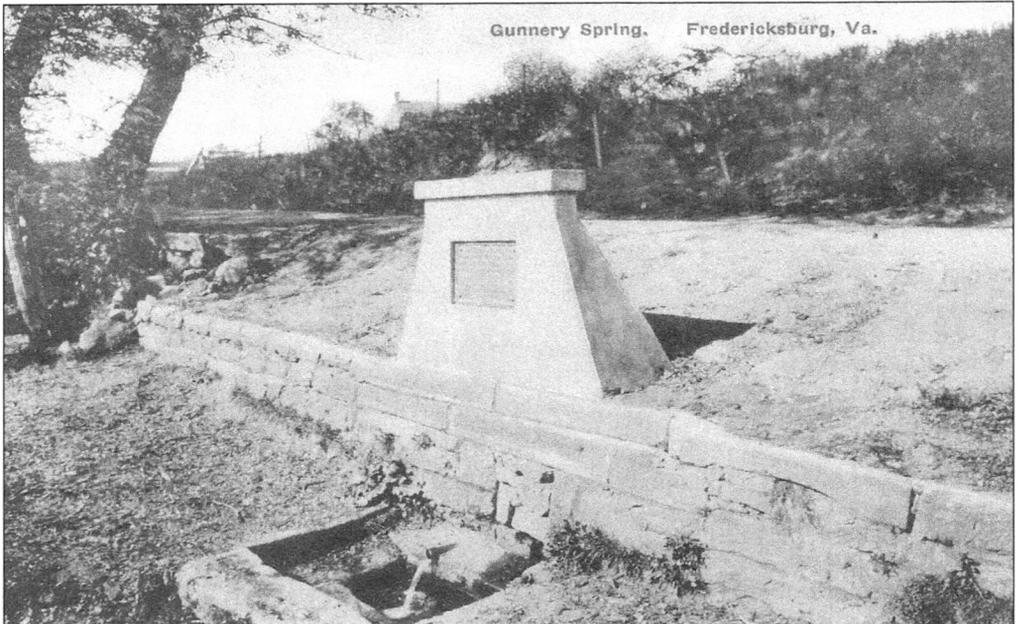

Gunnery Spring, seen here in a postcard from 1910, was the site of a Revolutionary War arms production facility. It was financed and operated by local patriots Fielding Lewis and Charles Dick mainly to supply the Virginia forces of the Continental Army. Lewis lost his personal fortune keeping the gunnery in operation. During the Spanish-American War in 1898, the gunnery site was turned into an Army training facility known as Camp Cobb. (Courtesy of JFC.)

This gigantic horse chestnut tree is said to be the last of 13 planted by George Washington on the estate of his sister Betty Lewis. Each tree was named after one of the original 13 states of the new nation. The trees were intended to create a shaded walkway for his mother between her home and Kenmore. (Courtesy of JFC.)

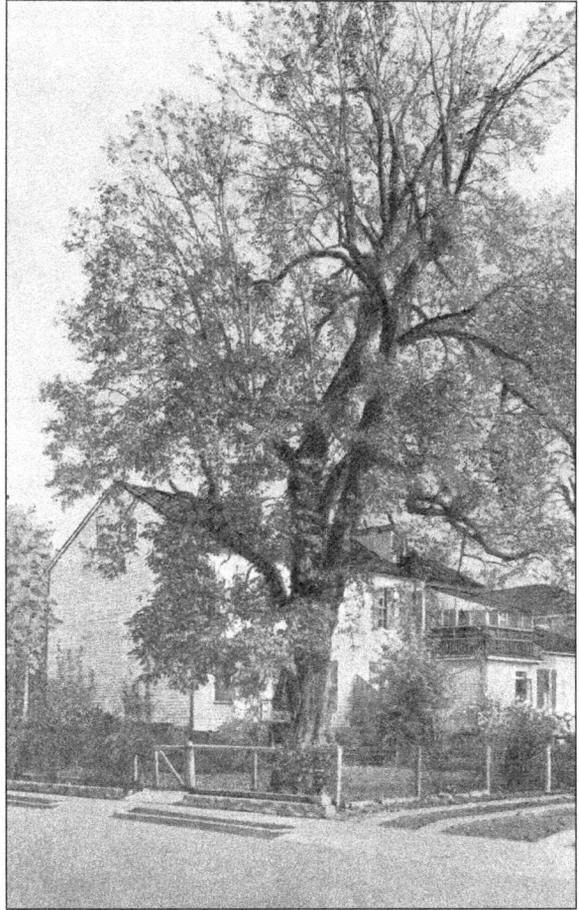

Federal Hill was the onetime residence of Robert Brooke, a former Virginia governor. Brooke purchased 504 Hanover Street after his 1794–1796 term as governor. Federal Hill's exact date of construction is uncertain, but 1792 has been suggested. There is a strange tale of this house being haunted by the ghost of Alexander Spotswood, made even stranger by the fact that Spotswood died over 50 years prior to the home's existence. (Courtesy of JFC.)

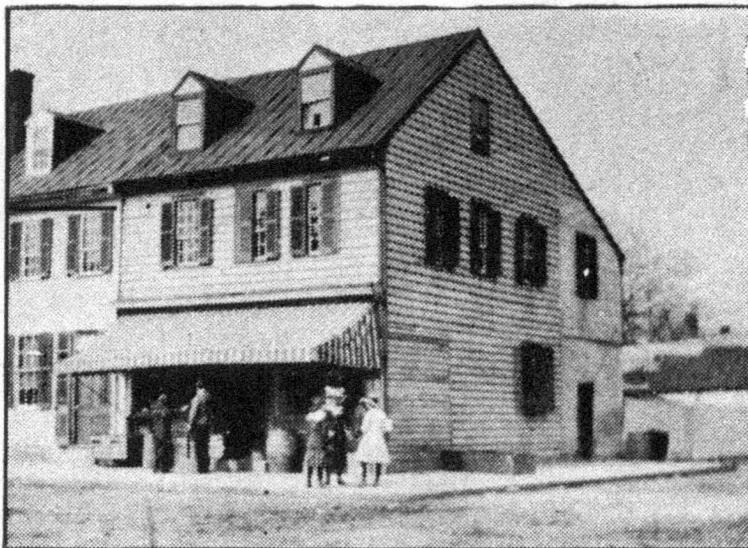

Cannon Ball Hole

JOHN PAUL JONES' HOUSE, FREDERICKSBURG, VA.

Another legendary landmark of historic Fredericksburg is the John Paul Jones House. Said to have been the tailor shop of his brother William Paul, legend has it that John Paul Jones rented the property for a period from the executors of his brother's estate. Documentation has yet to be produced to substantiate this. John Paul Jones is one of America's great Revolutionary War naval heroes. (Courtesy of JFC.)

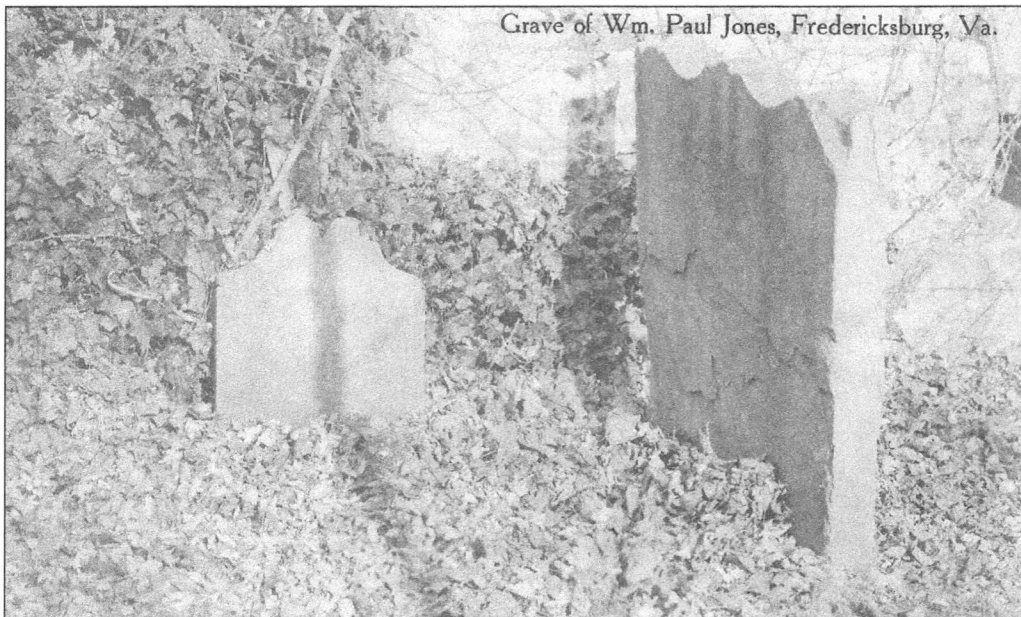

Grave of Wm. Paul Jones, Fredericksburg, Va.

The grave of William Paul rests in the yard of St. George's Episcopal Church on Princess Anne Street. The surname *Jones* was applied by John Paul after his brother's death in an effort to distract from a somewhat checkered reputation he had gained at sea by ordering the death of two men in separate disciplinary instances. (Courtesy of JFC.)

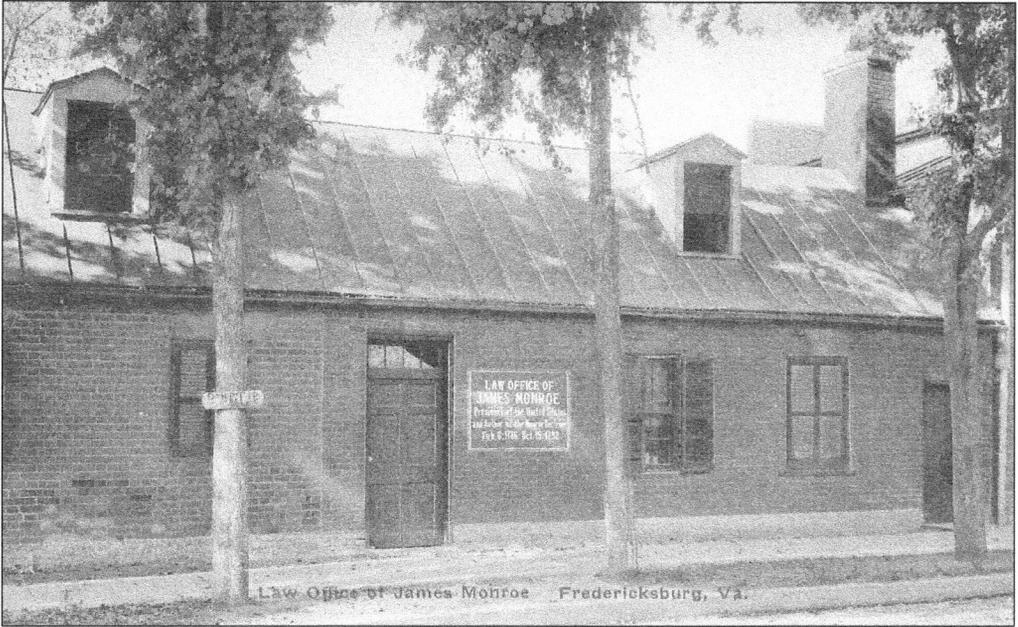

Equally mired in the myths of historic Fredericksburg is the life of Pres. James Monroe. Monroe enjoys a legacy as a Founding Father of the nation and as president. In his early career as an attorney, Monroe established his law office on a town lot now occupied by a row of brick structures built after his time here. (Courtesy of JFC.)

Local legend, however, maintained that these very buildings had indeed been his law office, and beginning in 1927, they have been used as a museum and library in his honor. Maintained today by the University of Mary Washington as the Monroe Museum, the buildings' dubious past has been corrected. The house in this photograph enjoyed notoriety as Monroe's home for a period, but in reality, he may have only owned the site via a pocket deed for legal purposes. (Courtesy of JFC.)

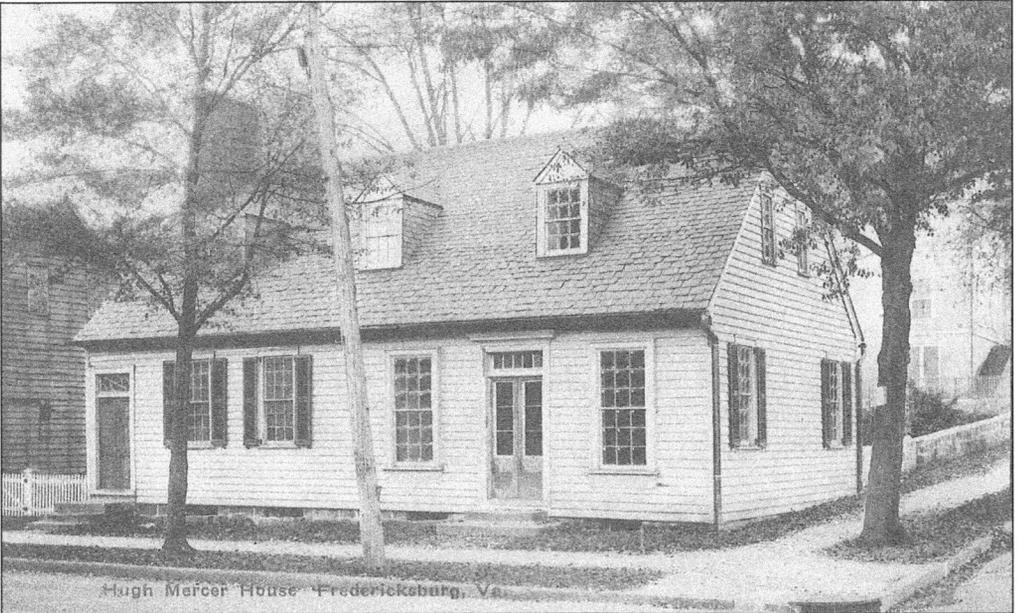
Hugh Mercer House, Fredericksburg, Va.

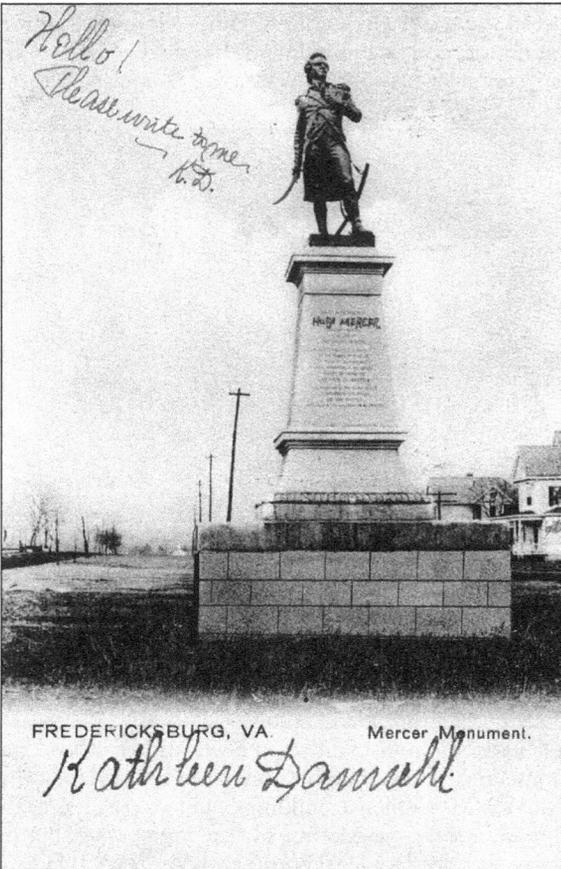
Hello!
Please write to me.
K.D.

FREDERICKSBURG, VA. Mercer Monument.

Kathleen Damuhl

The Hugh Mercer Apothecary Shop was restored in the 1920s by the Citizens Guild of George Washington's Hometown. Hugh Mercer, who was a friend of George Washington and other Virginians, moved to Fredericksburg in 1760. A physician, Mercer set up a practice along Caroline Street. The building pictured here memorializes him, but dendrochronological dating confirms that the building was built too late to serve as that structure. (Courtesy of JFC.)

Mercer was commissioned as a brigadier general in the Continental army and was with Washington during both the Christmas crossing of the Delaware and the Battle of Trenton the following day, December 26, 1776. Mercer died on January 12, 1777, from wounds received during the Battle of Princeton. Mercer may have been mistaken for Washington during the battle, when he was viciously clubbed and bayoneted by British soldiers. This monument was dedicated to Mercer in 1906. (Courtesy of JFC.)

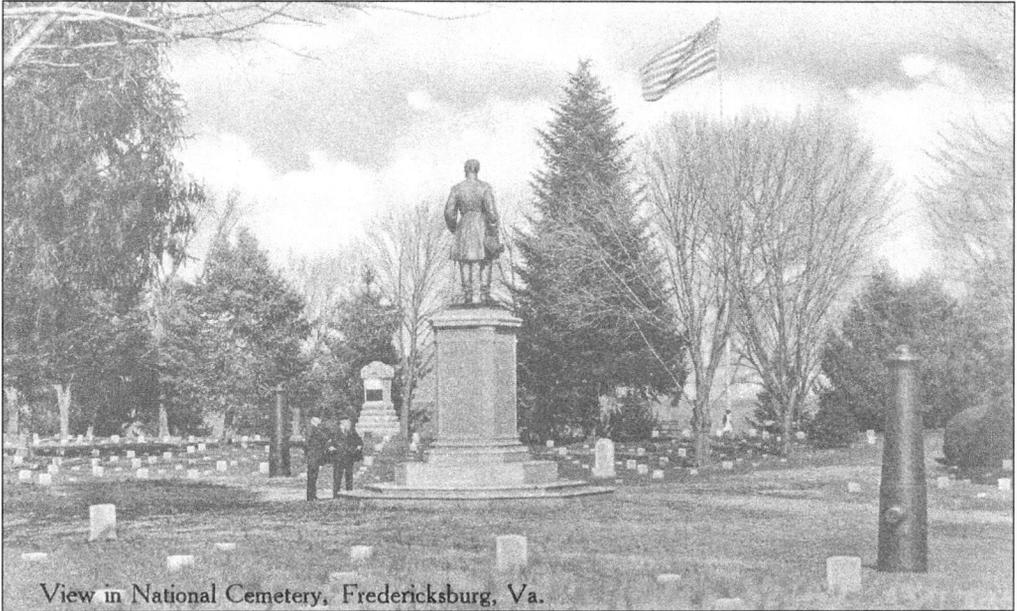

View in National Cemetery, Fredericksburg, Va.

Spared during the Revolution, the harsh hand of battle would visit Fredericksburg and Spotsylvania County during the Civil War. Battered by bombardment in December 1862, the town recovered, although at great cost to the residents. The most profound testament to the carnage of the fighting around Fredericksburg lies within the graves of the National Cemetery on Willis Hill, the commanding heights of which dominate the cityscape today. (Courtesy of JFC.)

Near the entrance to the National Cemetery stands the Fifth Corps Monument, also known by the name of the corps commander who advocated for its placement, Gen. Daniel Butterfield. Dedicated on Memorial Day in 1901, it has a commanding presence on the corner of Sunken Road and Lafayette Boulevard. (Courtesy of JFC.)

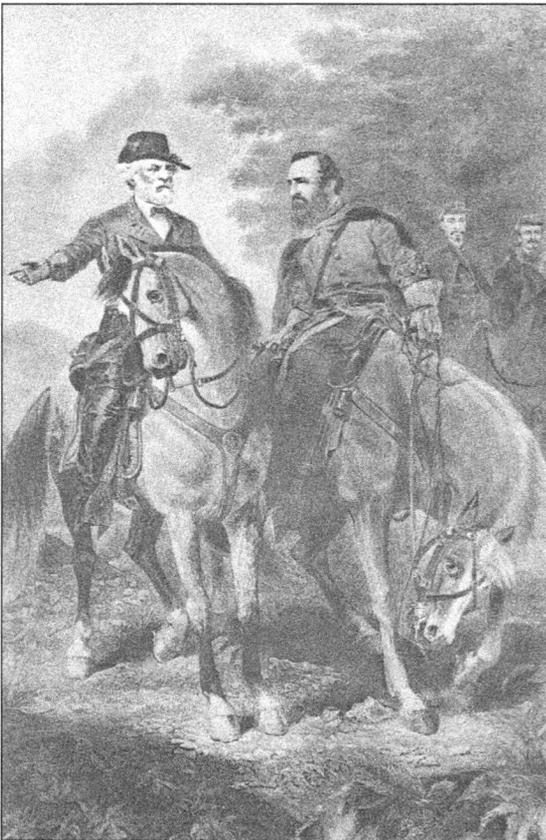

CONFEDERATE CEMETERY, FREDERICKSBURG, VA.

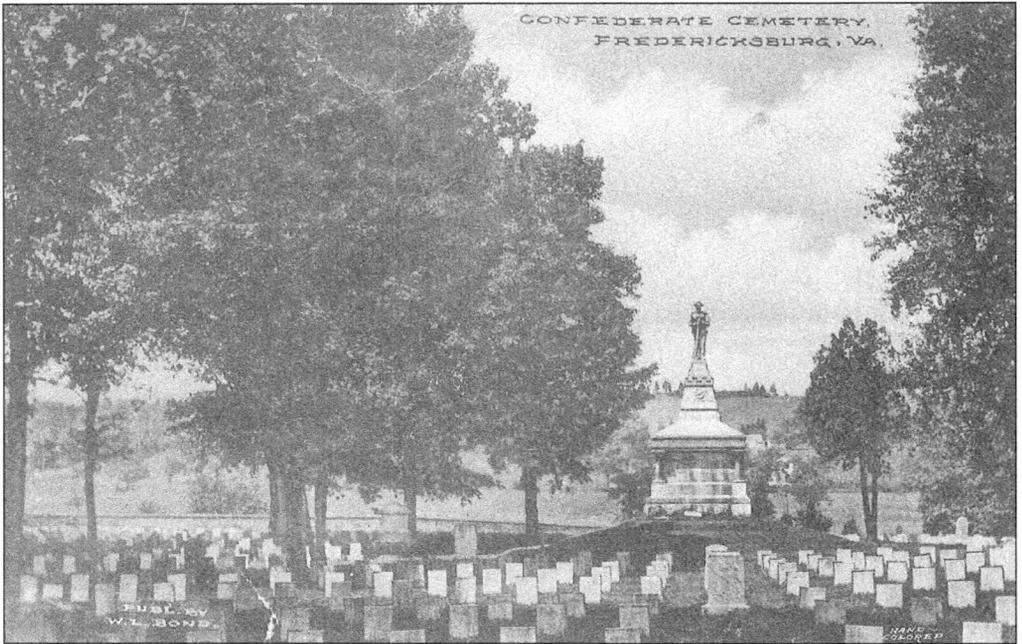

Along the old outskirts of the city on a ridge shared with the Mary Washington Monument and Kenmore lie the remains of 3,353 Confederate dead, nearly two-thirds of which are unidentified. The Ladies Memorial Association orchestrated the gathering and placement of the remains from around the region. (Courtesy of JFC.)

The iconic vestiges of Confederate generals Robert E. Lee and Thomas J. Jackson are firmly rooted to the region as a result of the two major Southern victories they shared. At Chancellorsville, on May 2, 1863, Jackson would briefly bask in the routing of the Union right flank. Later that evening, he was mistakenly shot by his own men while returning toward their line from a reconnaissance ride. (Courtesy of JFC.)

Two

A War-Torn Landscape

Photography enables us to forever capture moments in time with indelible memories of what was, both good and bad, a document of where we have taken ourselves as a civilization. With the national crisis of the 1860s, enterprising artists and early photographers set out to affix the story as it happened to sensitized glass negatives and sketch pads. Through these primary resources, one can see how a simple, vernacular landscape shaped by the agricultural and commercial needs of those who lived on it was transformed by the intrusion of warring factions. From the moment these landscapes went from pastoral vistas to battlefields, their very essence was changed and forever hallowed.

For 18 months, from December 1862 through May 1864, Spotsylvania was visited with horrific uncertainty, wanton destruction, and despair. As war cast its hand across the landscape, farms were made desolate, homes were destroyed, crops were burned, livestock was slaughtered, and, above all, a faith in humanity was challenged to the brink.

Quite certain that it had no place in leaving the Union, Virginia had held out to the bitter end in the days leading to war until seeing no other course but to ally itself with its Southern sisters. Spotsylvania harbored a great deal of Union sentiment even after secession, although not expressed vocally. Some residents left the county to avoid the wrath of neighbors, while others secretly stood vigilant to the Union cause, some even offering their services as spies.

But in the end, no matter the allegiance, practically everyone in the county would meet with hardship, either in the loss of property, loved ones, or both.

Here is the proof that Spotsylvania can truly be called the most blood-soaked soil in the nation, where over 100,000 casualties fell. Behold some of the key players that waged war over this land and view the wreckage that resulted.

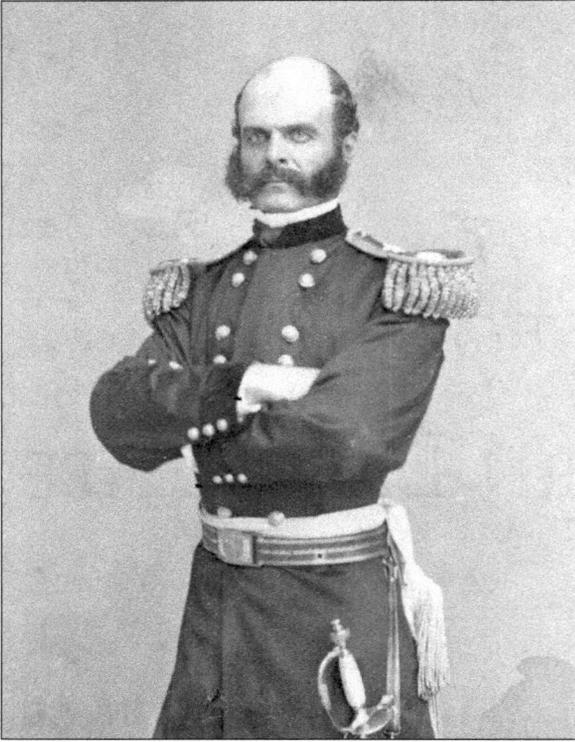

Union general Ambrose Burnside, who hesitantly took command of the Army of the Potomac, willingly took the blame for a catastrophic series of mistakes leading up to and ending in embarrassing defeat at the Battle of Fredericksburg. On December 13, 1862, fourteen brigade-sized assaults against a fixed Confederate position on high ground west of town produced nothing but the butchering of waves of men, leaving 12,700 Union soldiers killed or wounded. (Courtesy of LC.)

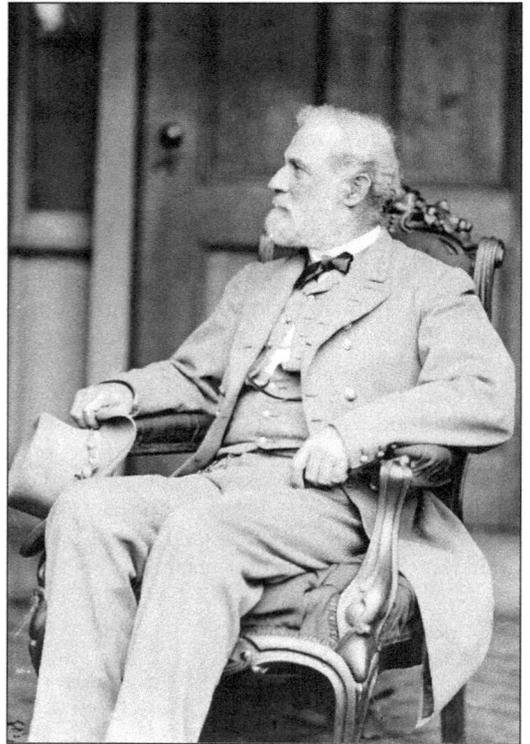

Confederate commanding general Robert E. Lee had already gained a saintly reputation with the people of the South before his major repulse of the Union advance to Richmond via Fredericksburg. Shocked by the senseless waste of troops by the Union command, Lee is said to have exclaimed, "It is well that war is so terrible—lest we should grow too fond of it." (Courtesy of LC.)

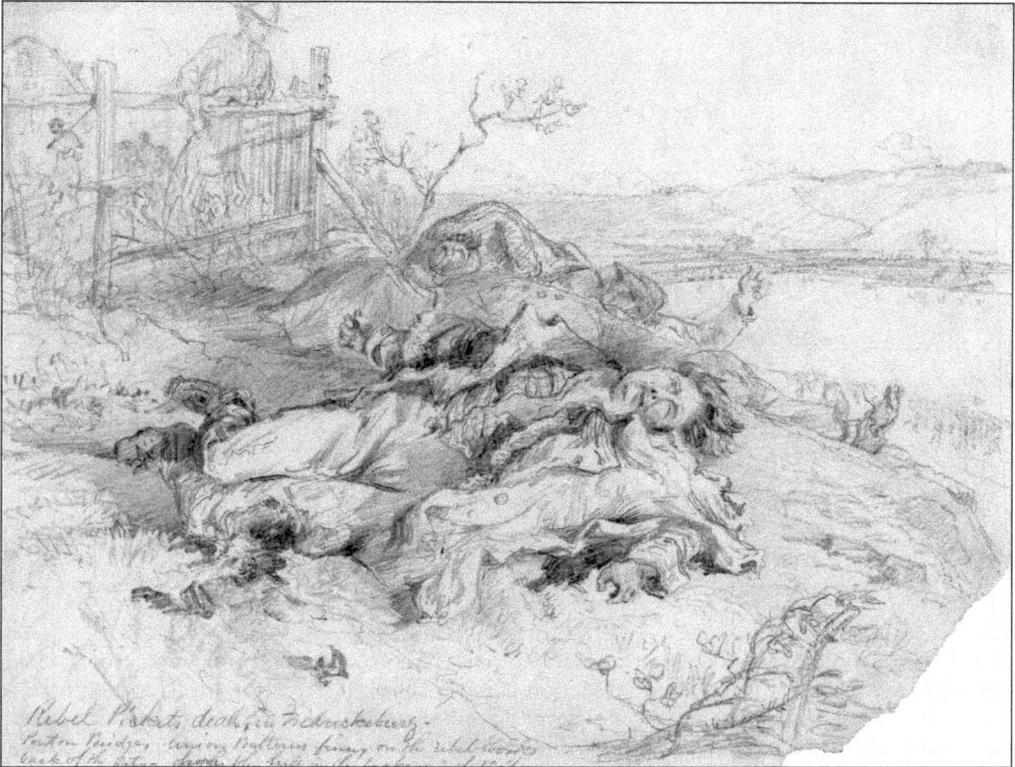

In an eyewitness sketch horrifyingly reminiscent of the *Disasters of War* series by Francisco de Goya, newspaper artist Alfred Waud recorded the aftermath of Union bombardment at Fredericksburg. The dead shown here are Confederate sharpshooters who were delaying the Union crossing of the Rappahannock River and ultimately buying time for Lee's strengthening of the heights beyond the town. (Courtesy of LC.)

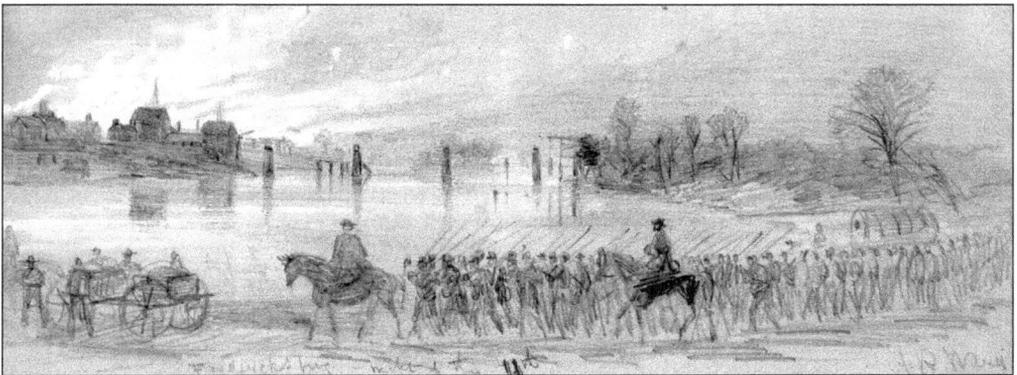

After establishing a foothold on the Fredericksburg side of the river, Union men entered the town on the evening of December 12, 1862. Another eyewitness sketch by Waud depicts the silhouetted lines of soldiers filing across pontoon bridges as sections of the town are consumed by flames that illuminated the evening sky. (Courtesy of LC.)

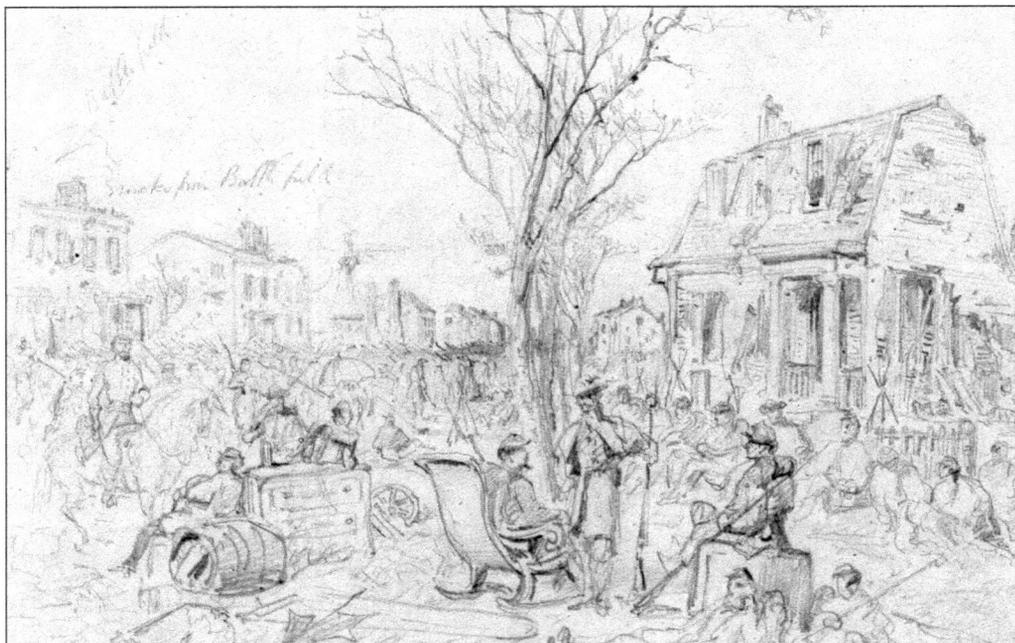

Waud once again provides his eyewitness view into the Union occupation of Fredericksburg. Here, brigades are arriving at the residential section of lower Caroline Street, waiting for their turn at a suicidal plunge against the enemy. Soldiers had pulled furniture into the street and had freely looted the town on the previous evening. The battle raged three-quarters of a mile away, beyond the rooftops at left. (Courtesy of LC.)

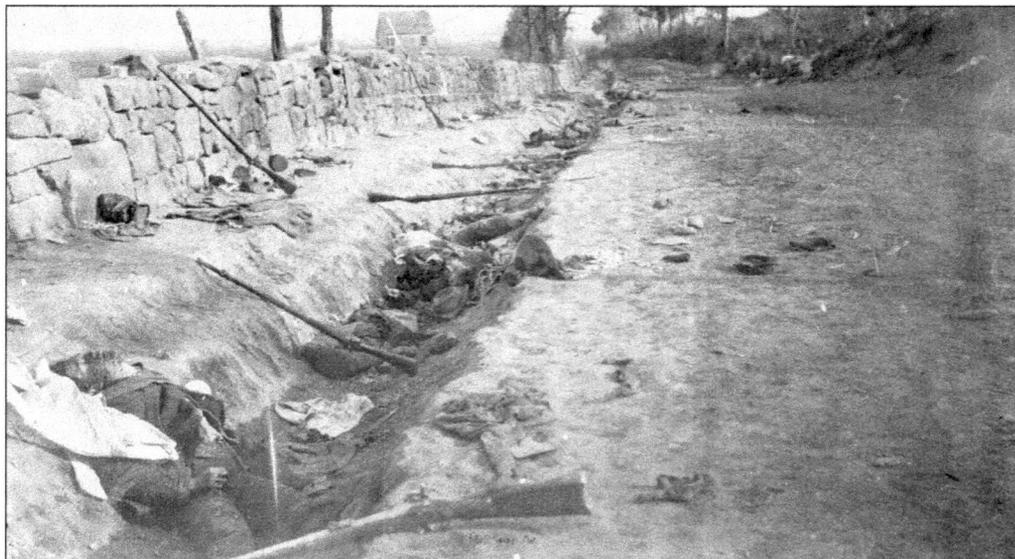

The objective—though it would not be gained that day—was this heavily defended stone wall at the base of Maryes Heights. The following May, however, Burnside's successor in command would launch a much broader effort to assail Lee's forces and move closer to the Confederate capital in Richmond. This photograph, taken on May 3, 1863, shows the now conquered wall, which was abandoned by Lee's men during the Chancellorsville campaign. (Courtesy of LC.)

Awarded command of the Army of the Potomac on January 26, 1863, Union general Joseph Hooker planned to envelope Lee's forces in a sweeping maneuver up the Rappahannock River and back across country toward the rear of the Confederates, who had wintered in a more strongly held Fredericksburg. A smaller but distracting Union force was to once again hit the town and push toward the main body, squeezing the Confederate army. (Courtesy of LC.)

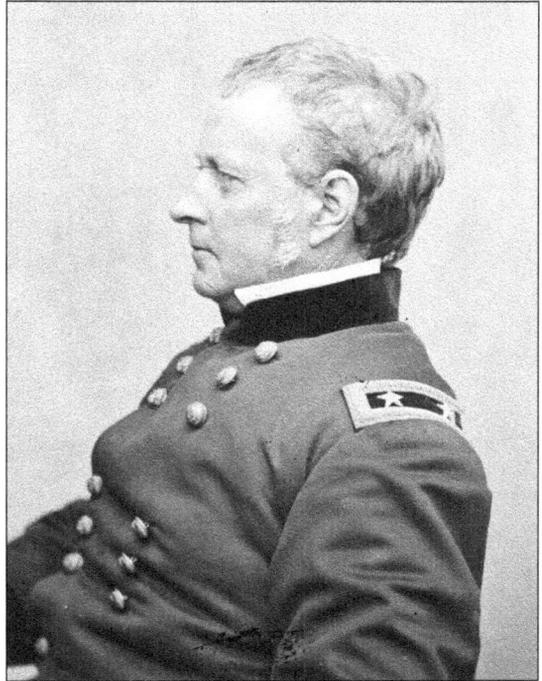

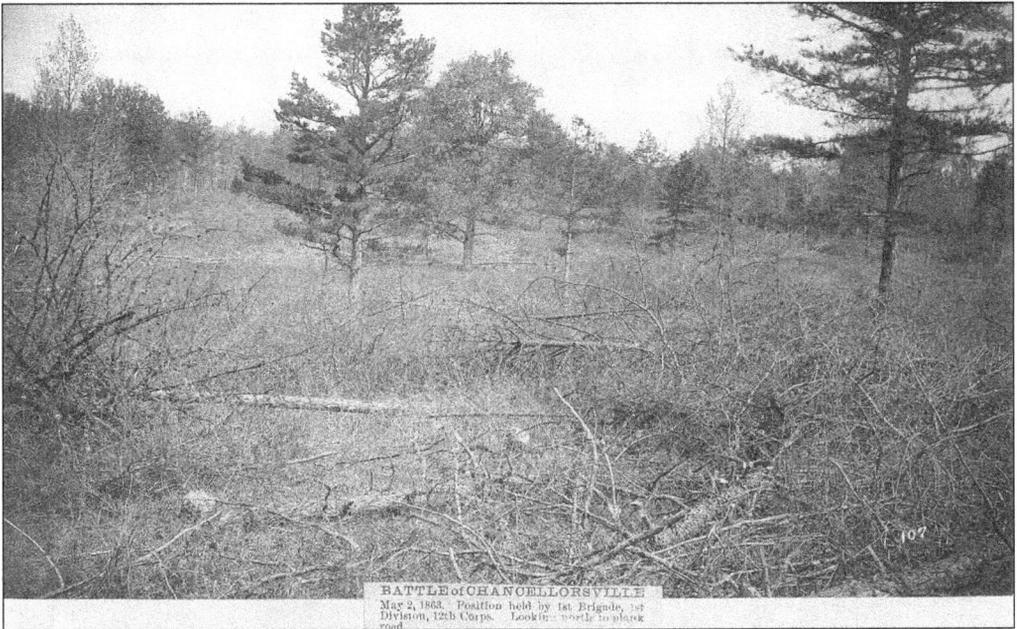

BATTLE of CHANCELLORSVILLE
May 2, 1863. Position held by 1st Brigade, 1st
Division, 12th Corps. Looking north to plank
road

Perhaps a bit overconfident and plagued by misperceptions of the Confederate reaction to his plan, General Hooker's fortunes would deteriorate in the four days of concerted fighting that followed. In the early evening of May 2, 1863, the Union right flank was left dangerously dangling near the Wilderness Church, 11 miles west of Fredericksburg. After a sly countermarch that was mistaken for retreat, 26,000 Confederates hammered that weakness, routing it extensively. (Courtesy of JFC.)

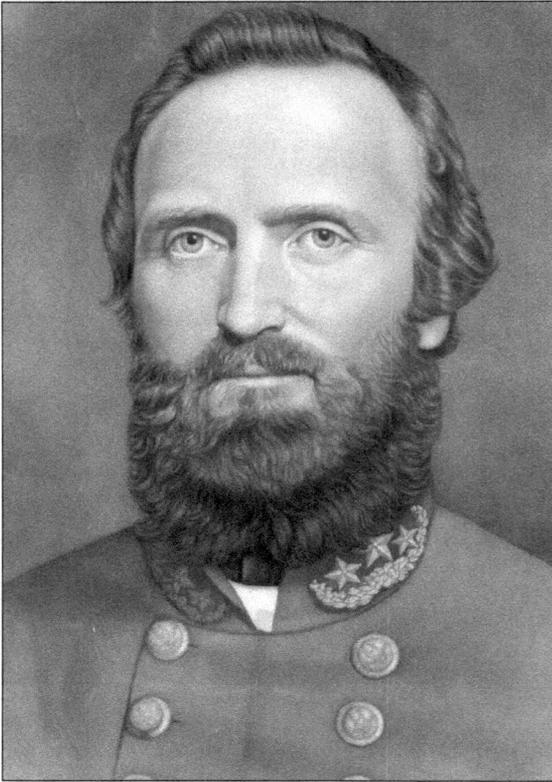

The mastermind of the daring countermarch was Confederate corps commander Stonewall Jackson, the demigod of the South. Hooker's army was poised for disaster but was spared by fate as the sun went down on May 2. Nearly diminishing the Confederate success that day was the mortal wounding of General Jackson, shot mistakenly by his own men upon returning from a reconnaissance ride that night. (Courtesy of LC.)

The wreckage of these battles around Fredericksburg was overwhelming. Many of the townspeople of Fredericksburg had been living as refugees with benevolent friends and family out in the countryside or in neighboring counties. This photograph from May 1863 shows a smashed artillery caisson with the dead horses that had once pulled it still harnessed to the snapped limber pole. This scene occurred on the back slope of Maryes Heights after the Confederates vacated. (Courtesy of LC.)

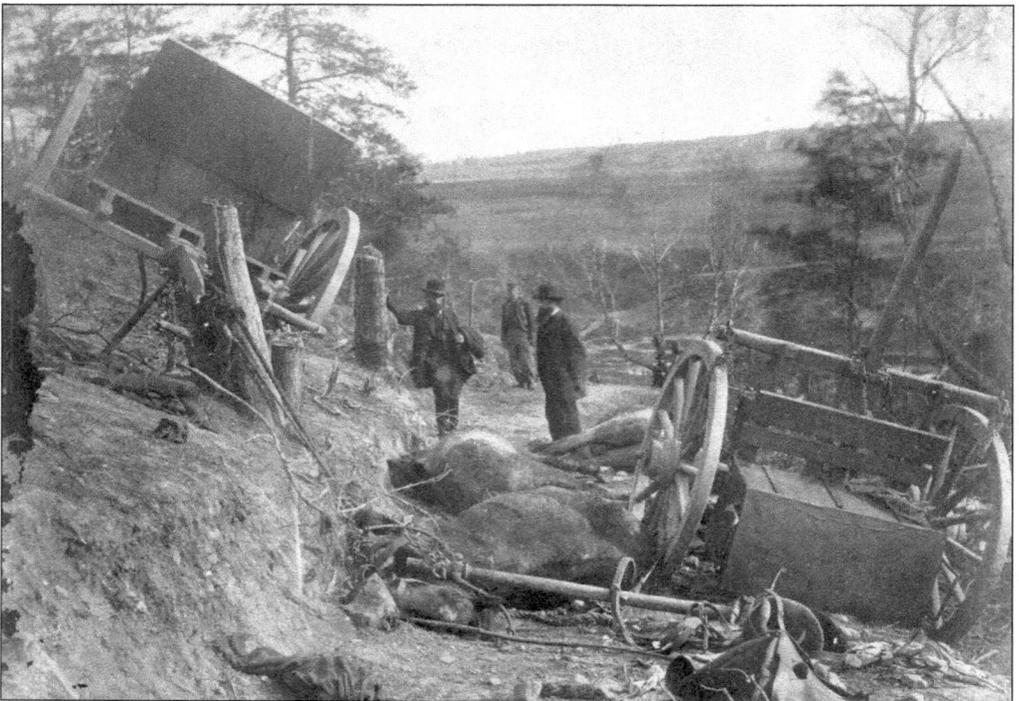

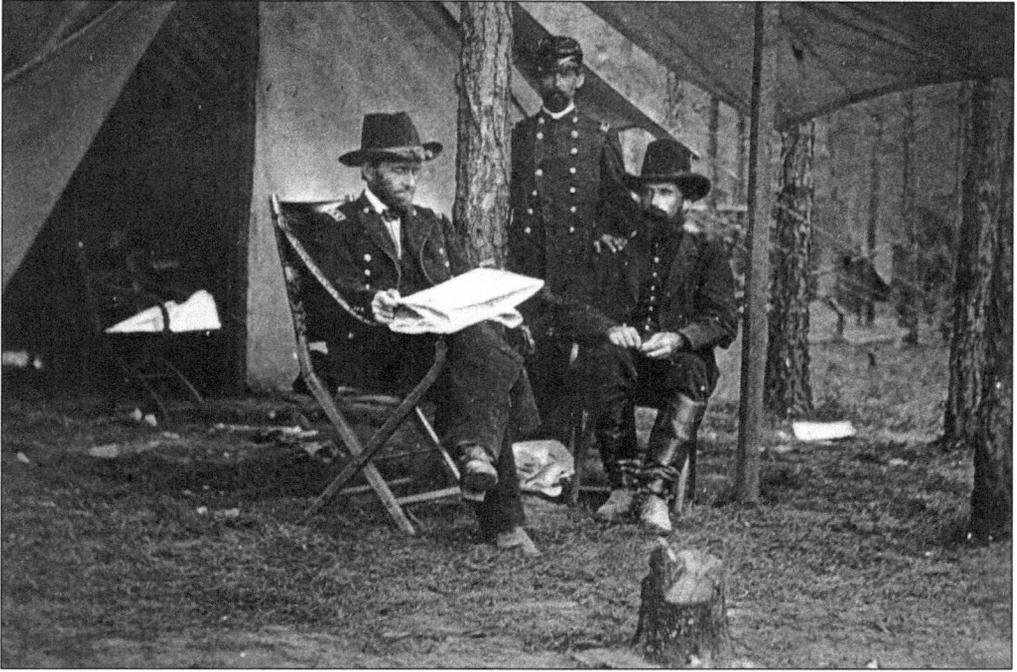

One year later, after the Confederate
defeats at Gettysburg and Vicksburg, a new
overall Union commander was appointed
by Pres. Abraham Lincoln. Having proven
himself in the western theater, Gen.
Ulysses S. Grant came east, accompanying
Gen. George G. Meade, the somewhat
humiliated commander of the Army of the
Potomac, who was known as the "victor
of Gettysburg." Grant's strategy would be
very different than those who had come
before him in the east. (Courtesy of LC.)

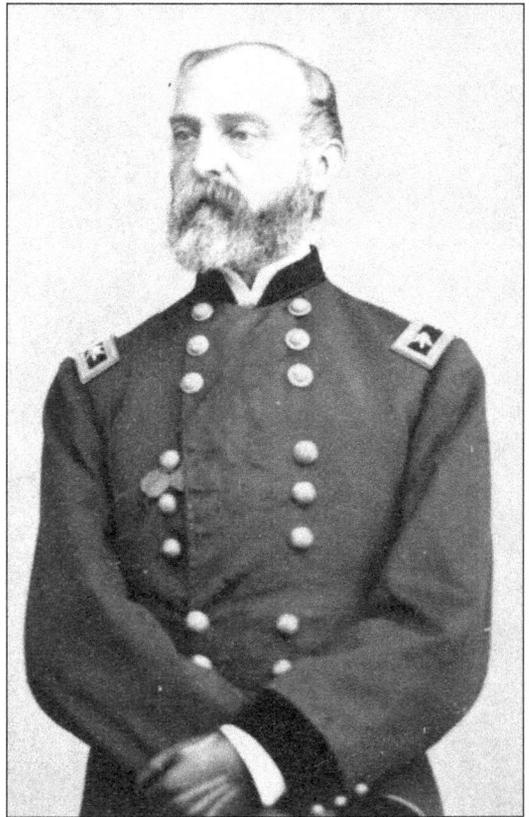

Instead of conducting the war from an
office in Washington, DC, General Grant
chose to stay in the field, keeping a vigilant
eye on what he saw as the most pressing
theater of operations. General Meade
would retain command of the Army of
the Potomac but resented having Grant's
constant presence. (Courtesy of LC.)

33

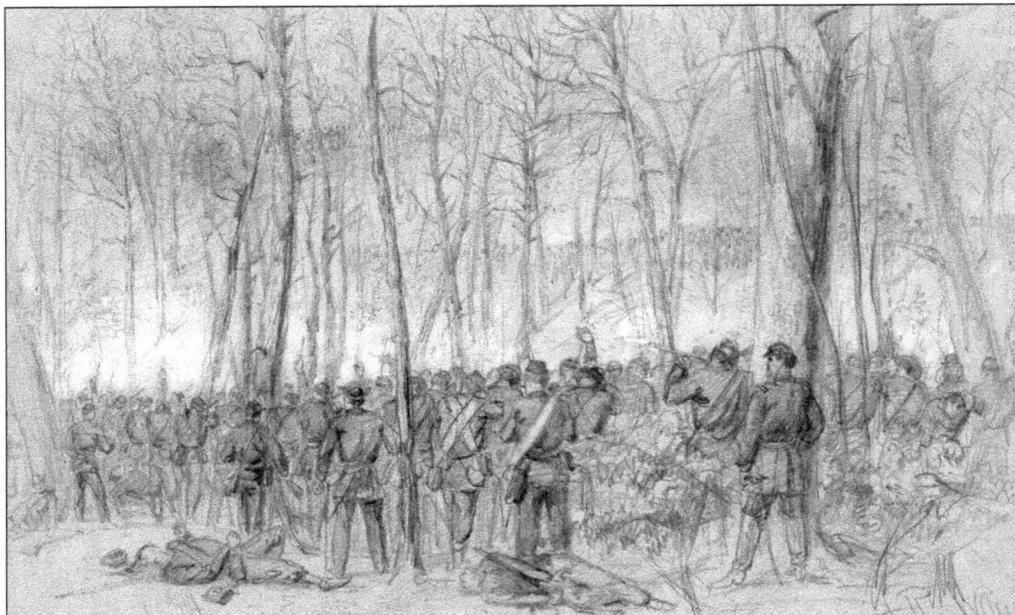

Fighting erupted along the borders of Spotsylvania and Orange Counties on May 5, 1864. The Union swept south from winter encampments and crossed the Rapidan River at Germanna Ford, the site of Governor Spotswood's Colonial-era fort. Pressing through the forest that was once harvested heavily for iron furnace operations, the Army of the Potomac encountered General Lee's men in a savage clash of wills, as depicted in this Alfred Waud drawing. (Courtesy of LC.)

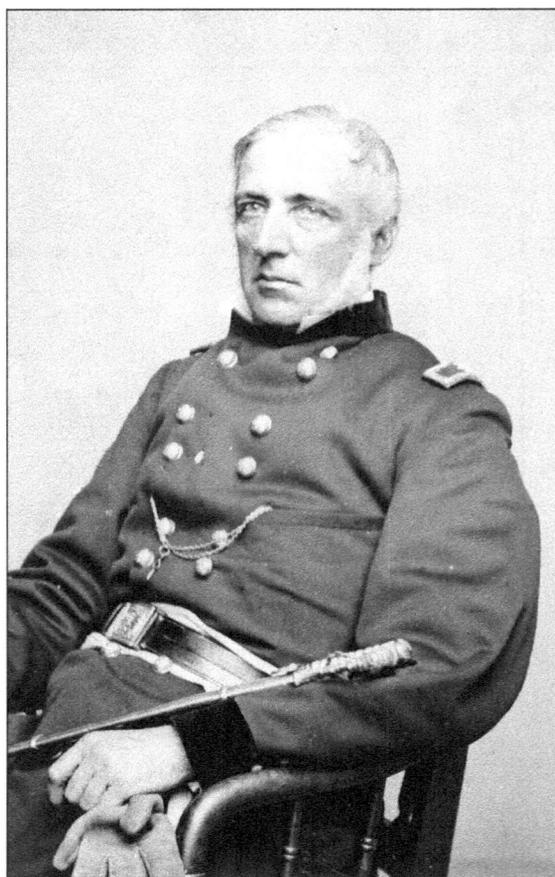

Desperate fighting along Orange Plank Road brought a heavy toll to both armies. Sections of the tangled woods caught fire, consuming many of the helpless wounded unable to be extricated. Union division commander Gen. James Wadsworth, a millionaire educated at Harvard and Yale, was shot on the top of the head on May 6 while trying to rally his panicked command. He died two days later behind Confederate lines. (Courtesy of LC.)

Not far from where General Wadsworth was struck down, Confederate general James Longstreet advanced triumphantly along Orange Plank Road with his staff. Fully in the throes of a flanking action that threatened to drive the Union from the Brock Road intersection, Longstreet, just like General Jackson before him, was tragically shot by his own men, but he would survive the wound and return to command after a five-month convalescence. (Courtesy of LC.)

Depicted here is an engagement on the approach to Spotsylvania Courthouse, today's Route 208. Drawn by Alfred Waud and dated May 9, 1864, it shows an early afternoon encounter. Union infantrymen of the IX Corps advanced across an open field toward a thicket of "dwarf pine," where concealed Confederates fired on the Blue line. The ground behind begins to rise toward the courthouse and the main Confederate entrenchment. (Courtesy of LC.)

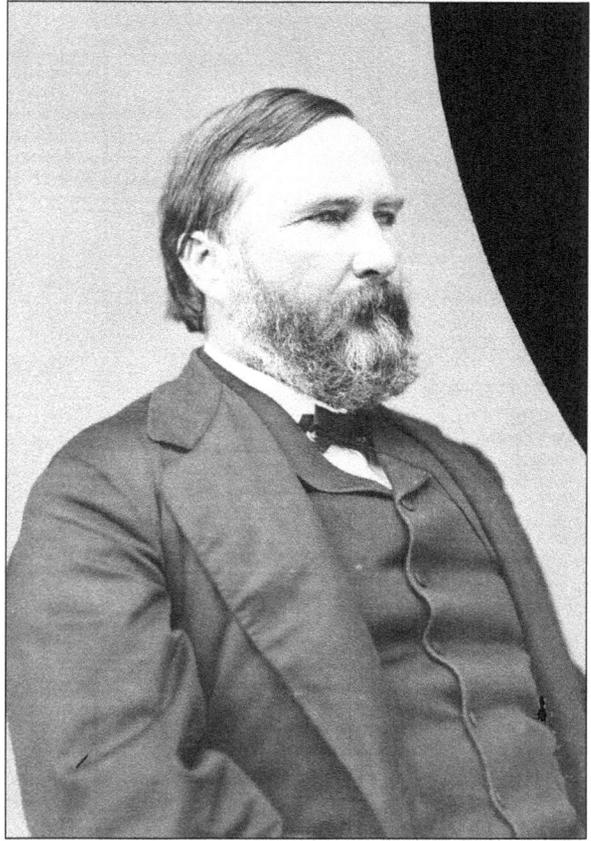

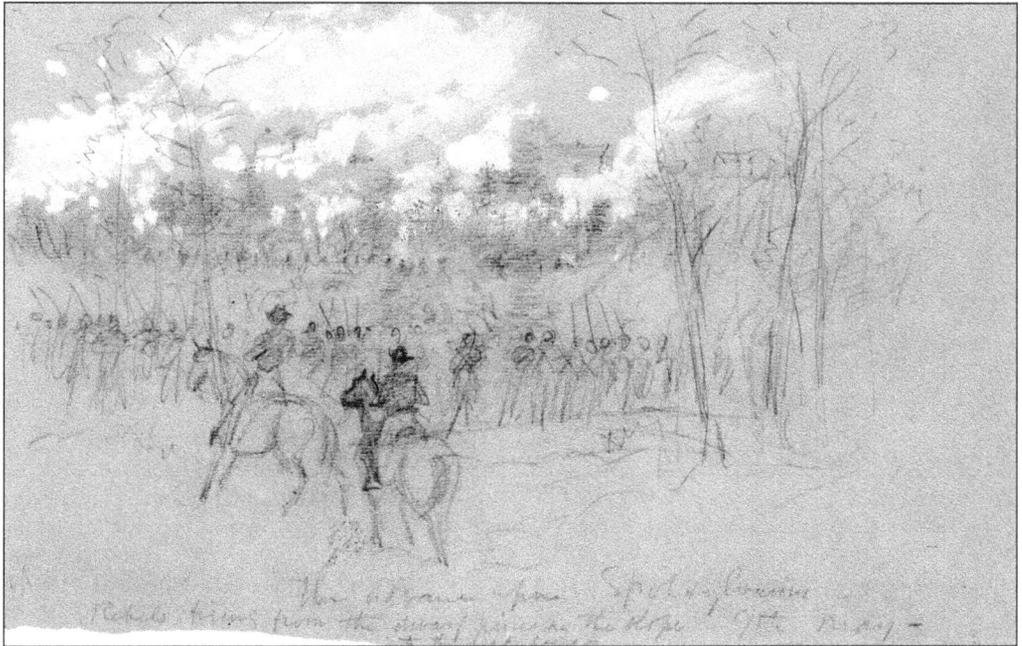

35

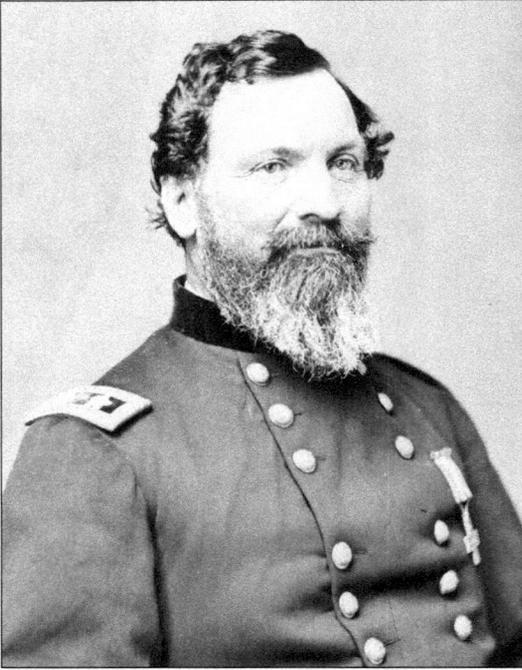

One of the most loved Union generals, dubbed "Uncle John" by his men, was VI Corps commander John Sedgwick. A career military man who had seen numerous wars and campaigns, Sedgwick was felled by a sniper's bullet on May 9, 1864, while he directed the placement of an artillery battery near Laurel Hill. (Courtesy of LC.)

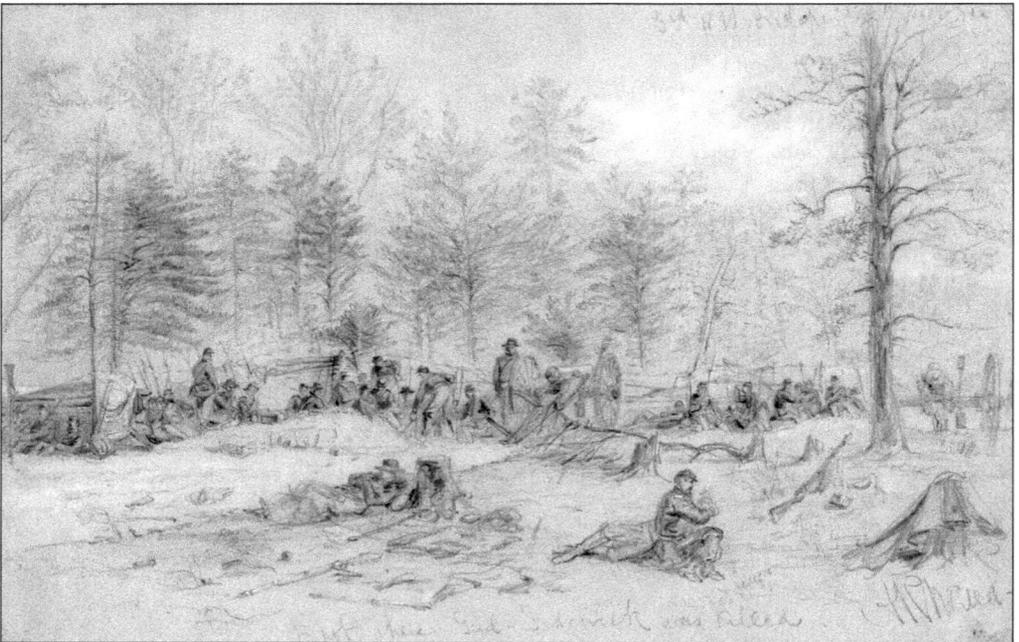

Artist Alfred Waud illustrates the location of Sedgwick's death. As recounted by a staff officer, Sedgwick was playfully admonishing some of his command for dodging occasional bullets, "What? Men dodging this way for single bullets? What will you do when they open fire along the whole line? I am ashamed of you. They couldn't hit an elephant at this distance." Laughing heartily he repeated, "They couldn't hit an elephant at this distance." At that moment, with a smile still on his face, he was struck below the left eye and died instantly. (Courtesy of LC.)

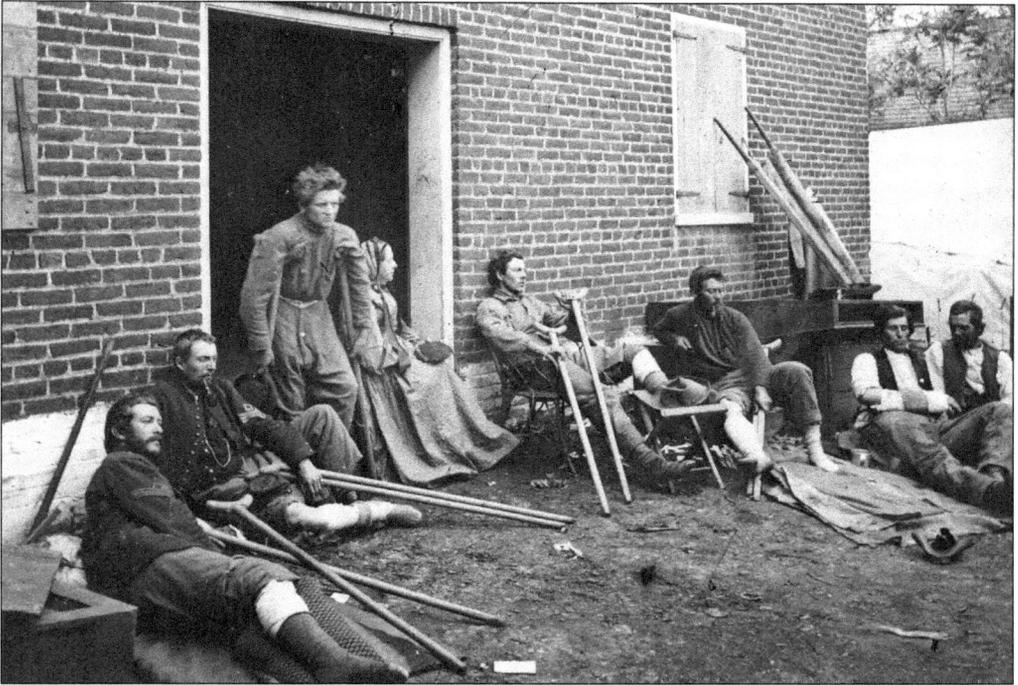

With the heavy casualty rate from the battlefields west of Fredericksburg, the town was thrust into service as an enormous hospital to treat the most severely wounded. In these two vivid photographs of wounded soldiers in the town of Fredericksburg, the pain and anguish is clearly written on the men's faces. The warehouse shown in this photograph was used for VI Corps casualties and still stands today. It now contains law offices. (Courtesy of LC.)

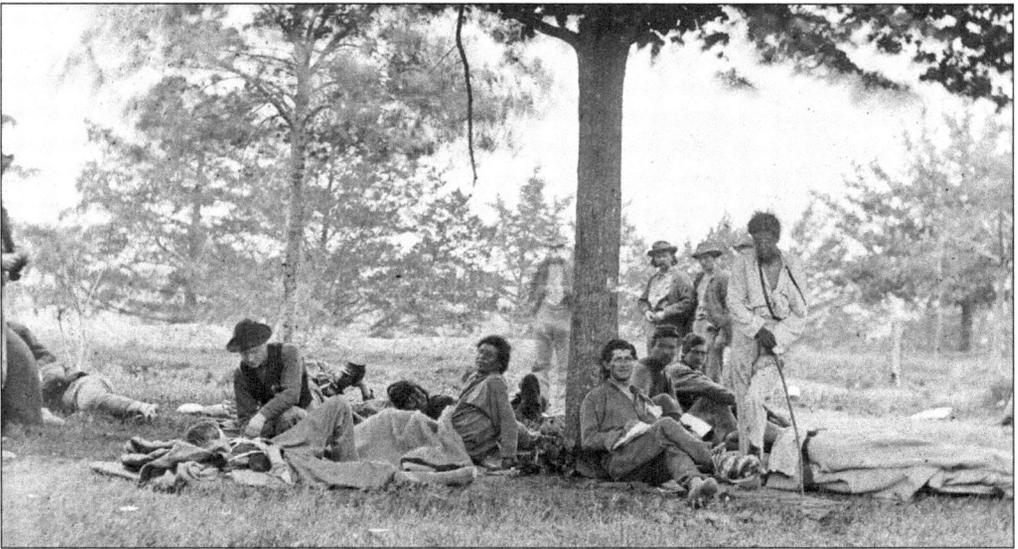

Minor wounds and injuries were dressed behind the lines in the fields near the fighting, and those men could usually return to action in short order. This photograph was taken on the grounds of the stately Marye Mansion, which overlooks the scenes of the December 1862 and May 1863 battles. (Courtesy of LC.)

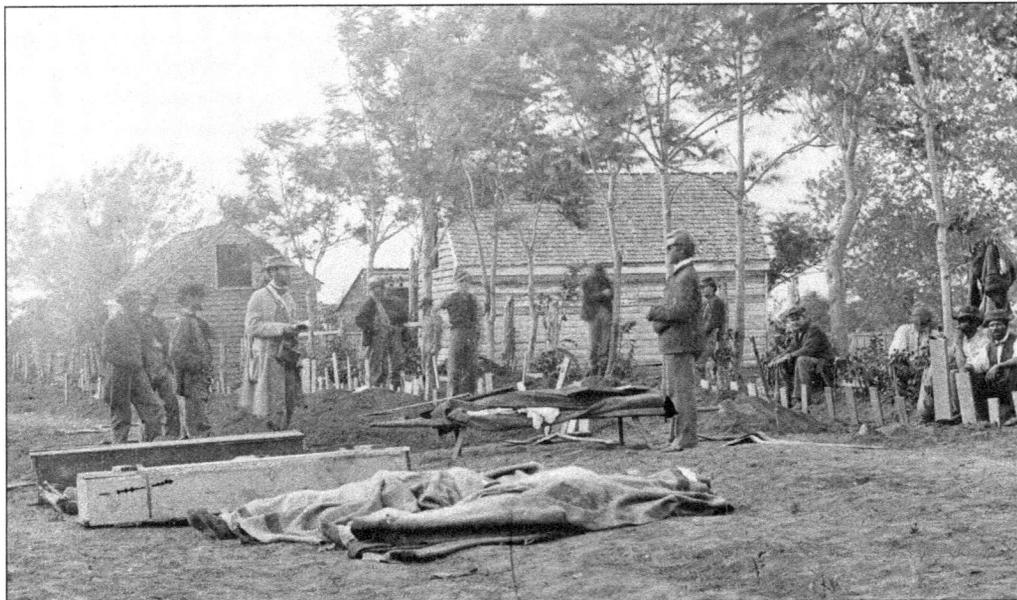

Tragically, not all the wounded survived. This photograph from May 1864 shows a burial service for newly deceased and a row of simple board markers indicating the many who had gone before standing nearby. The location of this sad occasion was determined after years of extensive research by historian Noel Harrison. It is now the approximate location of Winchester Street between Amelia and Lewis Streets. (Courtesy of LC.)

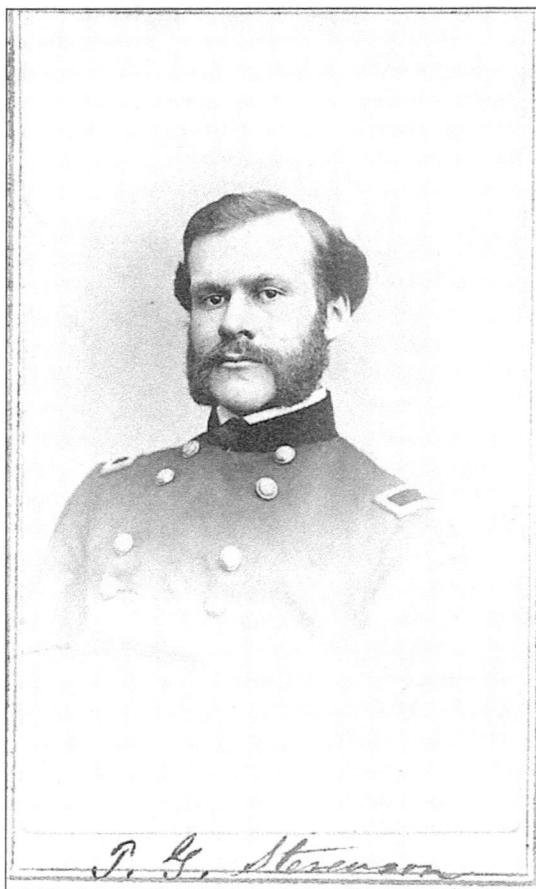

Union general Thomas G. Stevenson came from a prosperous Boston family. Commissioned as a colonel of the 24th Massachusetts in December 1861, Stevenson quickly moved up to brigadier general during admirable command in the Carolinas. In April 1864, he commanded an IX Corps brigade at Spotsylvania and was killed by a sniper while finishing a relaxed lunch and smoking a pipe. (Courtesy of JFC.)

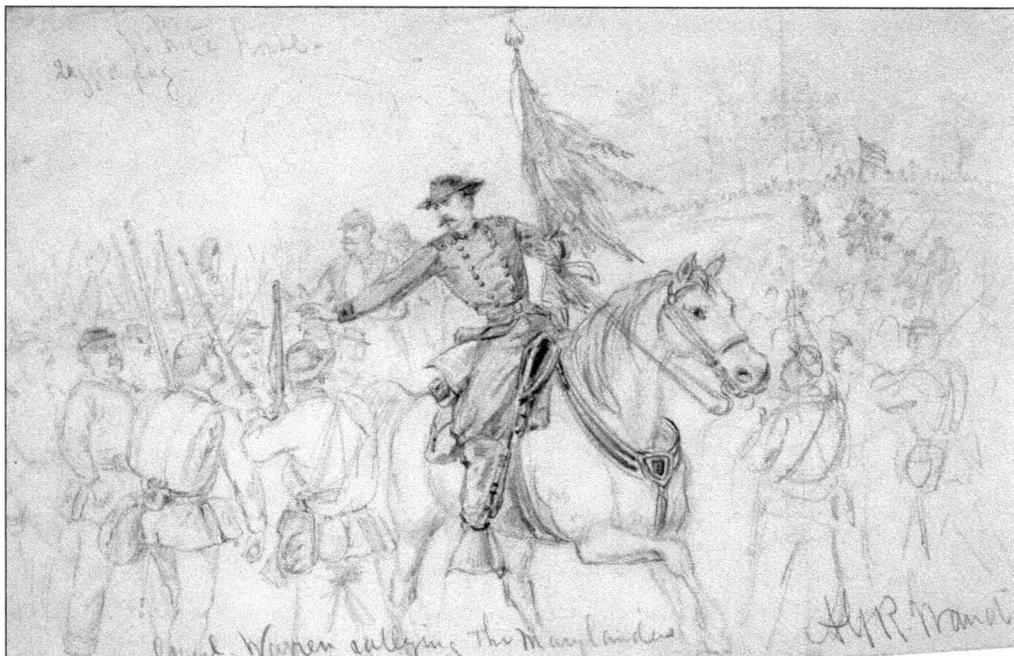

An extremely talented commander of the Topographical Engineers, Gen. Gouverneur K. Warren had won accolades as the savior of Little Round Top at Gettysburg in July 1863. As commander of the Union V Corps at Spotsylvania, Warren was under constant pressure to capture the Confederate position at Laurel Hill, the key to taking the Spotsylvania crossroads and the path to Richmond. The line proved impenetrable, and Warren's reputation suffered greatly. (Courtesy of LC.)

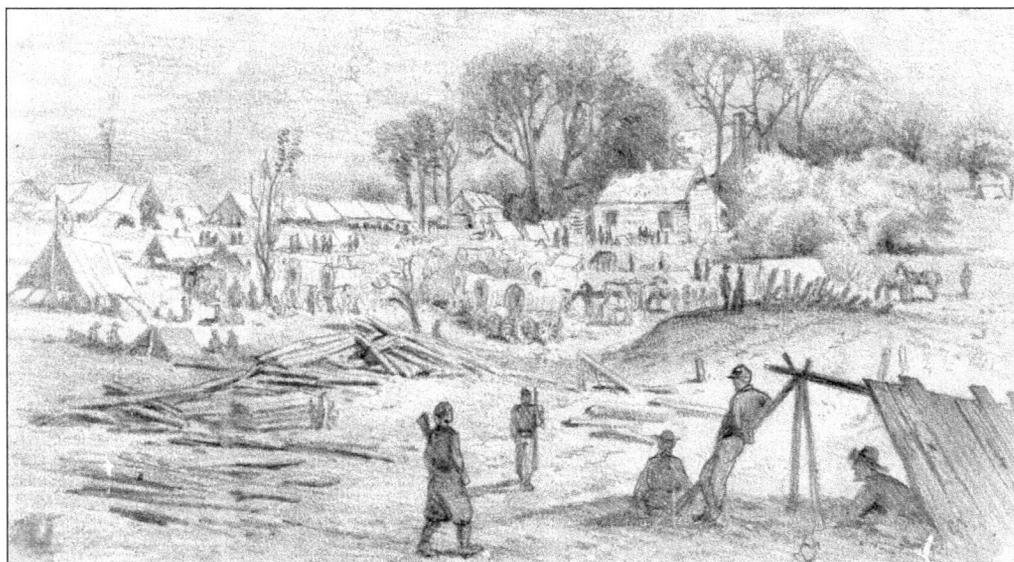

Another newspaper artist who traveled with the Union army was Edwin Forbes of *Frank Leslie's Illustrated*. Dated May 12, 1864, this pencil drawing depicts a Union V Corps field hospital on the grounds of the Couse Farm. Positioned almost two miles behind the fighting, the farm is now the Lake Acres subdivision off of Gordon Road. (Courtesy of LC.)

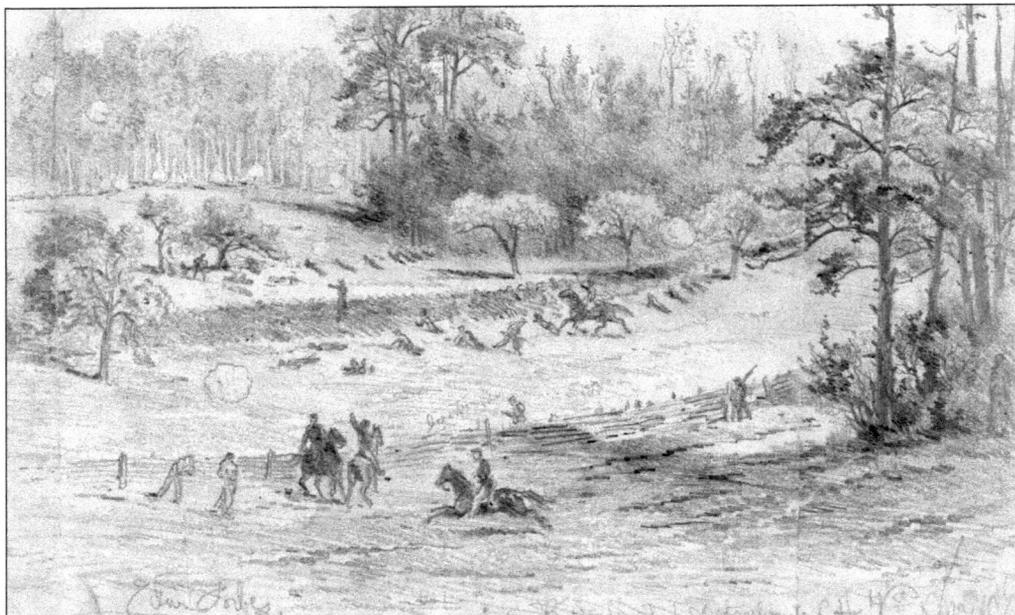

On May 10, 1864, Edwin Forbes witnessed this fighting, which he described as on the "right center" of the Union line, most likely near the Spindle Farm. For five days, the Spindle Farm and the fields to the west, near the Po River, were hotly contested. Despite continued efforts of competent veteran units, the Confederate position was impossible to break in this sector. (Courtesy of LC.)

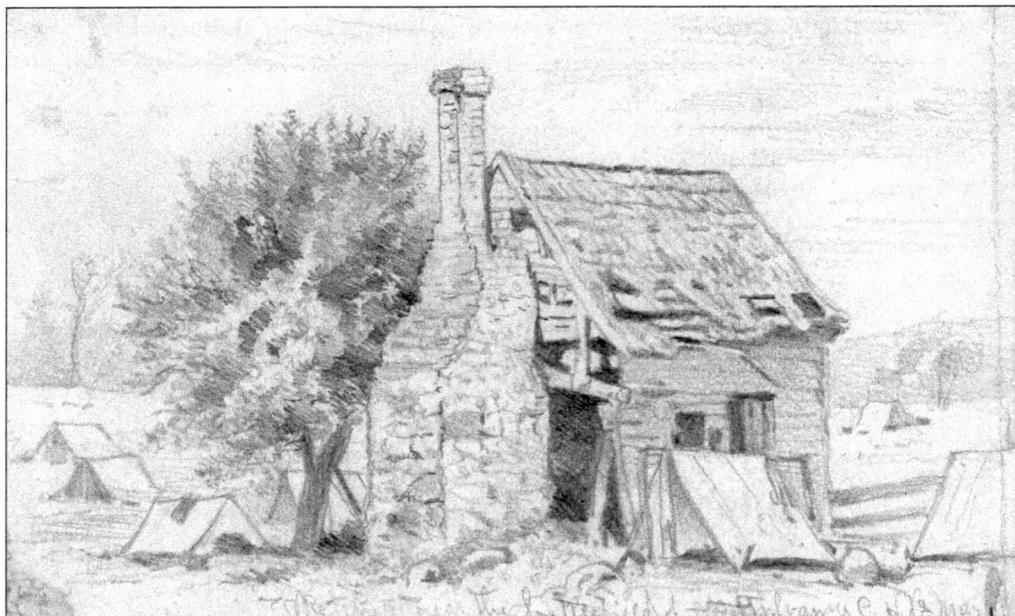

Also on May 10, Forbes drew this battered home "near the Spotsylvania Battlefield." With the scattered tents in the fields, it must be assumed this is another behind-the-scenes location, but it does not appear to be set in the same organized fashion as the field hospital depicted at the Couse Farm. (Courtesy of LC.)

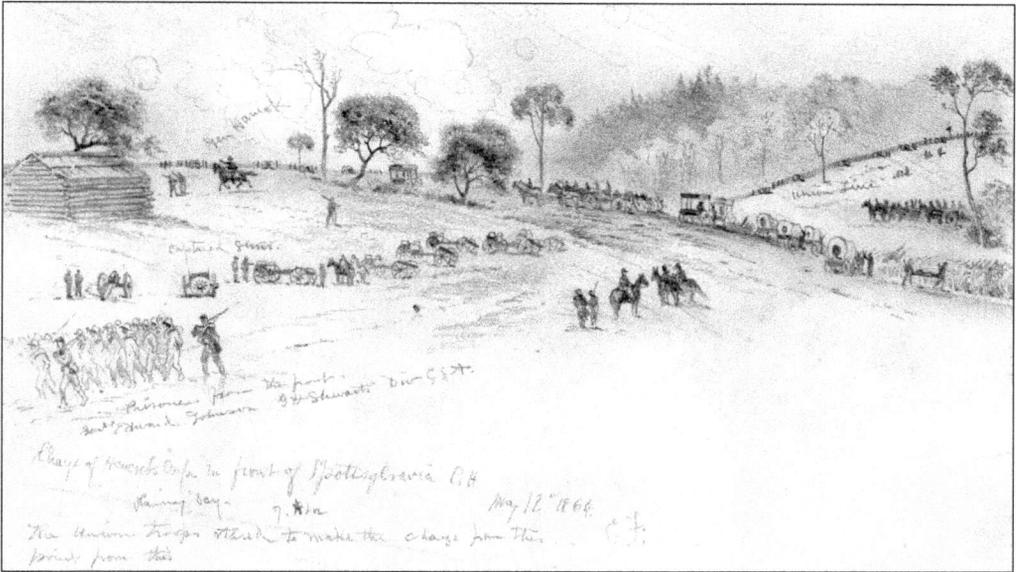

On May 12, 1864, Forbes was on the Brown Farm to document the Union advance upon the Muleshoe Salient. In the early morning hours, through fog and rain, a 20,000-man assault hit the Confederate works, gripping a wooded edge of the Landram Farm. Forbes shows troops advancing toward the smoke-filled horizon while captured Confederates (left) are being led off. Captured artillery (center) has also been collected. (Courtesy of LC.)

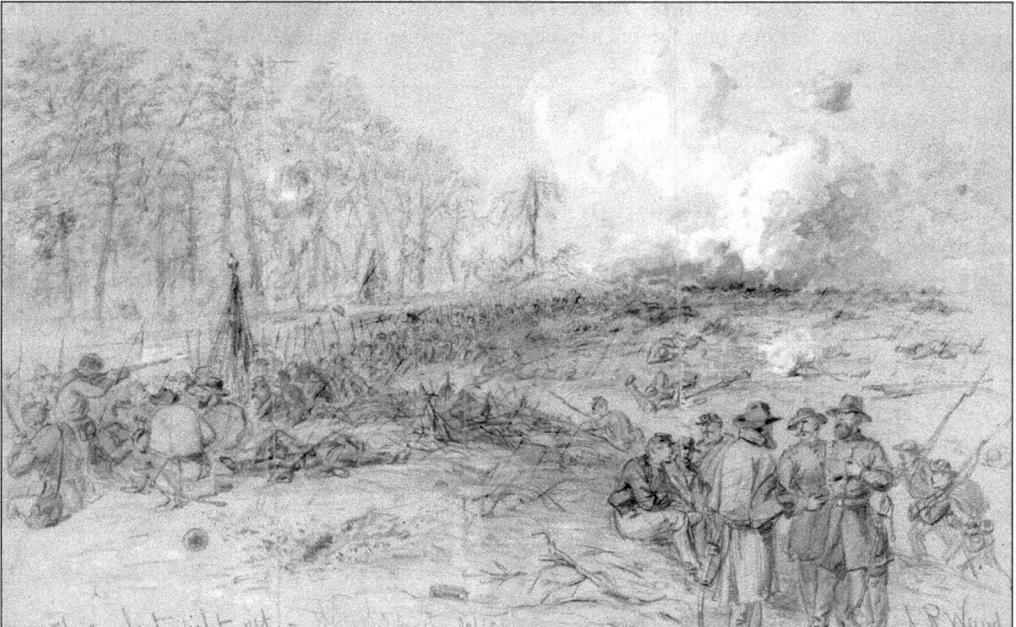

Alfred Waud was on hand at the Landram Farm to depict the struggle along what is known as the Bloody Angle. For 20 hours, two armies fought slammed up against opposite sides of the earthworks. At dawn the next day, the Union men realized the Confederates had gradually withdrawn to a new position a mile away. They also discovered the water-filled ditch that was, in some places, piled four bodies thick with the dead. (Courtesy of LC.)

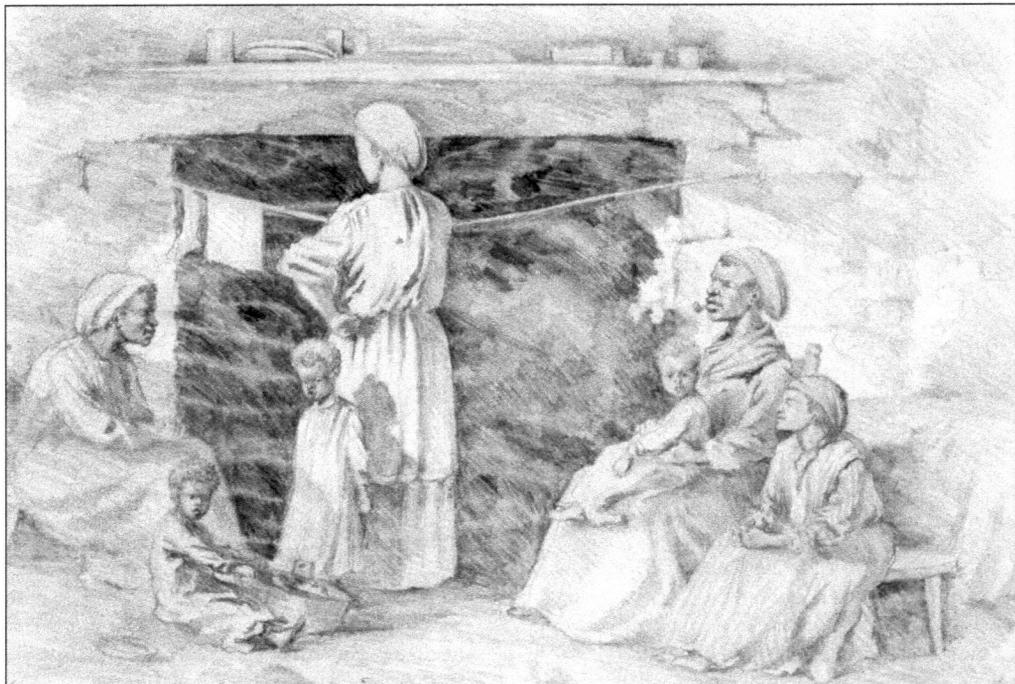

On May 14, 1864, Edwin Forbes came upon a slave cabin somewhere in the vicinity of Spotsylvania Courthouse. He depicted its three women and four children occupants gathered around the hearth. A faint notation along the bottom edge of the paper might suggest the woman at center was named Mary. (Courtesy of LC.)

This photograph, taken near City Point, Virginia, on the Appomattox River, illustrates the most frequently assigned duty of the thousands of former slaves and freemen that volunteered their services to the Union army. In the eastern theater of the war, African American regiments were relegated to guarding baggage trains and supply lines behind the fighting. May 14, 1864, would be the day this changed. (Courtesy of LC.)

Brig. Gen. Edward Ferrero commanded a division of the IX Corps with two brigades of US Colored Troops (USCT). As was typical at that time, the USCTs under his command were guarding a baggage train near the ruins of the Chancellor House on Old Plank Road. About three miles south, along Catharpin Road near the modern-day Ni River Middle School, a Confederate cavalry surprised and routed the 2nd Ohio Cavalry. (Courtesy of LC.)

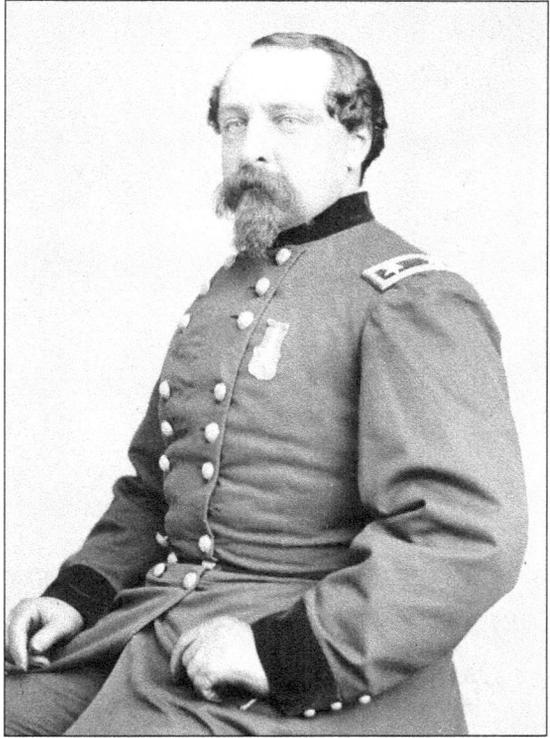

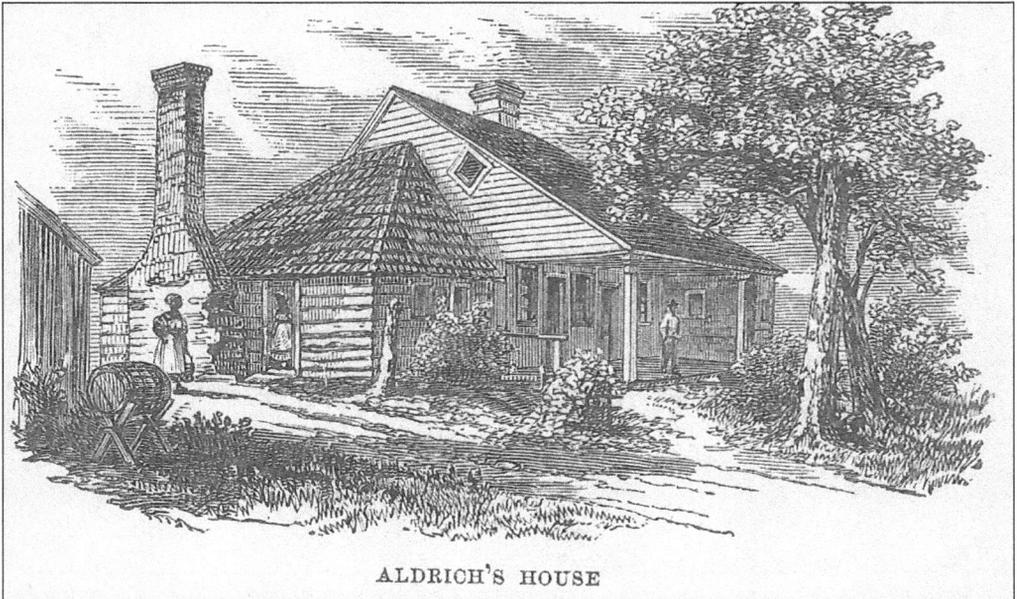

ALDRICH'S HOUSE

While Union forces were being pushed north toward the Old Plank Road, word of the threat reached General Ferrero. He quickly dispatched the 23rd USCTs to make a fast two-mile march to the Alrich Farm at the intersection of Catharpin Road. They successfully challenged and repulsed the Confederate cavalrymen in their very first exchange of shots with the Army of Northern Virginia. (Courtesy of JFC.)

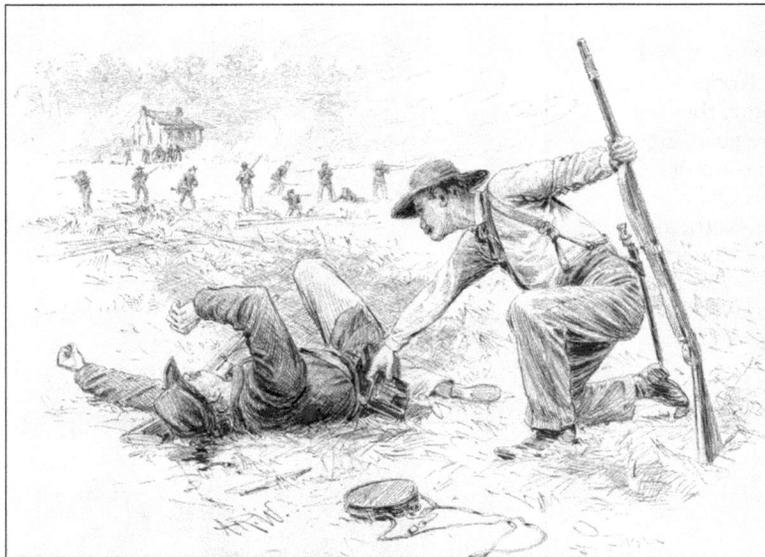

For two weeks, the armies sparred with each other around the Spotsylvania Courthouse area, with dramatic shifts of manpower from one flank to the other and back again over several days of intense, deadlocked trench warfare. (Courtesy of LC.)

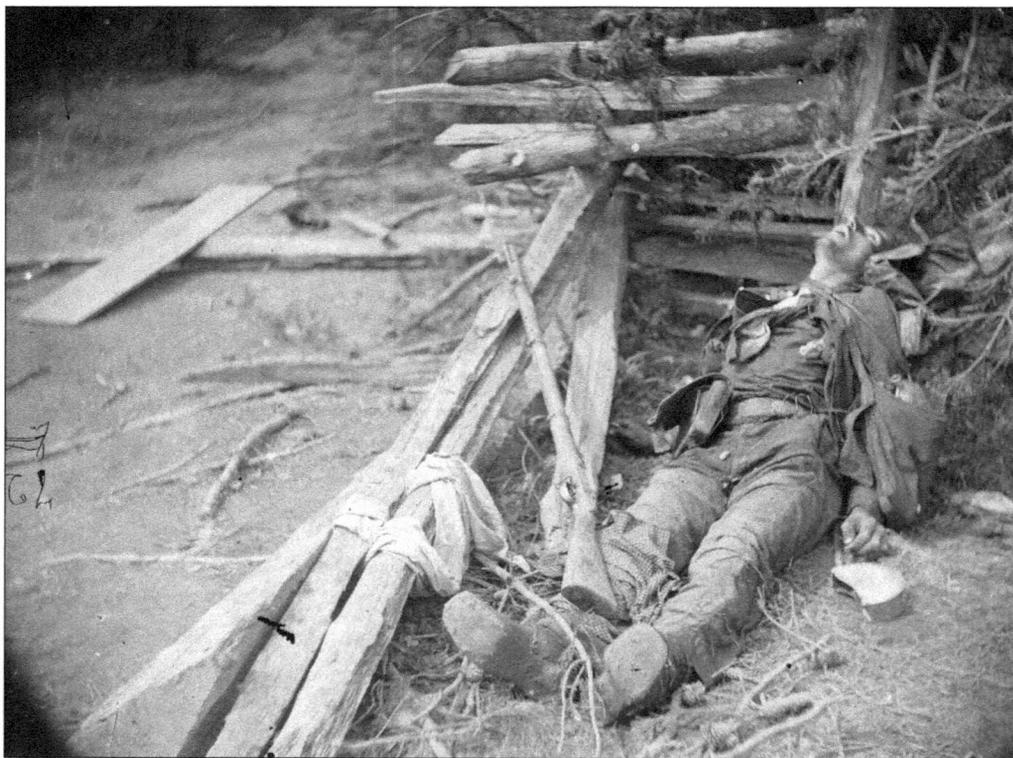

Under Gen. Ulysses S. Grant, the Army of the Potomac fought with an entirely new determination. Before the spring of 1864, the Union forces would typically fight an engagement for a day or two and then withdraw to assess their strength and tend to their wounds before going at it again. This always allowed for lost momentum. With Grant in command, that was not going to happen again. When he would see a stalemate developing, he would take his army and shift the left flank around to his enemy's right, forcing the game closer and closer to Richmond. (Courtesy of LC.)

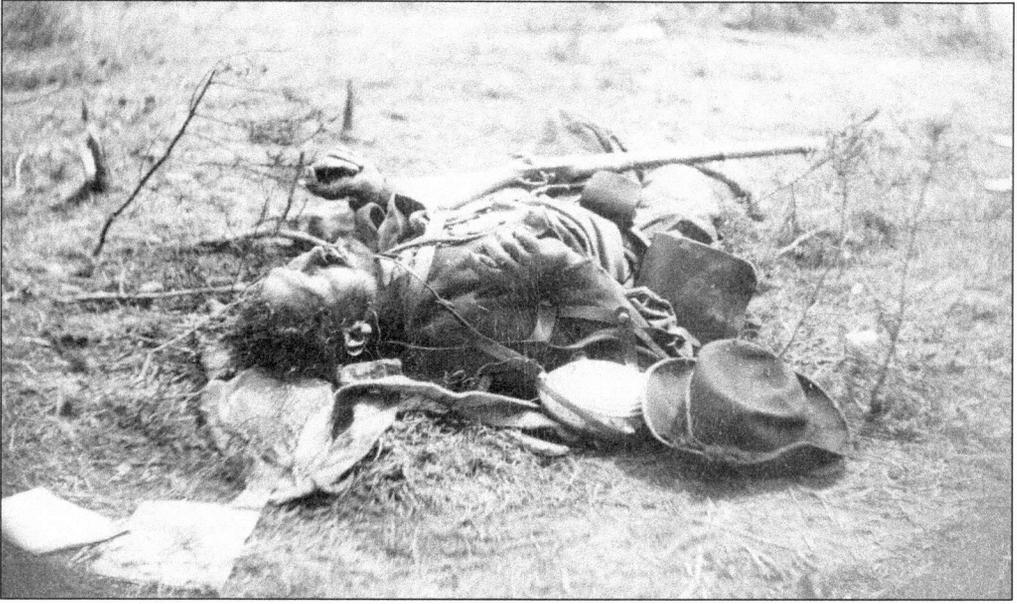

In the evening of May 19, 1864, two divisions of the Confederate II Corps made a reconnaissance move toward the Union right flank, possibly to capture a supply train near Harris Farm. Around 5:00 p.m., detection of the Confederate forces alarmed the Union line. The right flank was heavily manned at this time by five fresh heavy artillery regiments functioning as infantry. This would be the first time in battle for these units, who had spent the early years of the war in the forts defending Washington, DC. In the waning daylight, the "heavies" held their ground, fighting in near perfect parade-ground formation. (Courtesy of LC.)

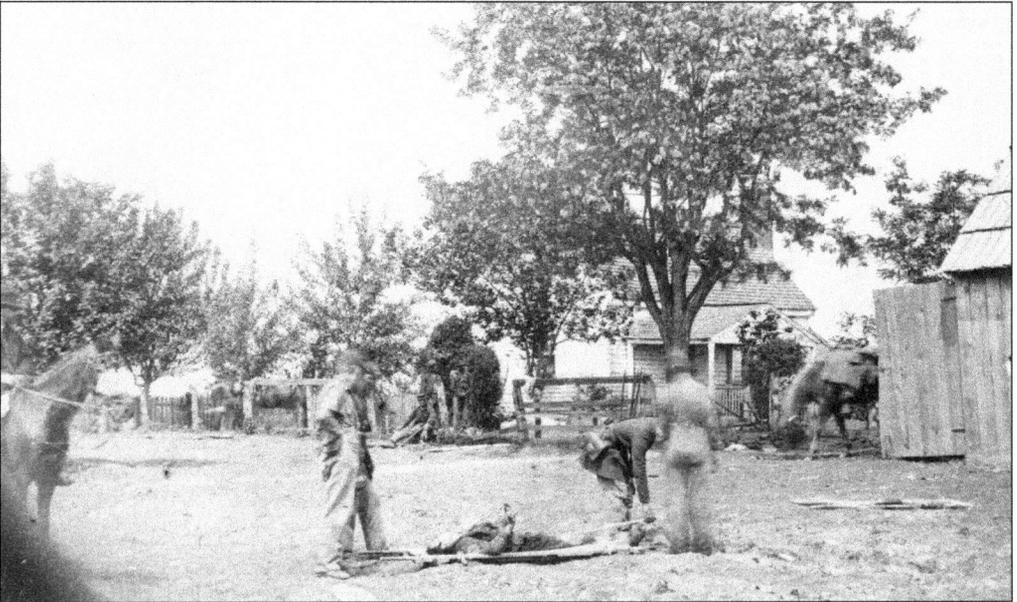

Although it sustained many casualties, the Union line was maintained and sent the Confederates back to their original position. The dead they left behind were buried the next day by Union men, seen here on the Alsop Farm. (Courtesy of LC.)

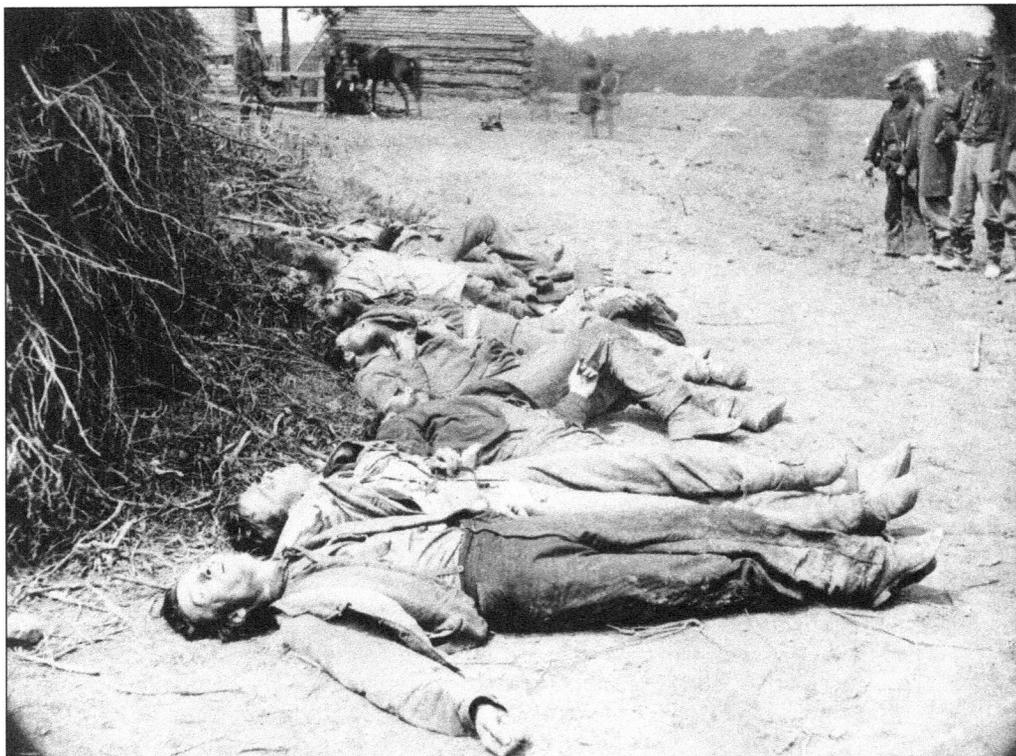

Photographer Timothy O'Sullivan, employed by Alexander Gardner, documented these and the preceding images of the Confederate dead and the Union burial crew gathering them in the midday light of May 20, 1864. (Courtesy of LC.)

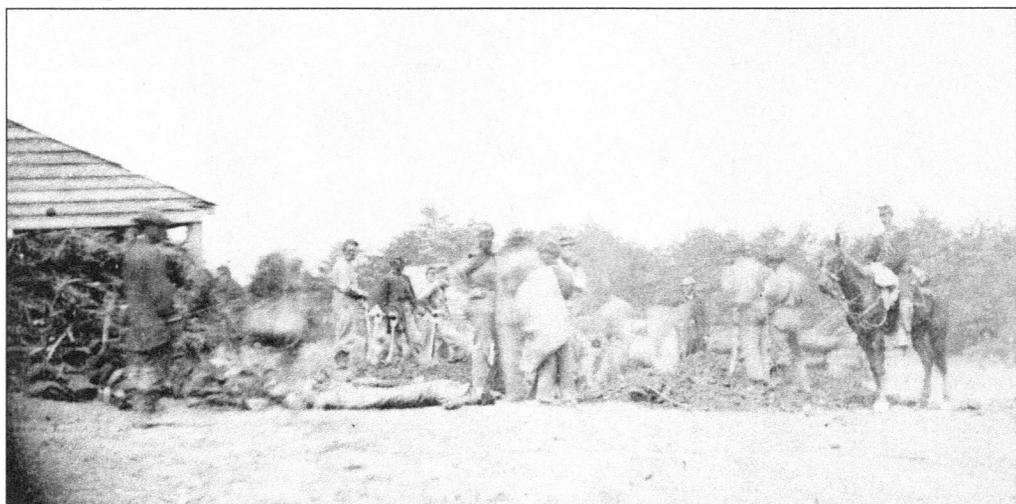

O'Sullivan had noted that the burial crew were members of the 1st Massachusetts Heavy Artillery, very possibly the same men that killed those they were laying to rest. The humble dwelling of Susan Alsop, a young widow whose husband had died before the war, will forever be associated with this bitter contest. Susan and her little son returned to start anew, and in time, the Union and Confederate soldiers buried on their place would be relocated to memorial cemeteries. (Courtesy of LC.)

Three

DESOLATION AND RECOVERY

The collateral damage in the Civil War was inflicted with determination, regretfully perhaps at first, but it was seen as a necessary evil toward breaking the will of a people who adhered in halfhearted desperation to the economic engine they felt was everything to their maintenance as a society. As an abstract concept, slavery both made and destroyed Spotsylvania County. Once that wreckage was cast to the ground, the determined will that fought so hard now focused its strength toward rebuilding a shattered existence.

Traveling through the county in the summer after the war, Northern journalist John Trowbridge noted, "Our route lay through a rough, hilly country, never more than very thinly inhabited, and now scarcely that. About every two miles we passed a poor log house in the woods, or on the edge of overgrown fields . . . sometimes tenantless, but oftener occupied by a pale, poverty-smitten family afflicted with the chills. I do not remember more than two or three framed houses on the road, and they looked scarcely less disconsolate than their neighbors." Arriving at the courthouse, he met the county clerk, who informed him of the hardships being faced. "The county had not one-third the number of horses, nor one-tenth the amount of stock it had before the war. Many families were utterly destitute. They had nothing to live upon until the corn harvest; and many would have nothing then. The government had been feeding as many as 1,500 persons at one time."

There were those, however, who were determined to rebuild their families' shattered lives, demonstrating a strong perseverance even under the most adverse of conditions. One such family was that of George Washington Estes Row, who came home from the war determined to recapture what had been cast asunder. His family home was Greenfield Plantation, an 889-acre estate located inside today's Fawn Lake subdivision on the Wilderness Battlefield. Their story is a paradigm of the local experience.

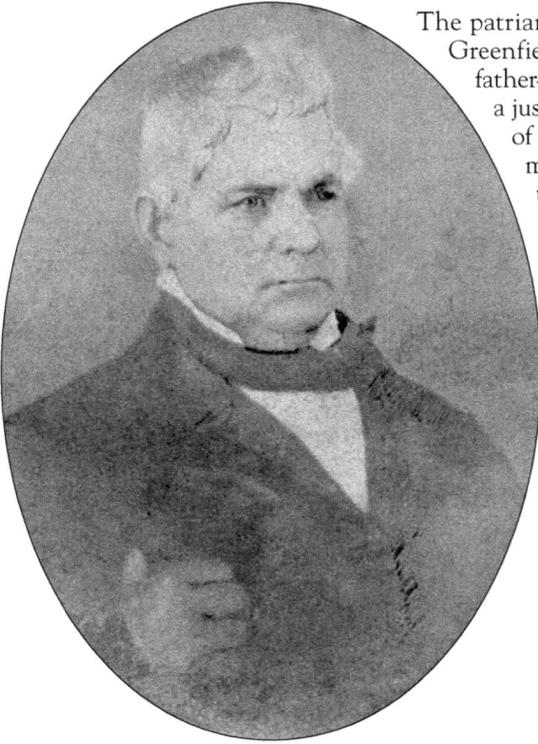

The patriarch Absalom Row, born in 1796, purchased Greenfield Plantation in 1832 from the estate of his father-in-law, Richard Estes. Row served 22 years as a justice of the peace and was an official overseer of the poor. Quite prosperous, he operated a gold mine on his land and supplied material assistance to the nearby White Hall Mining Company. Row died before seeing war devastate his family. (Courtesy of DH.)

Nancy Estes was born 1798 at Greenfield. Upon her husband's death in 1855, she took over the management of the estate through the turbulent years of the Civil War. Upon her death in 1873, the estate passed to her daughter Nannie Row. She had also deeded the lower plantation to her son George Washington Estes Row; he named it Sunshine. Some of the people Greenfield had formerly enslaved were hired on to work for pay after the war. (Courtesy of DH.)

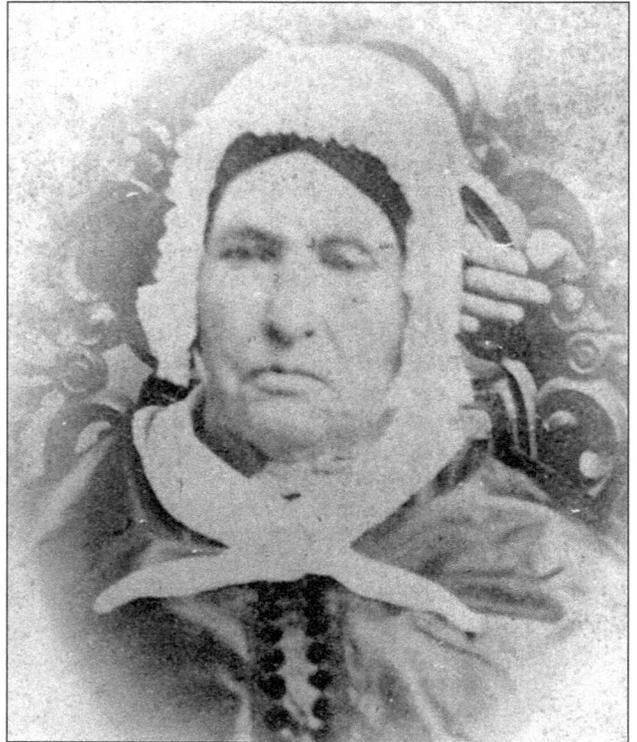

George Washington Estes Row fought in the Civil War at the age of 17, serving with the 9th Virginia Cavalry and later with the 6th Cavalry. After the Battle of Gettysburg, he was promoted to a sergeant but later reduced in rank for having gone AWOL in 1864. Anxiety over the affairs of his family and their safety prompted the absence. At the war's end, he was under Gen. Thomas Rosser's command. (Courtesy of DH.)

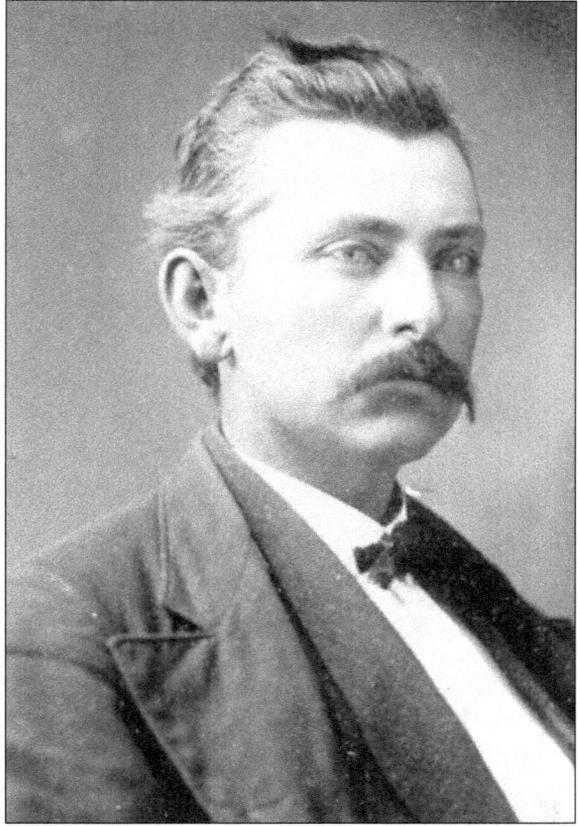

Relaxing on the porch of Greenfield, George Row and his sister Nannie entertain Row's daughter Mabel in this photograph taken around 1882. Mabel became a schoolteacher in the 1900s. Historian Robert Mansfield interviewed Mabel extensively during research for his 1960 monograph on Greenfield. (Courtesy of LD.)

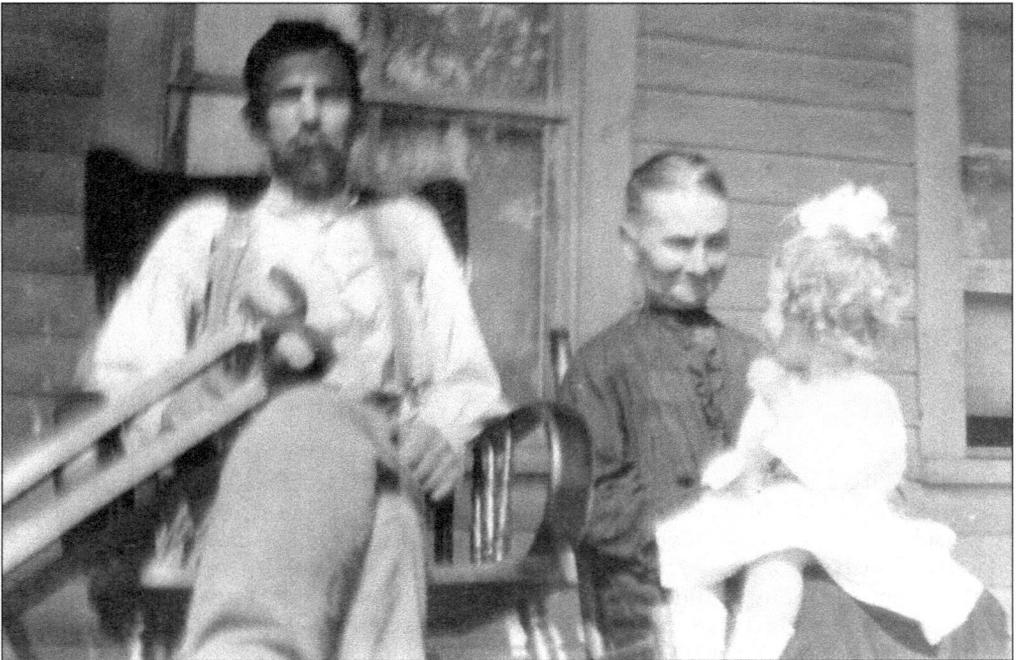

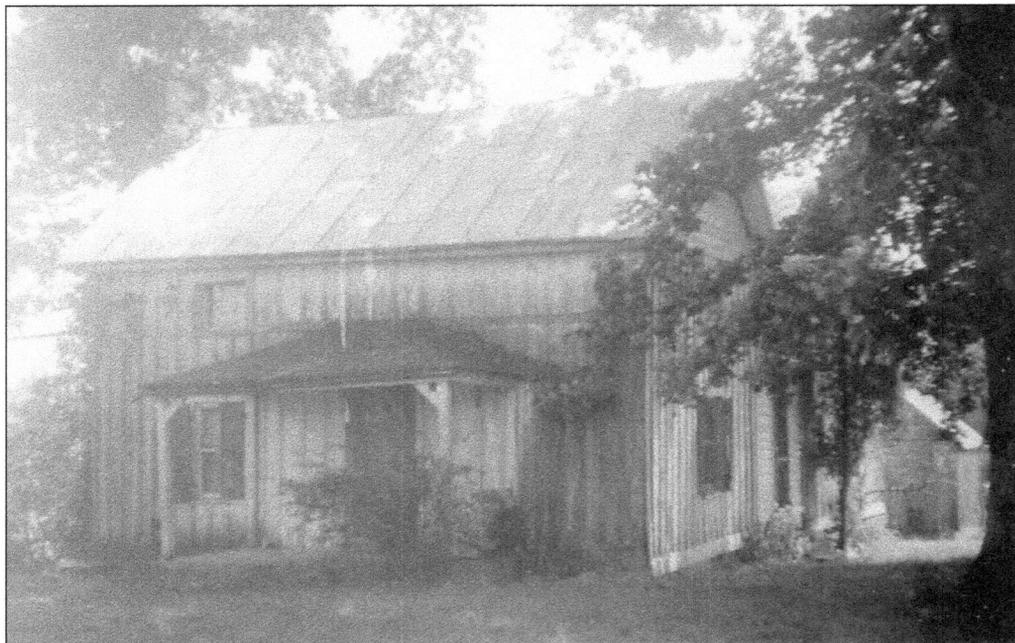

Around 1880, while living with his family at Greenfield, George Row built this house, which he named Sunshine. It was on the site of an older log cabin on the lower plantation section of Greenfield. (Courtesy of DH.)

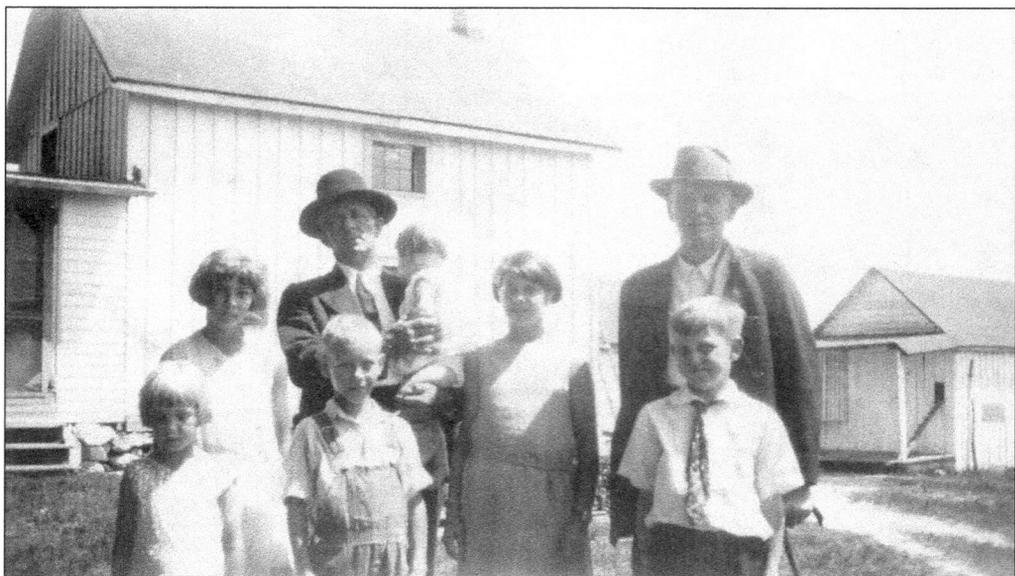

Row's son Horace holds his young daughter Judy. In this photograph from around 1929, he is standing in the side yard of Sunshine. His other children are, from left to right, Nancy, Mary, George, and Margaret. The boy wearing the tie is their cousin Tom Row. His grandfather, Absalom Alpheus "Abbie" Row, is standing behind him. Abbie was Horace's older half-brother; his parents were George Row and his first wife, Annie Daniel Row. Abbie was the last Row to own Greenfield, which he sold to Scott Stephens in 1905. (Courtesy of DH.)

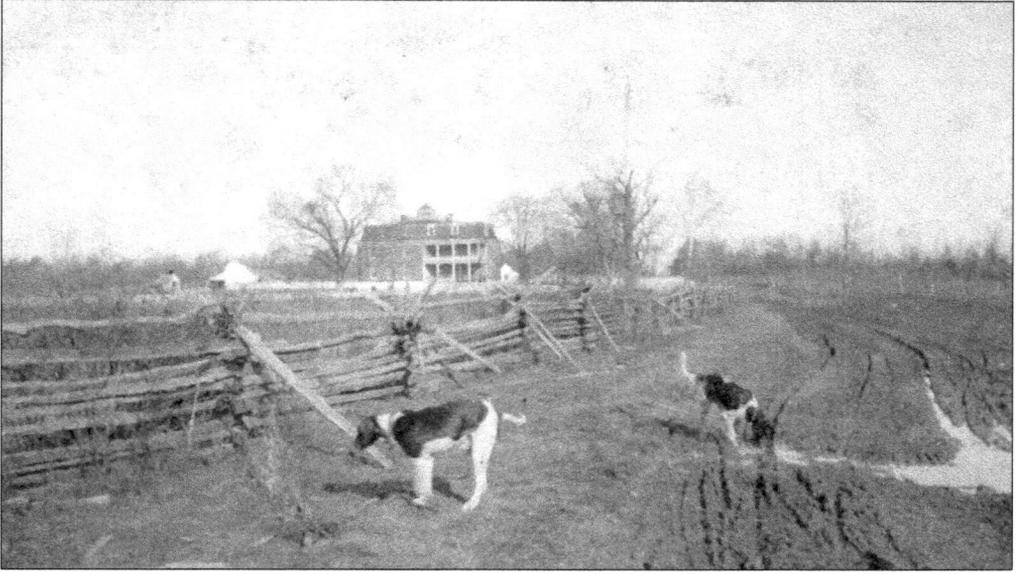

This photograph of the rebuilt Chancellor House was taken in 1900 by John Okie. According to Kathleen Colvin, John and his wife would come down from Pennsylvania to hunt. The hunting dogs in the picture belonged to Kathleen's grandfather Thomas P. Payne. Payne is one of the boxers in the photograph on page 53. (Courtesy of KC.)

Another photograph by John Okie shows the south face of Salem Church. The area around Salem Church, once lush farm fields, has been engulfed by the vast sea of commercial development that began unabated in the late 1970s. Today, it is nearly impossible to imagine the huddled refugees camped here in December 1862 or the armed contest that rolled over the terrain in May 1863. (Courtesy of KC.)

This photograph by John Okie shows the shattered Wilderness Church. The sweeping attack of Gen. Stonewall Jackson's men on May 2, 1863, began in the hills surrounding the church, sending the panicked men of Joseph Hooker fleeing back toward the Chancellorsville intersection. Today, the church is still maintained and attended by a faithful congregation. (Courtesy of KC.)

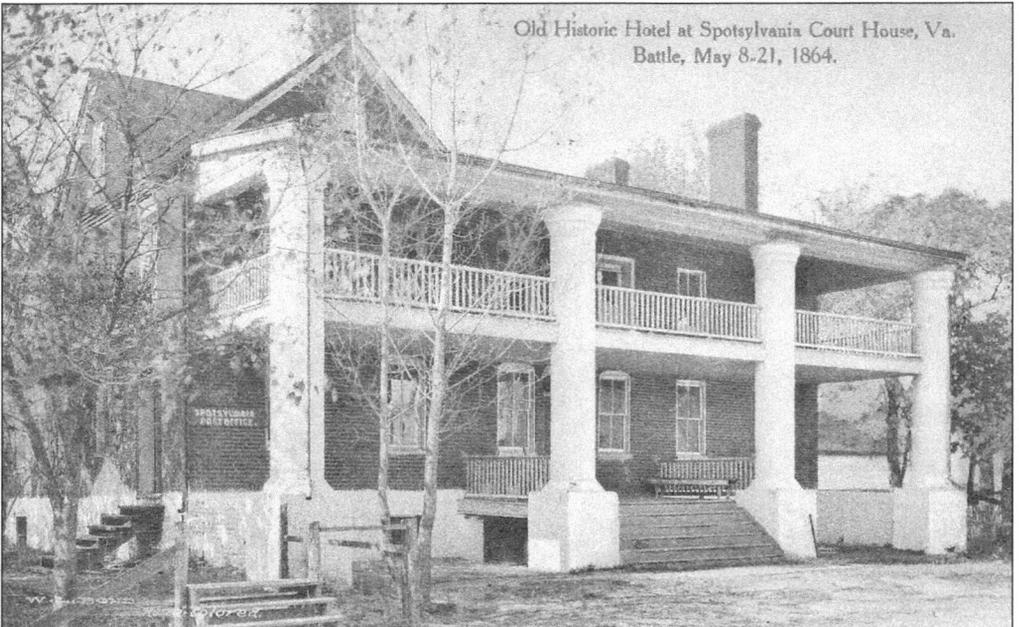

As a visitor approaches the Spotsylvania Courthouse area on Fredericksburg Road, the structure that usually captures their eye first is the old Sanford Hotel, standing directly at the head of the intersection. Because the Sanford Hotel dominates the view, those without prior knowledge of these structures tend to assume the hotel was the old courthouse. (Courtesy of JFC.)

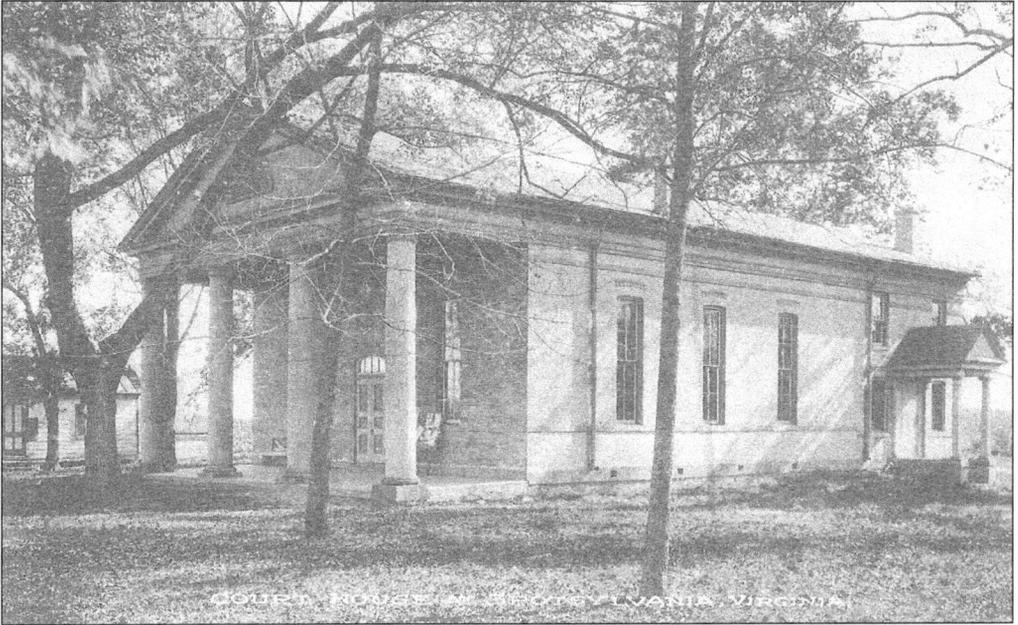

The Spotsylvania Courthouse is seen here soon after a stabilization and modification effort in 1900. Damage sustained during the Civil War had made the structure dangerous, and repair was necessary. (Courtesy of JFC.)

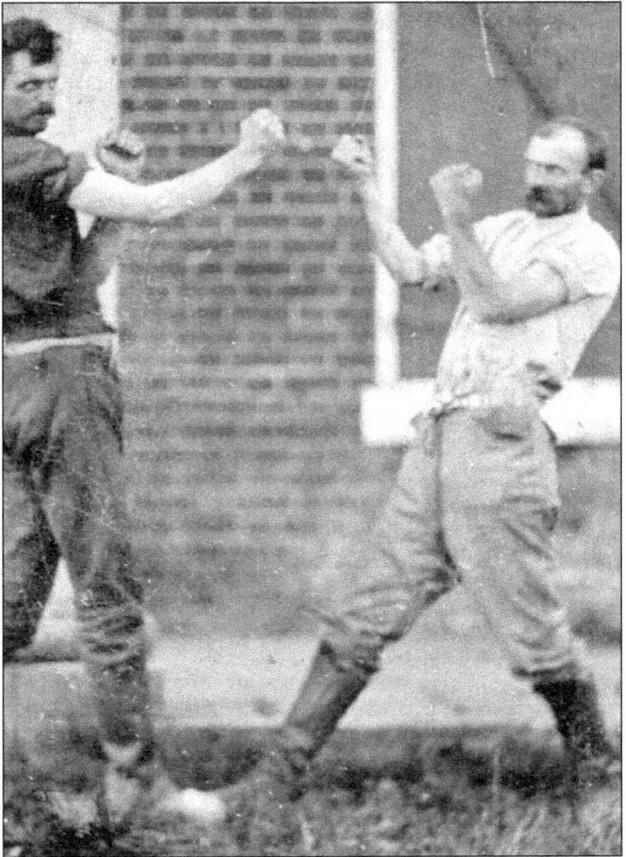

A boxing exhibition on the courthouse lawn was designed as entertainment between court sessions. James Payne (left) and his brother Thomas are seen here squaring off. Thomas Payne was the deputy commissioner of revenue. The matches were always held in good spirits, and no one was ever seriously hurt. (Courtesy of KC.)

Horace Row and his wife, Fannie, pose with daughters Margaret (left) and Mary for this photograph, taken in 1921 at Parker's Store. The Potomac, Fredericksburg & Piedmont Railroad (PF&P) stopped at Parker's Store. The PF&P, known mockingly as the "Poor Folks & Preachers" line, can be seen running at the left of the photograph. Never able to operate profitably, it was abandoned in 1938. (Courtesy of DH.)

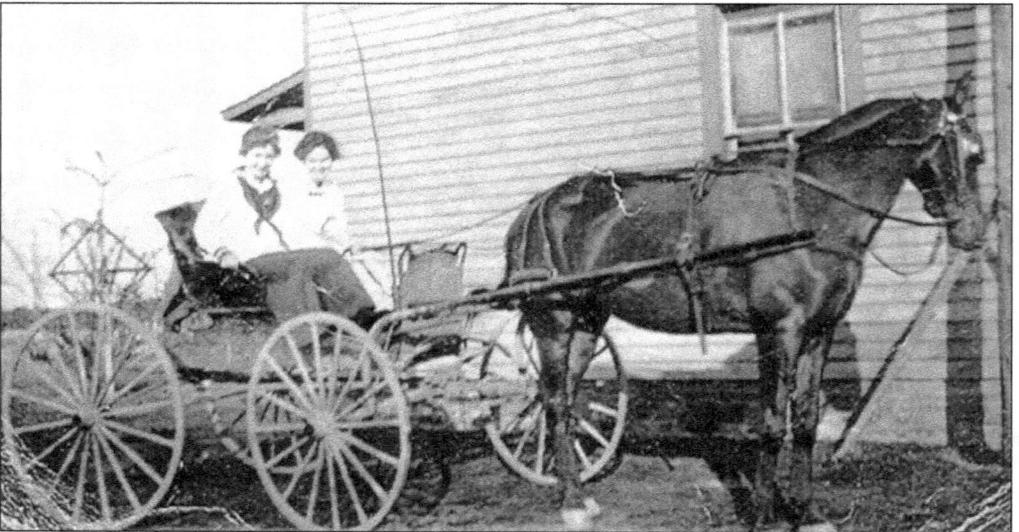

Cora and Lottie Kent are pictured here in a horse-drawn buggy outside the house of Parmenas Pritchett. Cora and Lottie were sisters of Horace Row's wife, Fannie Kent. (Courtesy of DH.)

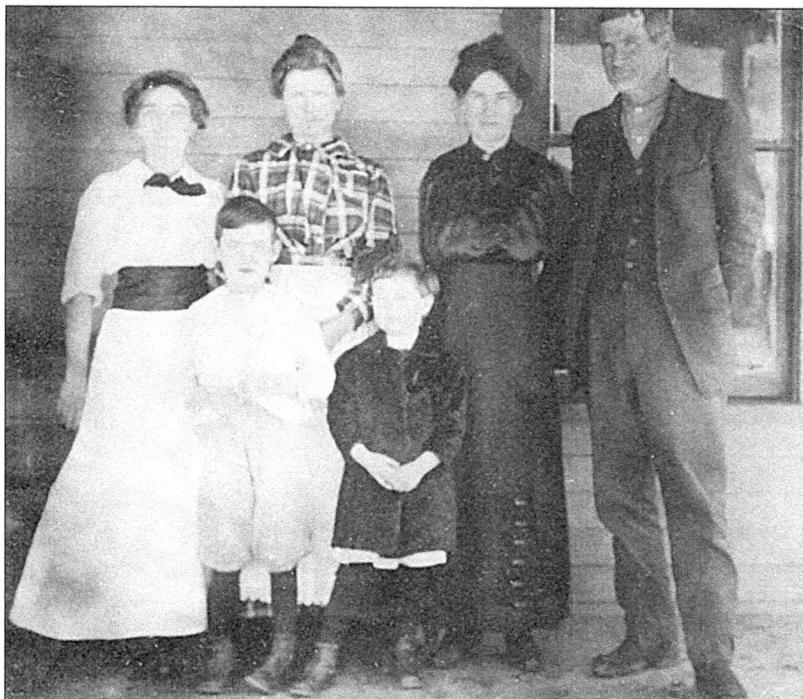

Fannie Kent Row, at far left, is pictured with the Larkin Pritchett family. Her sister Cora is standing next to Larkin. (Courtesy of EP.)

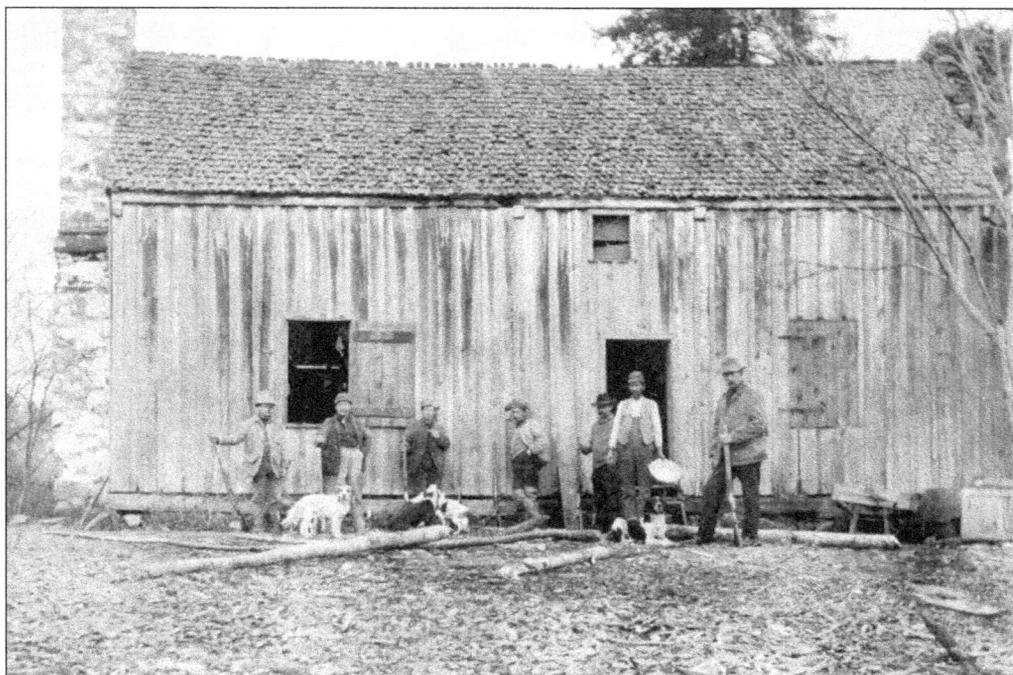

A man identified as Sheriff Hicks (far right) poses with a hunting party in this photograph from 1880. In all probability, the sheriff is Thomas S. Hicks, a constable elected in a special election held on July 18, 1865, to establish new county officials after the Civil War had disrupted the community so roundly. (Courtesy of KC.)

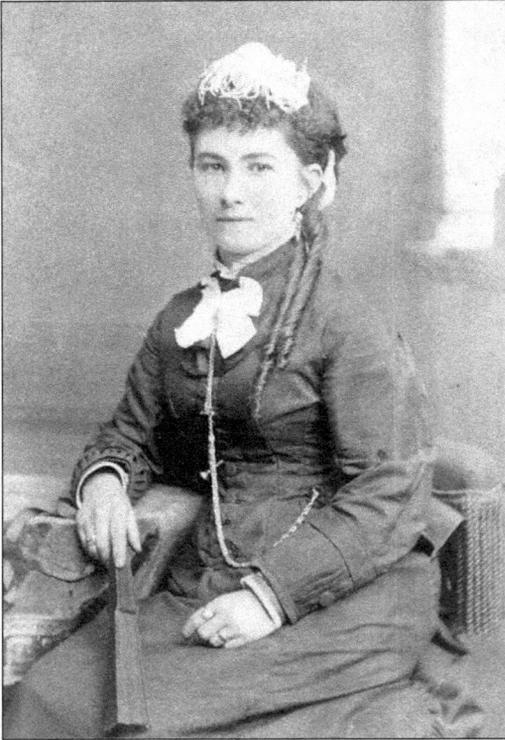

Emily Charlotte "Lottie" Conley was born in Manchester, Virginia, on December 23, 1854. This photograph was taken in Richmond in 1877. Lottie Conley married William Franklin Kent of Spotsylvania on December 5, 1878. Their children were Fannie, Cora, Ellis, and Charlotte Mae. (Courtesy of EP.)

A tiny woman, Lottie Conley Kent stands in front of the corncrib of her homestead, the Oaks, in this photograph taken during the 1920s. She died October 11, 1928. Lottie and her husband, William, are buried in unmarked graves in the Hicks Cemetery. They were the aunt and uncle of William Lee Kent, who is pictured on page 59. (Courtesy of KC.)

After the death of his first wife, George Row married Lizzie Houston, who was 11 years his junior, on December 14, 1875. This portrait was taken that year. They lived at Sunshine and had four children together; one died in infancy. Horace, their last child, was born in July 1882. George Row died intestate in April 1883, leaving Lizzie in an uncertain financial condition with no one to help her manage the family farm. (Courtesy of DH.)

This may be Lizzie Row's mourning portrait. She hired out neighbors to assist on the farm and maintained the property for another 16 years, opting not to auction off the estate. On June 3, 1899, her mother died, and nine days later, her oldest son, Houston, died at age 22. Eventually, her youngest son, Horace, took over as head of the house. Despite continued hardships, she lived until January 2, 1928, dying of a heart attack at age 73. (Courtesy of DH.)

Horace Row poses with daughter Judy at Sunshine about 1931. Horace was born at Sunshine in 1882 to George and Lizzie Row. After the death of his older brother Houston in 1899, Horace assumed responsibility for the operation of Sunshine. Horace married Fannie Kent in 1917. He contributed acreage for the creation of Jackson Trail, part of the Fredericksburg and Spotsylvania National Military Park (F&SNMP). He received a letter from Branch Spalding, the park superintendent, thanking him for his generosity. In October 1939, Horace died of a heart attack in a Sperryville orchard while picking apples with his son George. (Courtesy of AH.)

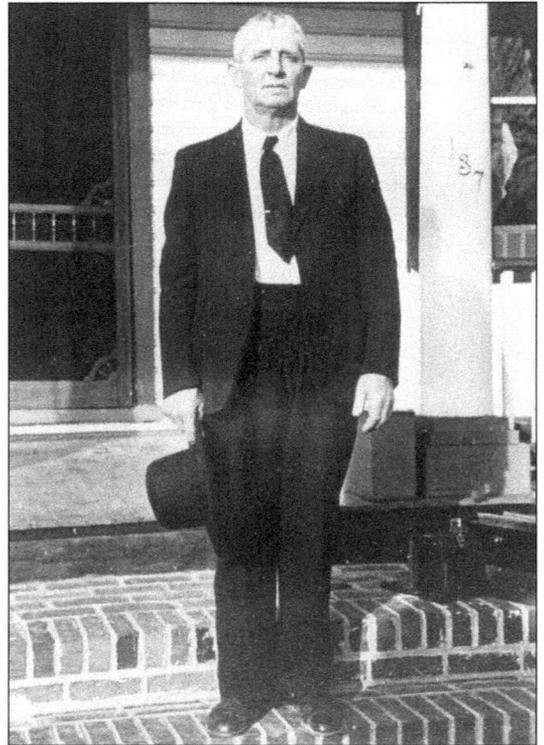

This photograph was taken at the Alexandria house of Horace Row's nephew Abbie Rowe. Abbie Row went on to serve as the official White House photographer for the terms of Pres. Franklin Roosevelt through Pres. Lyndon Johnson. (Courtesy of DH.)

William "Willie" Lee Kent (1862–1949) was the son of John Wesley Kent, who fought in the Confederate infantry and returned home physically broken and emotionally shattered after Appomattox. John Kent died on January 1, 1867. (Courtesy of KC.)

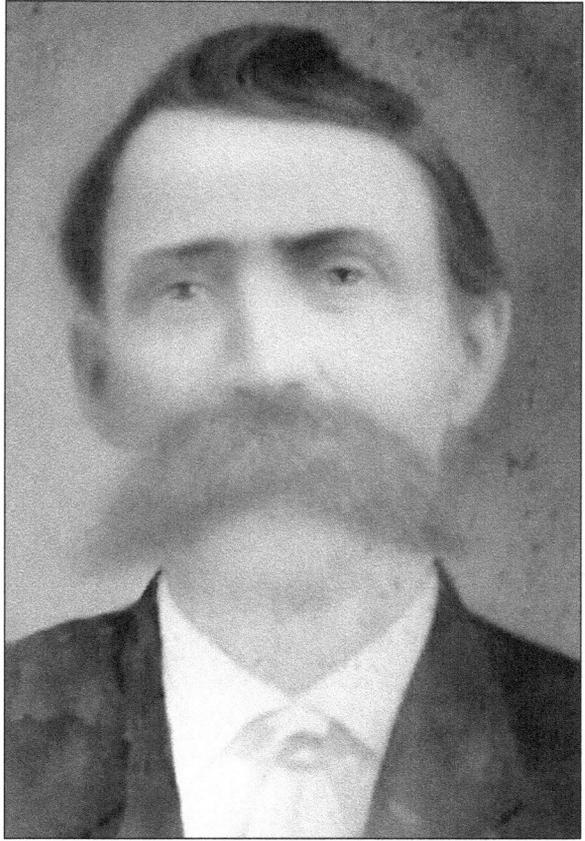

William "Willie" Lee Kent was the grandson of Warner and Susan Kent, who had moved to Spotsylvania from Fluvanna County. Kent was distinguished in the region for his impressive mustache. In this photograph from a family reunion 1941, he is in the white shirt (left center) with his mustache still prominent. (Courtesy of KC.)

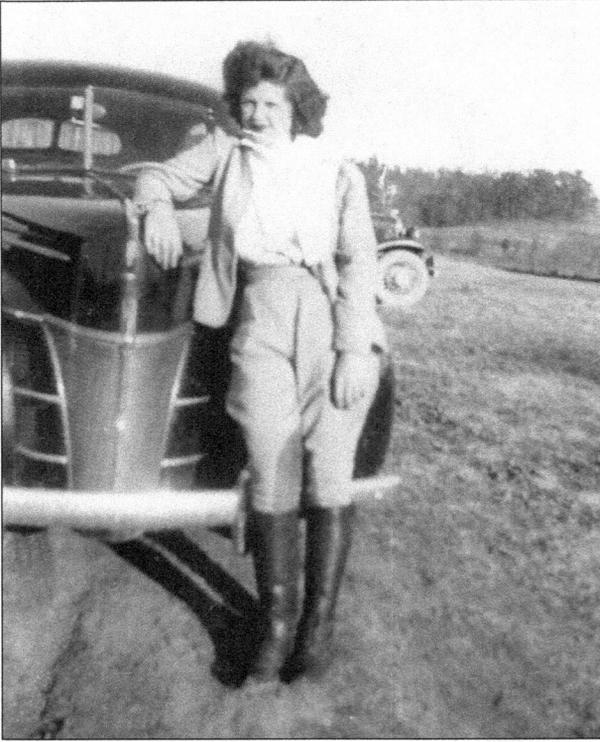

Urla Baker, born in 1924, married George Row in 1945. When this picture was taken, Urla's great passion was riding horses. George had inherited Sunshine after the death of his father, Horace, in 1939. It passed to Urla when George died in 1996. In 2007, Urla got a conservancy easement from the Virginia Outdoors Foundation, restricting the use of the land in perpetuity. (Courtesy of UR.)

When Sylvania, the world's largest cellophane plant at the time, opened on May 21, 1930, it was the economic savior of Spotsylvania during the Great Depression. The factory became the Fredericksburg region's biggest employer. This January 1953 issue of *Avisco News*, the mother company's newsletter, features two of the plant's oldest employees, Alvin E. Payne (left) and Clifton O'Bryhim. Payne, a foreman electrical engineer, was the oldest by length of service when he retired in 1963. (Courtesy of JFC.)

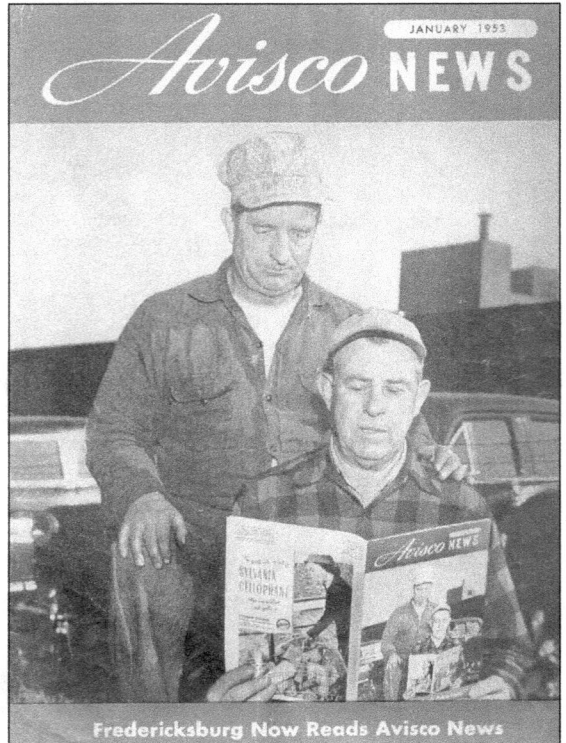

JANUARY 1953

Avisco NEWS

Fredericksburg Now Reads Avisco News

Four

A LANDSCAPE MEMORIALIZED

Spotsylvania was not a place of the mythical South, moonlight, and magnolia. In 1865, homes mostly of modest vernacular construction typified the small farms that made up the battlefield landscape of Spotsylvania. Yeoman farmers owned or rented the humble farmhouses. Only a few buildings, primarily in the immediate courthouse area, were made of more substantial brick construction. Certainly very little existed that could have compared to the grandeur of Georgia plantation homes, even if half the prewar population of Spotsylvania County was indeed enslaved. Closer to Fredericksburg, the landed gentry could be said to have presented something a bit more akin to sumptuousness, but even it was more reserved.

Nonetheless, when the bitter contest of Civil War resided on these bucolic fields, pastures, and woodlands, it shook even the humblest of abodes, leaving a profound distress and a cold pallor of desolation that could not renew a rosy-cheeked hue for many years.

Spotsylvanians, who in a great number of cases would have not consented to disunion, certainly had nothing to celebrate or embrace in the first 25 years after the Civil War, when a place like Gettysburg was fast becoming a shrine. Spotsylvanians sought a return to the understated prosperity that made Central Virginia what it was, nothing akin to the opulence of the James River descendants of the original Colonial Hundreds. Here in Spotsylvania was a longing for an honest dollar and for an honest day's work. The value of the land had plummeted, and it would stay dirt-cheap for generations. Many families sold out to speculators and left this place behind, for it was so full of pain.

So among the subsistence farms of the new ways, gradually, a request would come for an easement to place a monument—one here and one there. And as the automobile changed the travel practices of all Americans over time, there would be a desire to visit these fields of battle with an increasing reverence. In 1927, the federal government returned, this time to buy up parcels to memorialize the deeds of valor of both Blue and Gray. Thus the National Park Service would become a neighbor to Spotsylvanians.

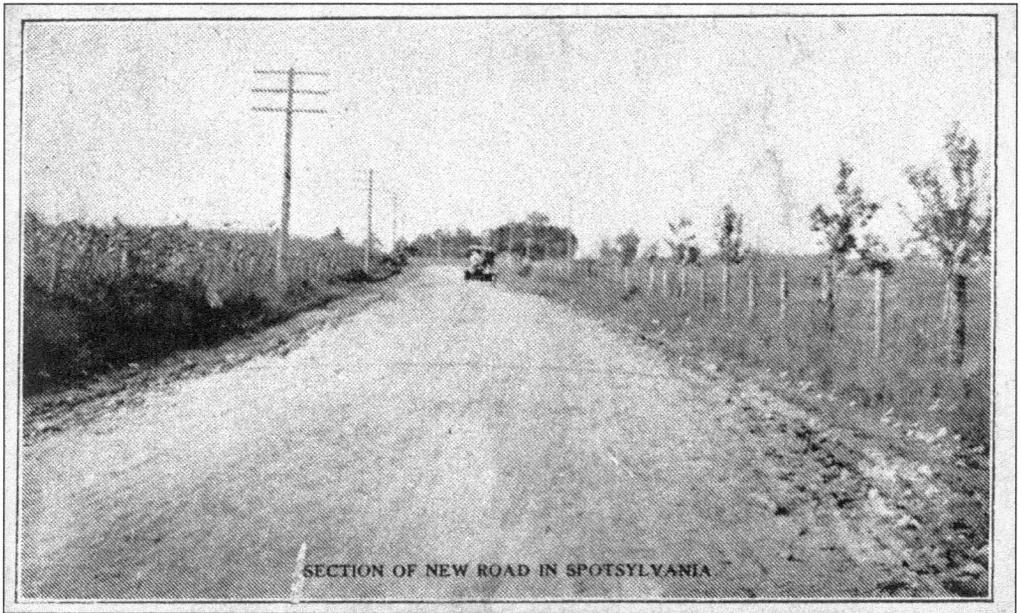

This postcard by publisher Robert Kishpaugh from 1910 is entitled "Section of New Road in Spotsylvania." What were once rolling roads for the transportation of hogsheads full of tobacco and then plank roads to facilitate a less restricted journey when rain would turn dirt roads to quagmires would, in the summer of 1910, become improved gravel roads, thoroughly compacted by a 10-ton roller and graded to promote runoff. (Courtesy of JFC.)

This postcard by publisher Robert Kishpaugh is entitled "Good Roads Near Fredericksburg." On June 4, 1910, the contract to improve the road from three miles outside Fredericksburg to the courthouse was awarded to R.G. Lassiter. After years of requests for better roads and debate among the Spotsylvania County Board of Supervisors about how to pay for them, 30 miles of new and improved roads would be completed in 1910. (Courtesy of JFC.)

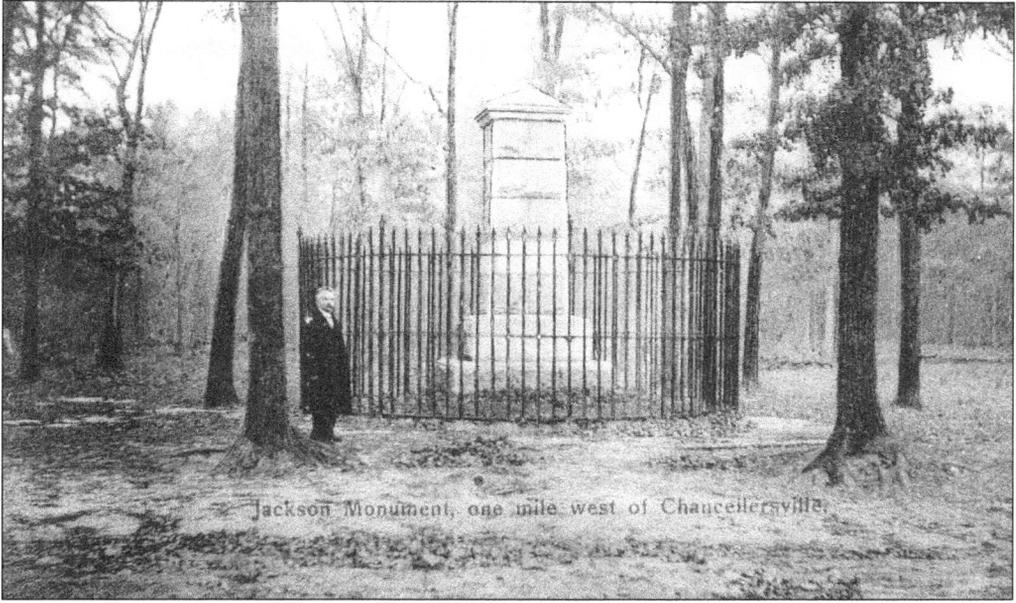

This monument, dedicated June 13, 1888, marks the approximate location of Confederate general Stonewall Jackson's wounding on the evening of May 2, 1863. The monument was preceded, perhaps by only a matter of years, by a simple quartz stone moved to the spot by local residents. Both monument and stone stand vigilant today along the heavily traveled Route 3, a divided highway. (Courtesy of JFC.)

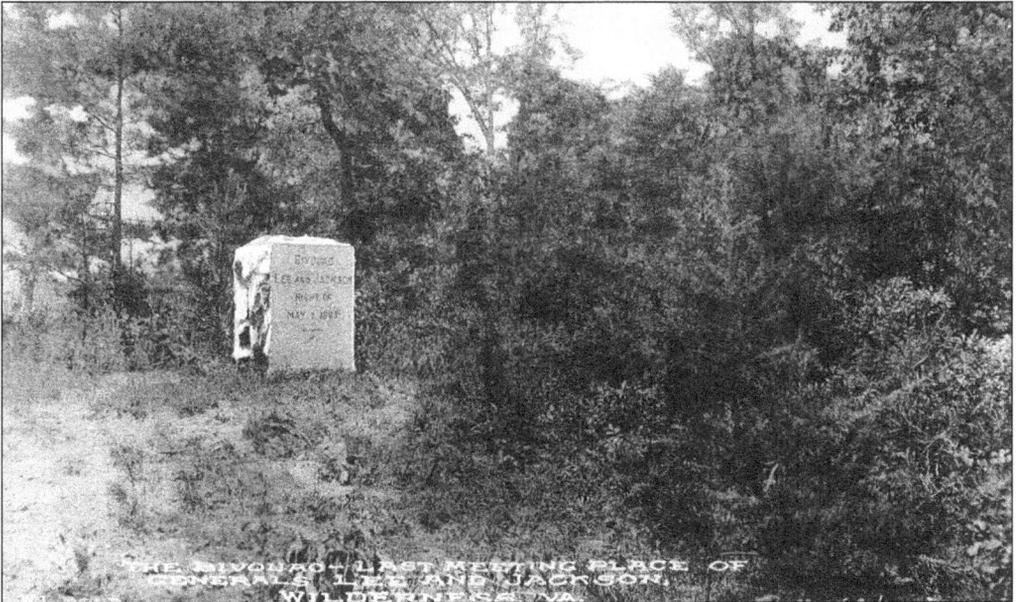

This simple stone was placed in 1903 by James Power Smith, a former member of Jackson's staff. It marks the spot where Generals Lee and Jackson are said to have held their final conference late into the evening of May 1, 1863. Here, at the intersection of Old Plank and Furnace Roads, they devised the plan to make a daring countermarch across the Union front and stealthily hit their unprepared right flank. (Courtesy of JFC.)

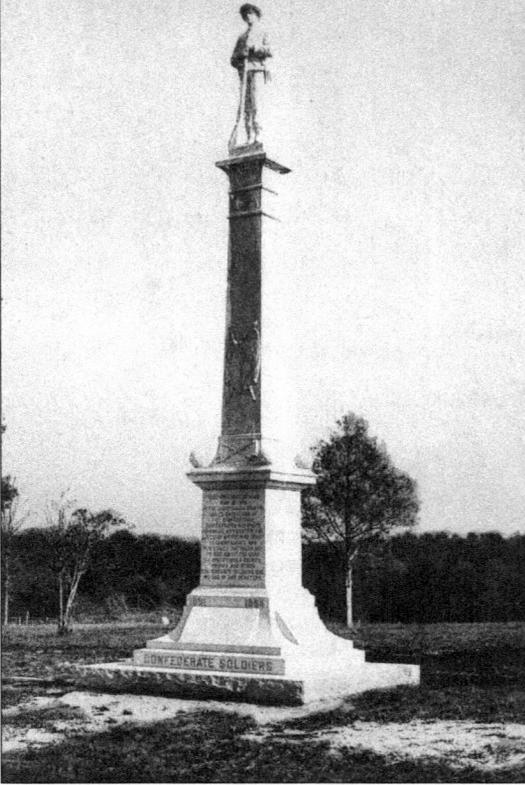

Monument to Confederate Dead at Spotsylvania Court House, near Fredericksburg, Va.

This traditional monument to the memory of fallen Confederates killed at Spotsylvania was erected on May 12, 1918, with funds raised by the Ladies Memorial Association. The Confederate cemetery where it stands was established in 1866 on five acres of land donated by Joseph Sanford. Nearly 600 soldiers are buried there; most are unidentified. (Courtesy of JFC.)

On October 9, 1902, the second Union monument to be erected on the Spotsylvania Battlefield was placed directly in front of the coveted Bloody Angle. It memorialized the 49th New York Infantry. Being first to dedicate a monument on a field has its advantages. It allowed the 49th to take center stage approximately 100 yards further east than the position it held during the fighting of May 12, 1864. (Courtesy of JFC.)

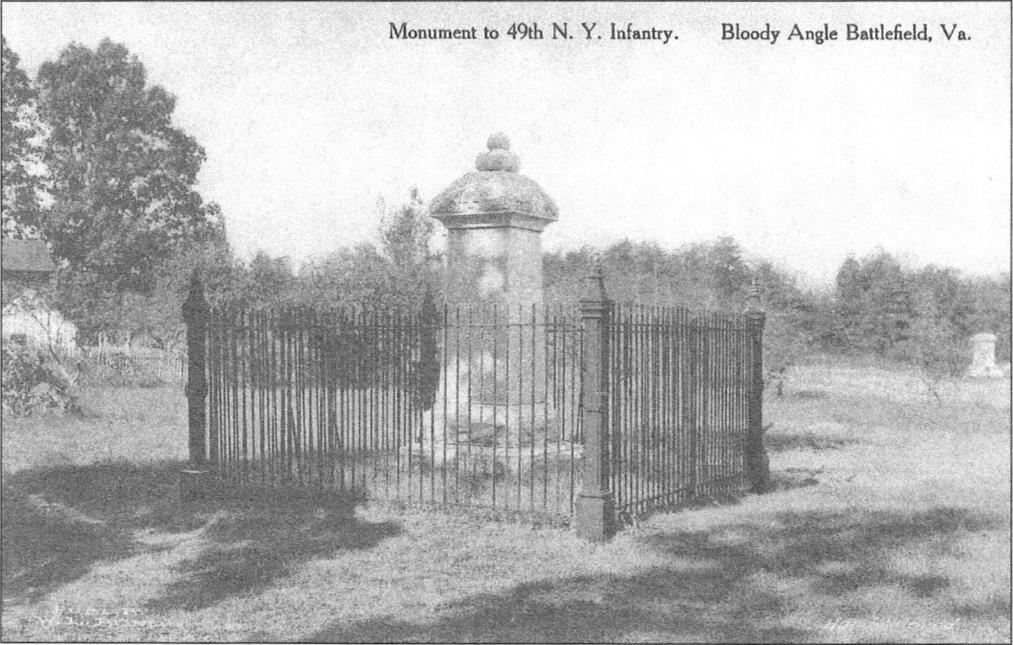

Monument to 49th N. Y. Infantry. Bloody Angle Battlefield, Va.

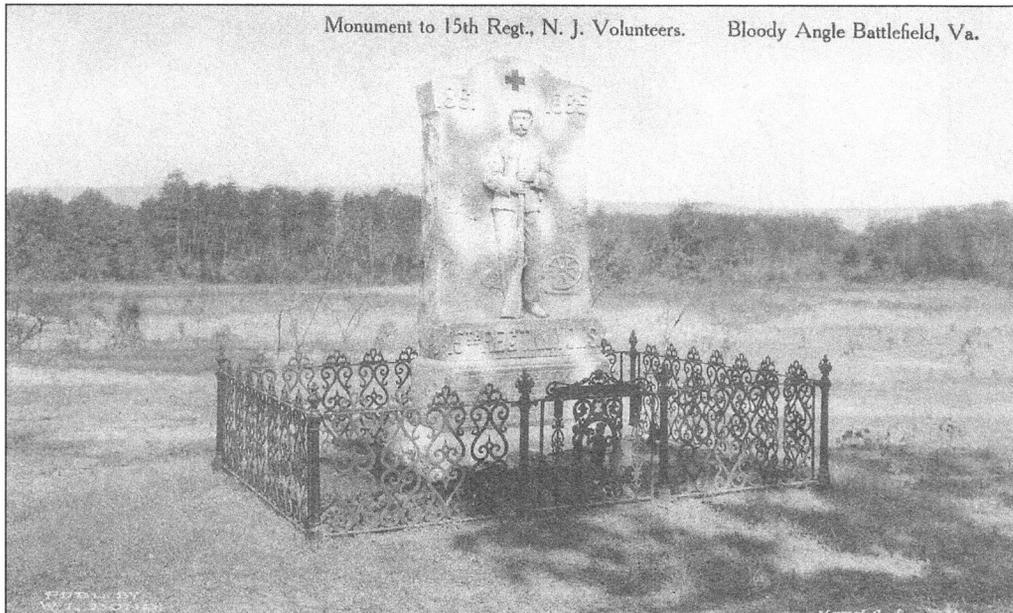

Monument to 15th Regt., N. J. Volunteers. Bloody Angle Battlefield, Va.

Nearly seven years after the New Yorkers made their mark, the 15th New Jersey Infantry dedicated its monument on May 12, 1909, the 45th anniversary of the battle. The absence of a mad rush by other regiments to mark their positions worked in favor of the New Jersey troops, too, allowing them to take hold just to the right of their battle mates. Likewise, they had made their contribution 100 yards or more away. (Courtesy of JFC.)

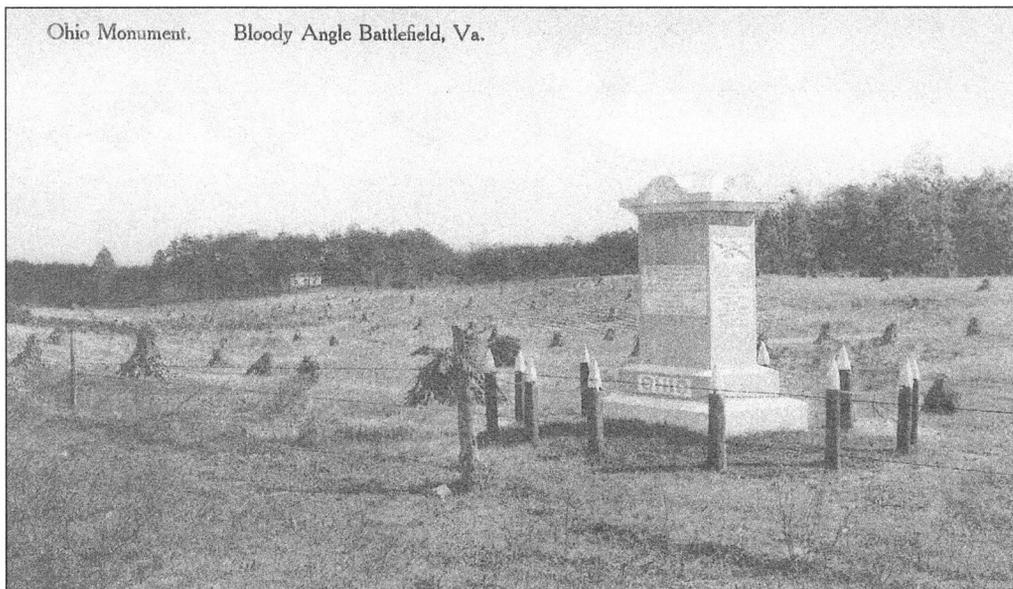

Ohio Monument. Bloody Angle Battlefield, Va.

On May 15, 1914, the veterans of the 126th Ohio Infantry erected their monument more accurately on the ground they held about 100 yards away from the Bloody Angle. From here, they were unable to press any further forward before running out of ammunition. Until the establishment of the park in 1927 and further acquisition of land, the Ohio monument sat as an island in the middle of the Landram Farm fields. (Courtesy of JFC.)

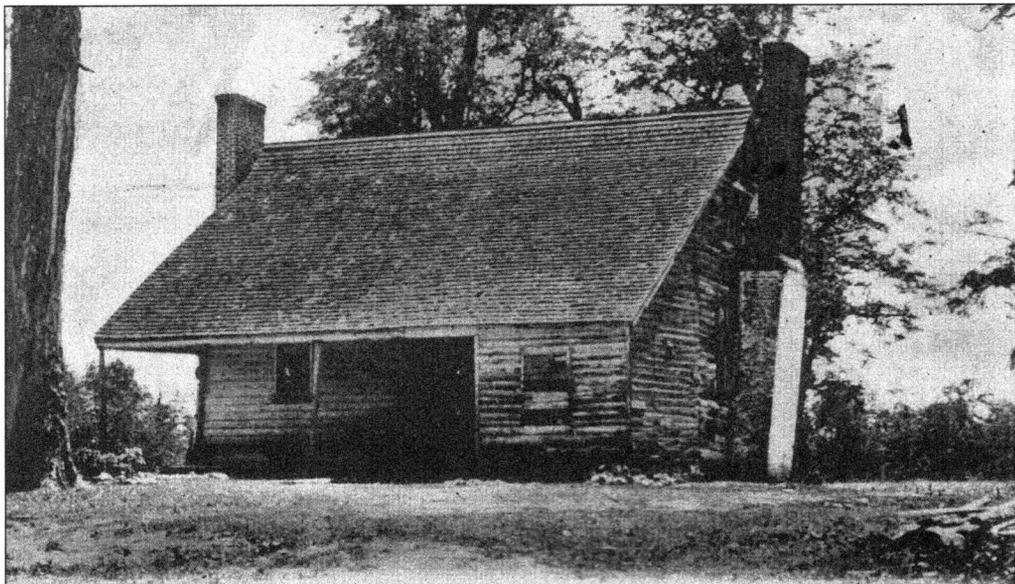

McCOOL HOUSE, EDGE OF BLOODY ANGLE BATTLEFIELD.

The home of Neil McCoull stood at the epicenter of the Confederate defensive position for five days until they fell back in the early morning hours of May 13, 1864, to a new line. In 1900, the chimney at the right fell away from the house and was replaced by a stovepipe venting from the roof. On July 17, 1921, the home caught fire from that vent and was completely consumed. (Courtesy of JFC.)

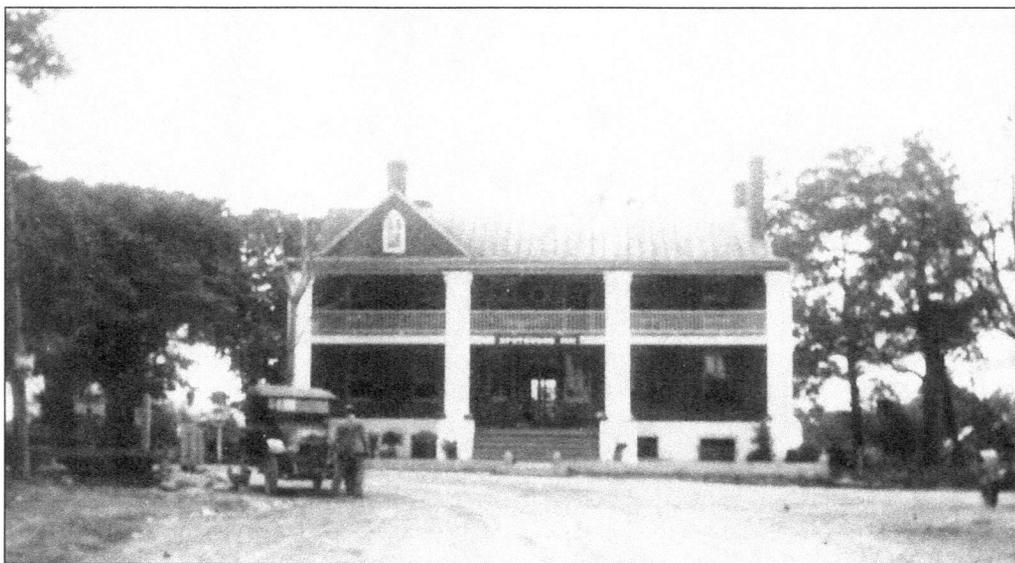

This is the Old Hotel, or Sanford's Tavern, at the intersection of the Courthouse and Brock Roads as it appeared in 1921. The balcony-like porch on the second floor did not exist at the time of the Civil War and was removed in the latter part of the 20th century. (Courtesy of JFC.)

The Zion Methodist Episcopal Church was built in 1859 as the nation inched closer to crisis. In May 1864, the building would become a temporary headquarters for Confederate general A.P. Hill, who was temporarily relieved of the command of the II Corps due to illness. He would confer with Gen. Robert E. Lee on May 14. The church suffered appreciable damage inside and out during the war. (Courtesy of SCG.)

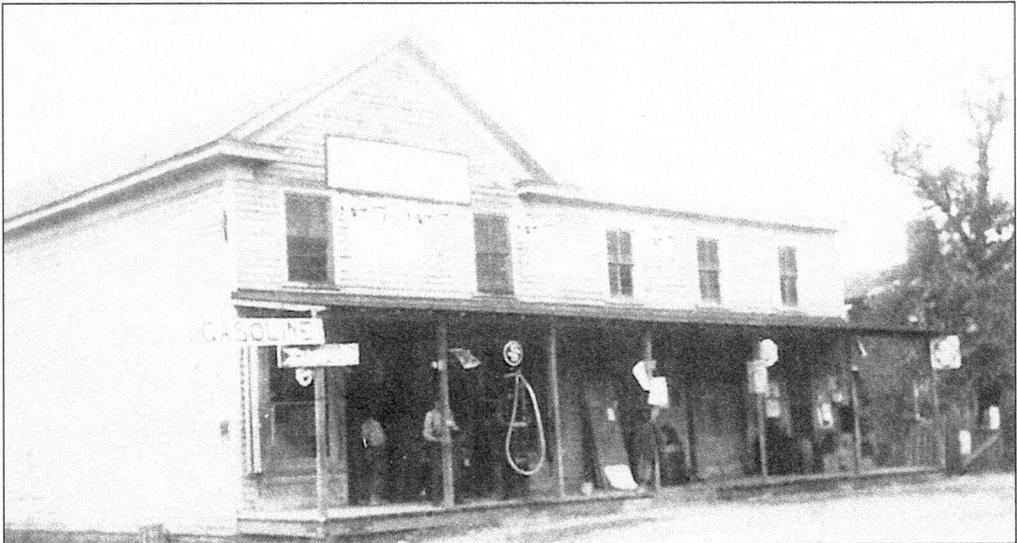

This is the general store owned by George Washington Perry in 1921. It was photographed by political correspondent Leroy T. Vernon, who worked for the *Chicago Daily News*. When he had the opportunity, he would visit Civil War battlefields to photograph them and purchase relics from local residents. Perry had witnessed the Battle of Spotsylvania as a young boy. His family farm was near the Spindle family's farm and the Po River. (Courtesy of JFC.)

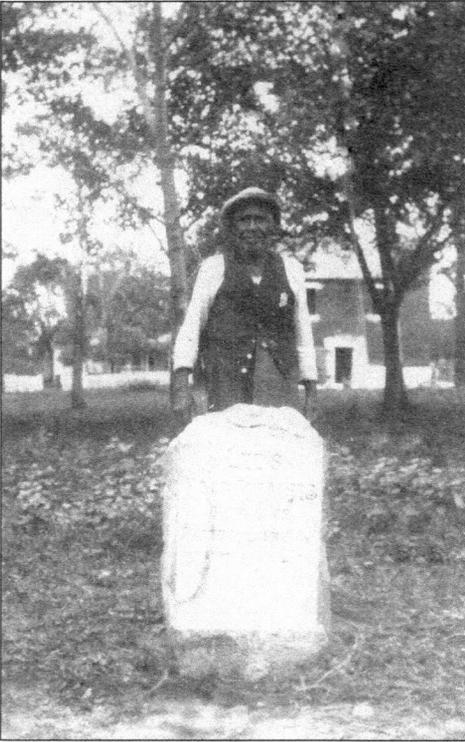

Across from Perry's store on the corner of the courthouse lawn is another of the James Power Smith markers, this one claiming to be the location of General Lee's headquarters during the Battle of Spotsylvania. In this 1921 photograph by Leroy T. Vernon, an African American referred to as "Uncle Archie" poses with the marker. In the background stands the old jail, built in 1856. (Courtesy of JFC.)

This is the corner where Perry's store would soon stand as it appeared in April 1866. It is referred to as "Cash Corner," perhaps an indication of its potential commercial viability. The view looks north, across the intersection. At left is a community well and behind it a stable where Perry's general store would be built. In the middle of the image is a brick wall that surrounded the courthouse lawn. Beyond the wall is a home owned by Joseph Sanford. (Courtesy of LC.)

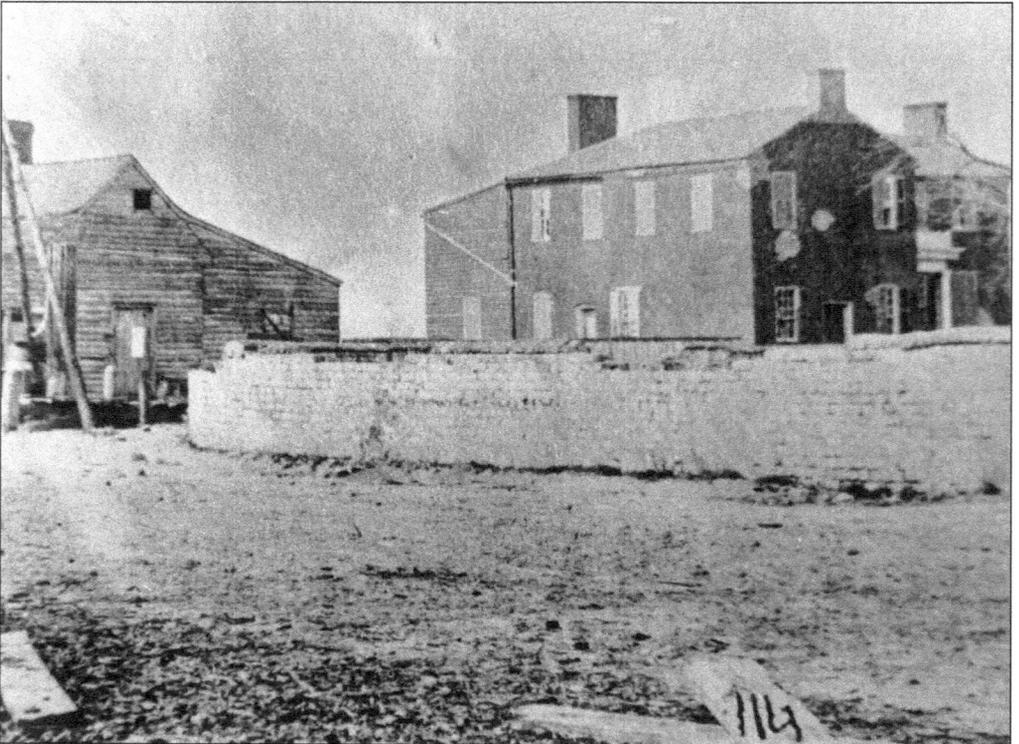

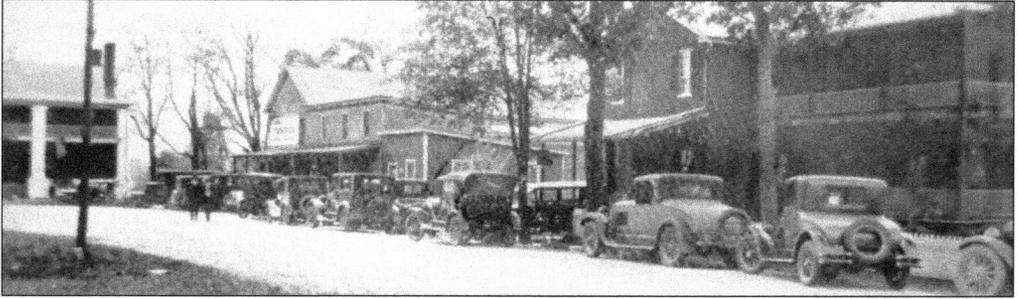

This c. 1929 image looks west at the Cash Corner intersection from the courthouse lawn. Pictured at the left is the old Sanford Hotel. Perry's store is shown in the center, and at extreme right, is Joseph Sanford's house. It had since become the office and residence of Virginia's attorney S.P. Powell. Repaired damage from the Union artillery shelling of the intersection during the Battle of Spotsylvania is visible in this photograph. (Courtesy of CPM.)

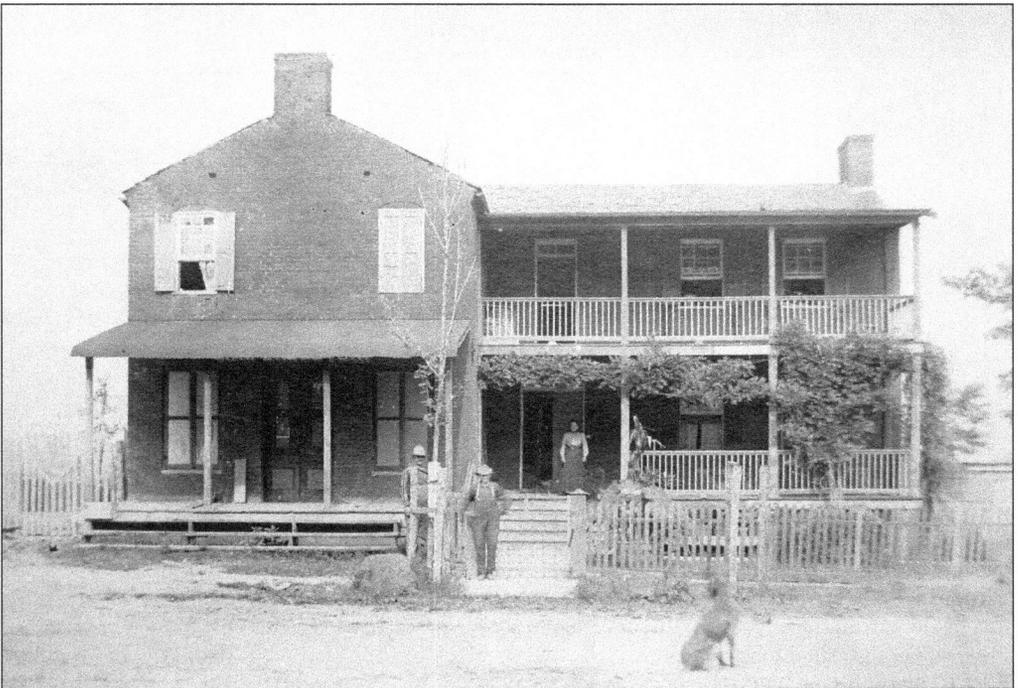

This photograph shows another view of Joseph Sanford's brick house around 1900, prior to S.P. Powell's ownership. The repaired damage from the Union artillery shelling is also visible in this photograph. It is concentrated around the second-floor window on left and just above that near the roof edge. (Courtesy of CPM.)

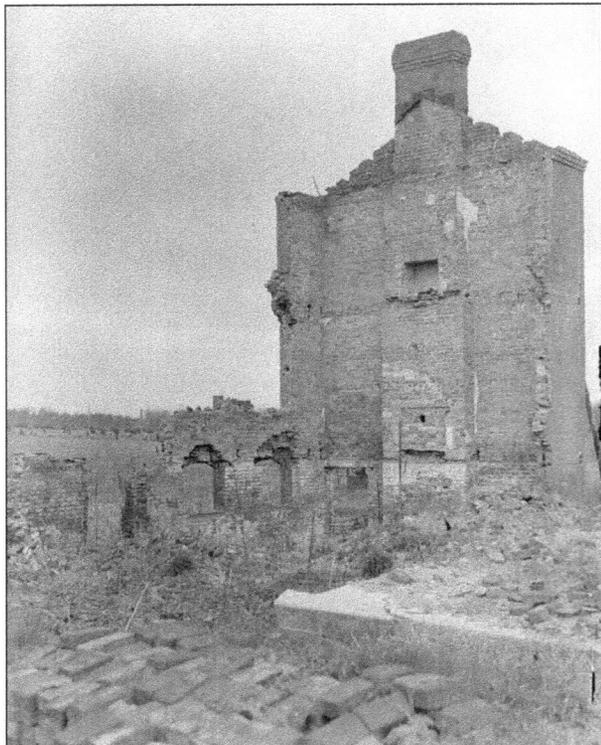

On Sunday evening, July 13, 1930, the Powell house caught fire and was completely destroyed. Thought at first to have been deliberately set as a strike against Powell, his daughter, Catherine Powell Miller, indicated in a 2001 interview that it was most probably a careless cigarette igniting the porch of Perry's neighboring general store, also consumed that night. This view looks through the gutted interior toward the north. (Courtesy of LC.)

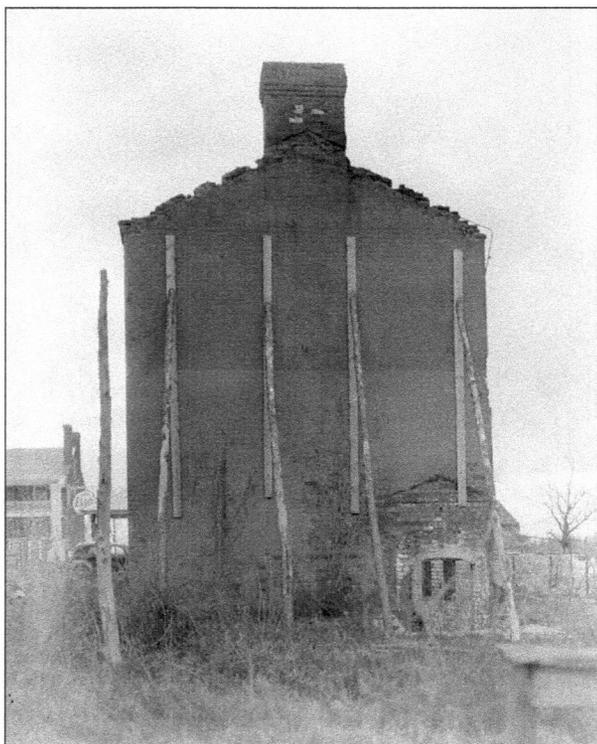

This view is of the northeast wall, looking southwest toward the Old Sanford Hotel. This photograph was made within a few years of the fire, enough time for another store to be built to replace the one that had burned. An Esso Gas sign stands in front of then-new store, which still stands today as the Chewning's Store. (Courtesy of LC.)

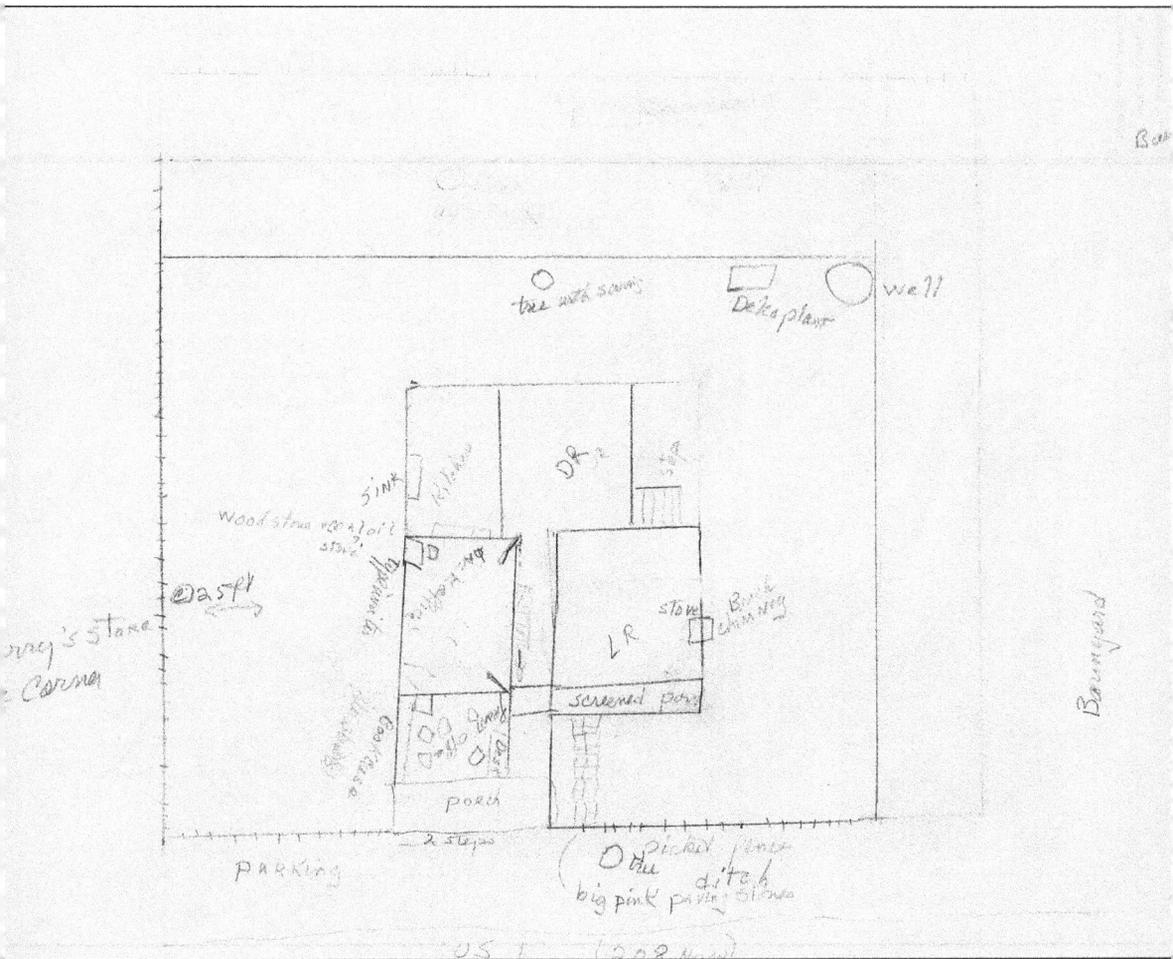

During an interview in 2001, Catherine Powell Miller drew a schematic-like diagram of the house interior and lawn arrangement. Not quite seven years old when the fire struck the family home, she vividly remembered waking up at a neighbor's the next morning with most of the family furniture stacked on the courthouse lawn, saved by the assistance of friends. The closest fire station in 1930 was in Fredericksburg, and they were hesitant to respond in case a fire broke out downtown. She remembered also that due to the July heat in the days before air-conditioning, they were sleeping on the second floor screened-in porch. Besides the hand-drawn interior views Catherine supplied, there is no further documentation as to the interior of this house. (Courtesy of JFC.)

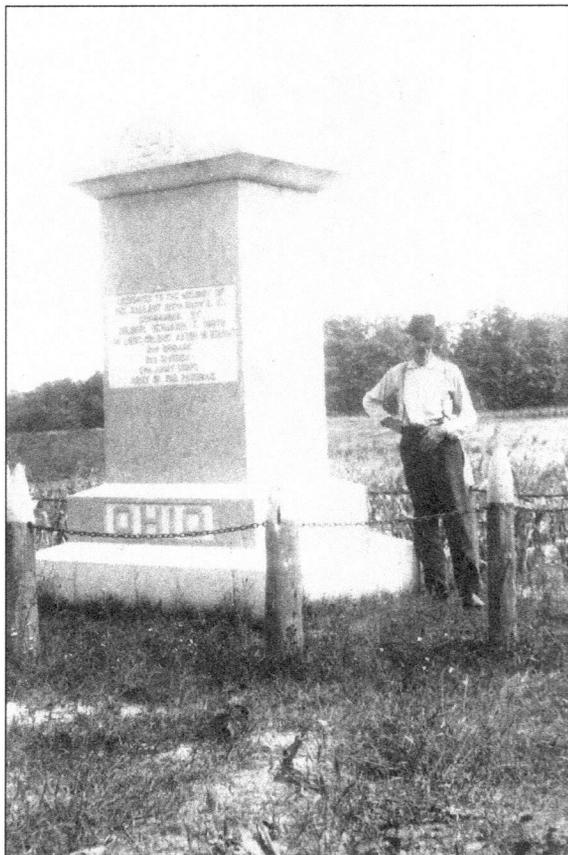

This photograph shows Edward L. Landram with the 126th Ohio Monument, which was erected on an easement he granted on his farm. Landram was 11 years old when the 1864 Battle of Spotsylvania raged over his family farm, 57 years before this photograph was taken. The photographer was Leroy T. Vernon, who, besides being a political correspondent for the *Chicago Daily News*, had been the campaign manager for Pres. William Howard Taft. (Courtesy of JFC.)

Edward T. Stuart was an early advocate of preserving the Spotsylvania Battlefield. He had purchased the second Landram house beside the Bloody Angle. Stuart, who was from Philadelphia, was the grandson of the chairman of the US Christian Commission. In the 1930s, Stuart donated the Bloody Angle property to the National Park Service. He is seen here (center) conducting a tour in front of the Confederate works. (Courtesy of NPS.)

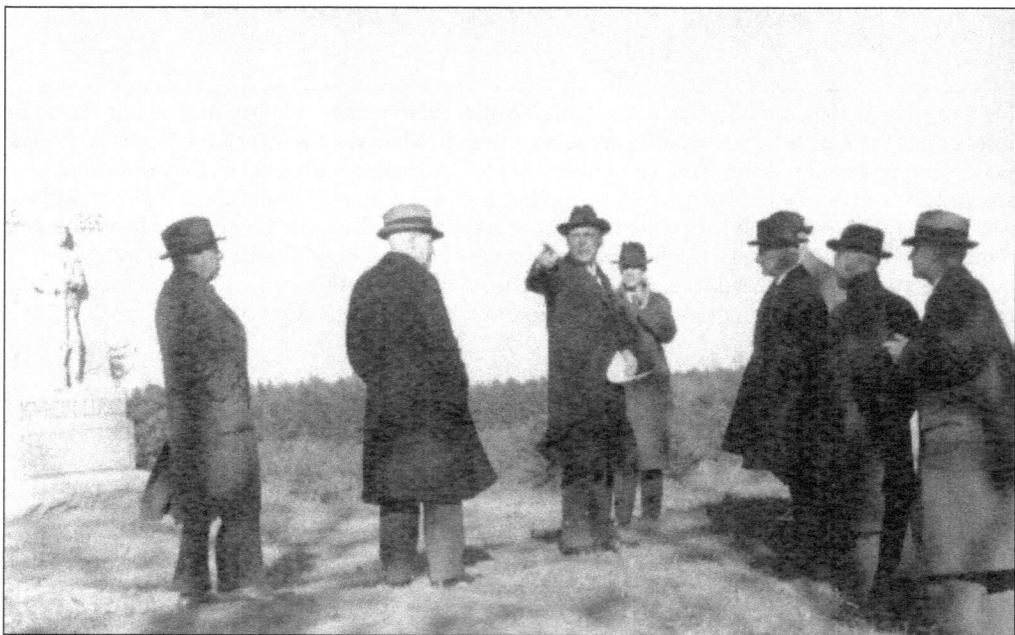

A group of battlefield-touring veterans stops for a reconnaissance on the Gayle Farm, named Rose Mount or Rosemont, on the old Charles Washington tract. As their horses take a rest, these men recline near the site of Washington's Bridge and the ford that crosses the Ni River just south of the modern-day Virginia 208 bridge. The photograph was taken in 1887. (Courtesy of NPS.)

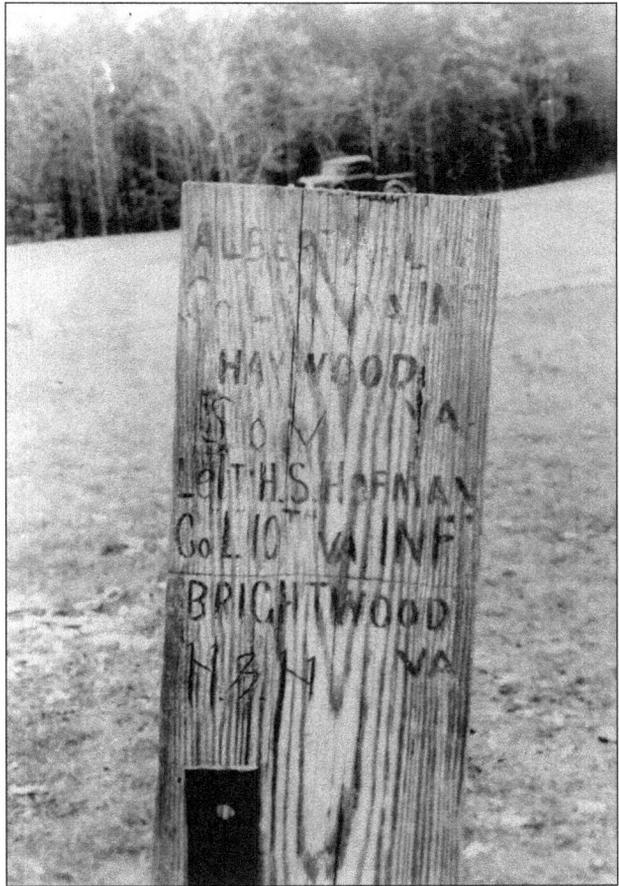

This crude wooden sign, affixed at an unknown date along the east face of Muleshoe Salient by two Confederate veterans of the 10th Virginia Infantry, was placed to designate the location of their capture and that of two Southern generals, George H. Steuart and Edward "Allegheny" Johnson. Over time, the sign had been moved some 175 yards and was subsequently lost. (Courtesy of NPS.)

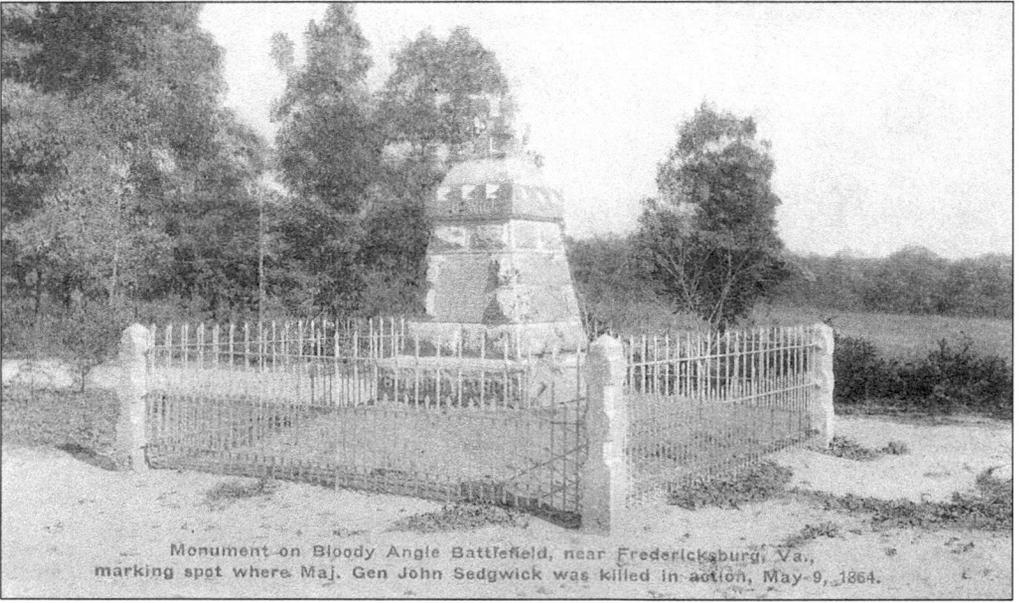

Monument on Bloody Angle Battlefield, near Fredericksburg, Va., marking spot where Maj. Gen. John Sedgwick was killed in action, May 9, 1864.

This monument, placed by men of the VI Corps in May 1887, stands on the location of John Sedgwick's ill-timed death at the hands of a Confederate sniper. So stunned was General Grant when told of the tragic event that he repeatedly asked, "Is he really dead?" Losing Sedgwick, bemoaned Grant, was equal to losing an entire division. (Courtesy of JFC.)

This obscure monument to Edward T. Stuart, located off the park trail leading to Landram Ridge, was dedicated in 1941. It reads, "Memorial to Edward Tobey Stuart 1876–1940 Student of history, patriotic citizen and loyal companion whose interests and donations of land contributed largely to the establishment of the Battlefield Park Erected by his friends." (Courtesy of JFC.)

Five

A NATIONAL MILITARY PARK AND THE CCC

The Civilian Conservation Corps (CCC) provided jobs for three million men across the nation who had fallen on hard times during the Great Depression. The Spotsylvania area benefited greatly from this New Deal program. Four camps were established in the county, the first designated MP-1, or the Bloody Angle Camp. It was built in the center of the Spotsylvania unit, the former McCoull Farm. Today's visitors may find it hard to visualize the vast facility that operated there from June 1933 through April 1936. Many of the men who formed the backbone of MP-1 were veterans of World War I, adults with a ready-made work ethic. They were older and more experienced than the average high school–age youth who formed the bulk of CCC enrollees.

Other CCC camps in the area were MP-3 on the Chancellorsville Battlefield and MP-4 in the Wilderness Battlefield area, along present-day Route 20. The fourth camp, P-69, was maintained for non-park projects and designated as private for conservation work on nonpublic forestlands. It was located on East Catharpin Road near Payne's Store. The P-69 camp concentrated its energies on the surrounding rural needs, such as the construction of fire lanes and trails. The other three camps concentrated on the requirements of the battlefield parks, establishing the standards that would enhance the visitor experience and conservation best practices. The Commonwealth of Virginia administered P-69, whereas the other camps in Spotsylvania were under direction of the federal government.

The MP-3 unit was manned predominately by an African American company through early December 1940. The company arrived in Fredericksburg by train on August 8, 1934, after citizen protests had prevented its assignment to both Lynchburg and Harrisonburg, Virginia. Fredericksburg and Spotsylvania County residents had made similar objections to stationing the company locally, but when CCC authorities threatened to close the camp and withdraw funding, public objections receded. Prejudice continued to be expressed privately, and a jaundiced eye was cast toward any perceived misdeed, real or imagined.

The CCC ceased operations in 1942 with the outbreak of World War II.

By the 1930s, the historic roads of Spotsylvania still maintained the appearance the marching armies witnessed. This view looks west toward Todd's Tavern, two miles away. The photograph portrays a quiet vista that had been the scene of dramatic delaying action in the early morning hours of May 7, 1864. It was at this intersection of Brock and Piney Branch Roads that the Confederate cavalry diligently detained the Federal advance toward Spotsylvania Courthouse. (Courtesy of NPS.)

Shady Grove Church Road (turning left), seen here around 1935 and better known today as Robert E. Lee Drive, was a scant half-mile from the courthouse and the scene of another confrontation with advancing Union cavalry on May 7, 1864. As with the Piney Branch intersection, adequate Confederate resistance made the location impenetrable. This view looks west from Brock Road. (Courtesy of NPS.)

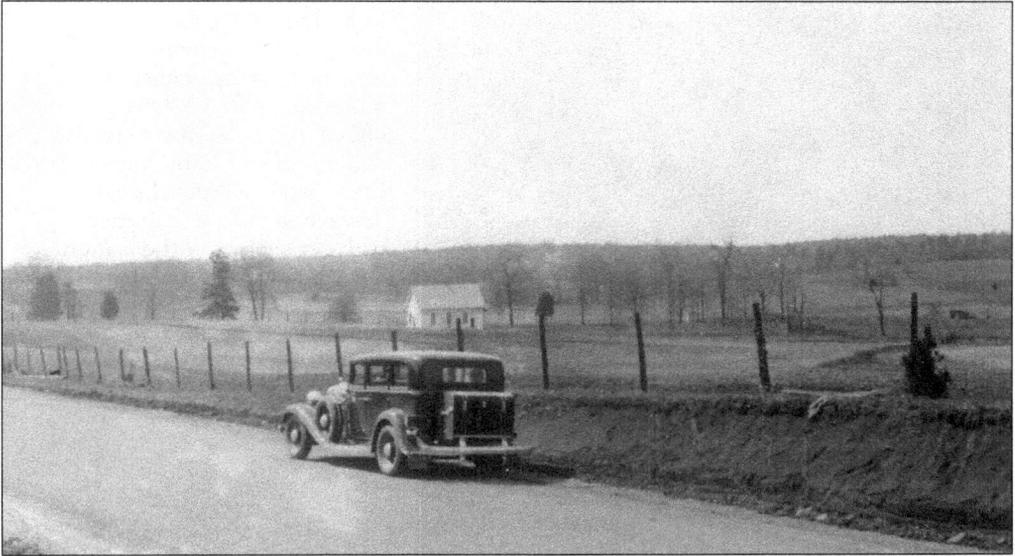

This photograph shows the Wilderness Church amidst the rural landscape that was the stage for Gen. Stonewall Jackson's daring countermarch attack of the Federal XI Corps flank on May 2, 1863. The Confederates effortlessly turned the tide of battle in favor of a Southern victory. In the 1930s, even though it was the main artery between Fredericksburg and Culpeper, travelers could pull to the edge of the road and take in the sites. (Courtesy of NPS.)

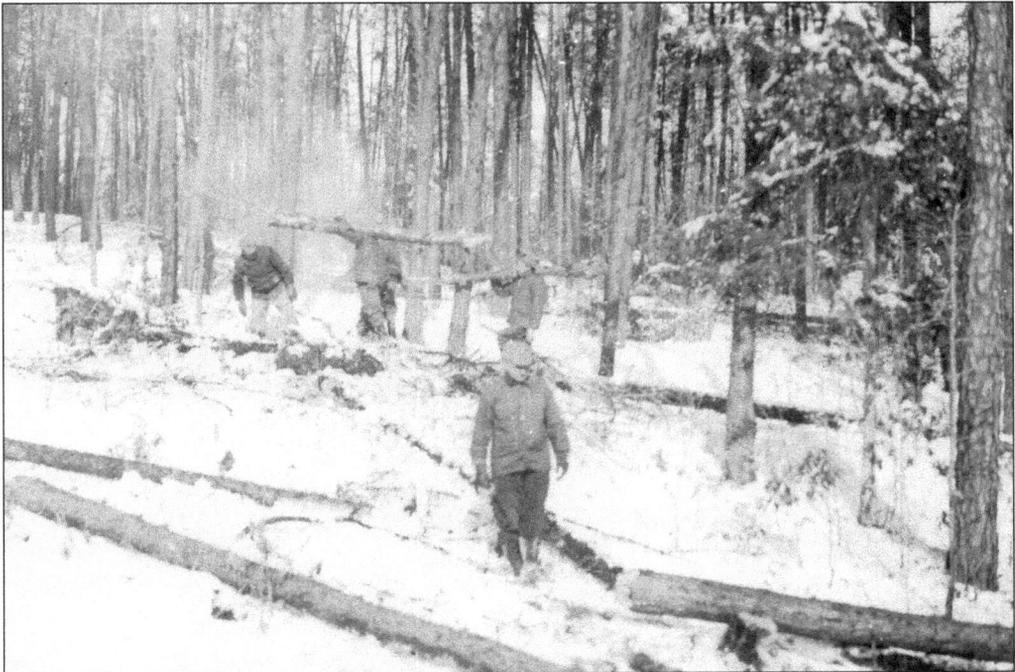

The heavily wooded areas of the battlefield park are consistently battered by the elements. Snow and ice storms in January 1935 were one such occasion. This photograph shows CCC members clearing damaged trees the month after the storms. Many large trees were snapped off or uprooted. Blizzard conditions returned in the days after Christmas as that year closed. (Courtesy of NPS.)

In March 1935, CCC workers discovered the remains of an unknown Union soldier on the south side of Route 3 near Hazel Grove. A similar discovery, the remains of six Union soldiers, had been made four months earlier. The remains were reinterred with ceremonies at the National Cemetery in Fredericksburg. This soldier's remains were placed to rest near the Chancellorsville ranger contact station and are marked there today. (Courtesy of NPS.)

Among the tasks taken on by the CCC was the removal of non-historic structures, including this old barn near the Spotsylvania Camp. The transition from private property to parkland had been gradual since the park was first established in 1927. (Courtesy of NPS.)

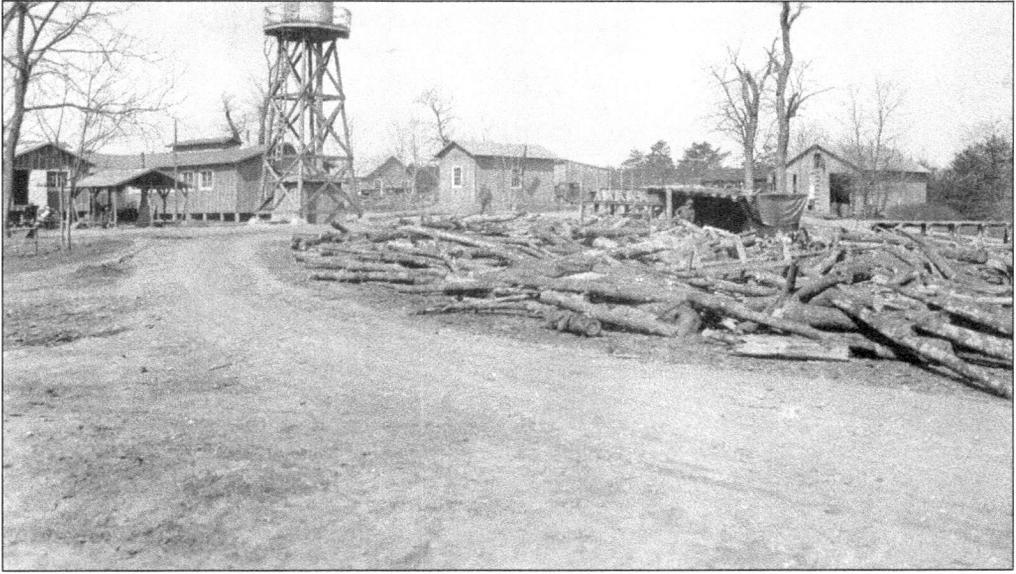

As fast and as efficiently as unwanted structures could be cleared away, corps members could also construct formidable facilities to sustain the daily needs of the camp, such as this new repair garage building for vehicle maintenance. (Courtesy of NPS.)

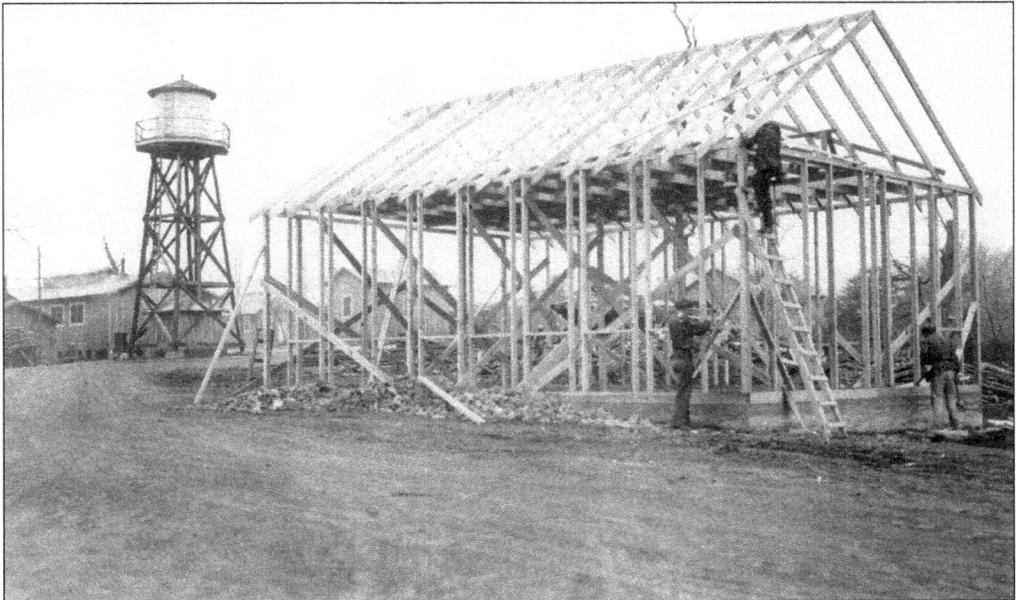

The garage project began on March 13, 1935, and was "progressing rapidly" according to senior project superintendent William Howard in his March 30 narrative report. This was to function as the consolidated garage for all the vehicles of Camps MP-1, MP-3, and MP-4. The report lists the mechanics' names as May and Beasley. (Courtesy of NPS.)

The two images presented here portray a decidedly different presentation from that experienced today near the Chancellorsville Contact Station. In June 1935, visitors drove directly off of Old Plank Road and parked on a semicircle driveway near the Jackson wounding markers. (Courtesy of NPS.)

Nearby, visitors could partake of the picnic facilities, which are shown while being enjoyed by the members of this large tour group, and afterward take a stroll through the Jackson Wildflower Preserve. With today's manifestly heavier traffic flow, visitors must carefully navigate the short turn lane into the visitor center parking lot behind a heavy screen of trees that protects the historical features from the invasive sights and sounds of a divided highway. (Courtesy of NPS.)

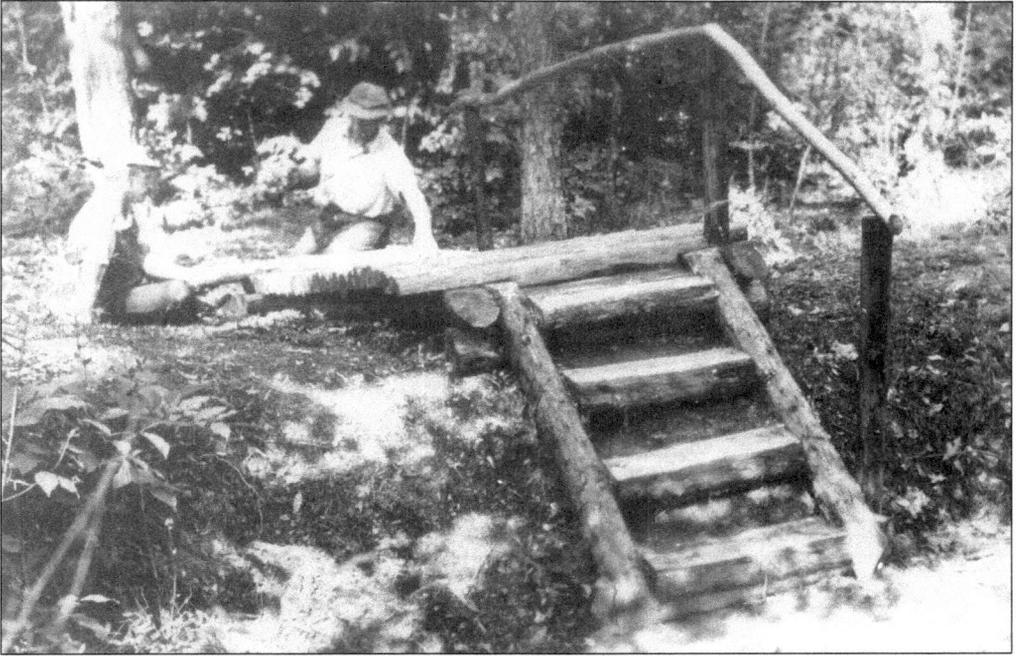

The abundant raw materials found in the onsite woodlands provided for affordable trail enhancements, such as this bridge on an old foot trail along Grant Drive East, now called Burnside Drive. Certain trails have fallen from favor over the years and have been allowed to return to a natural condition as new park superintendents and historians exercised their preferences of interpretation. (Courtesy of NPS.)

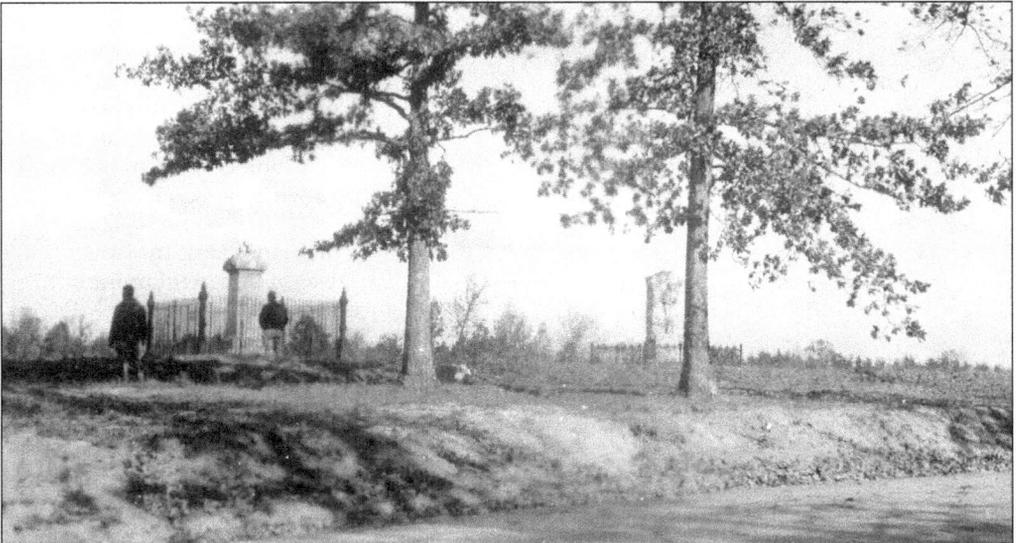

Substantial wrought iron fences surrounded many of the earliest monuments erected by veteran groups in the late 19th and early 20th centuries. Some were taken down for ease of grounds maintenance or due to lack of foreseen necessity. Others became donations in scrap metal drives. Before the battlefield park was established, these monuments stood on private property, allowed by prearranged easements with the landowners. (Courtesy of NPS.)

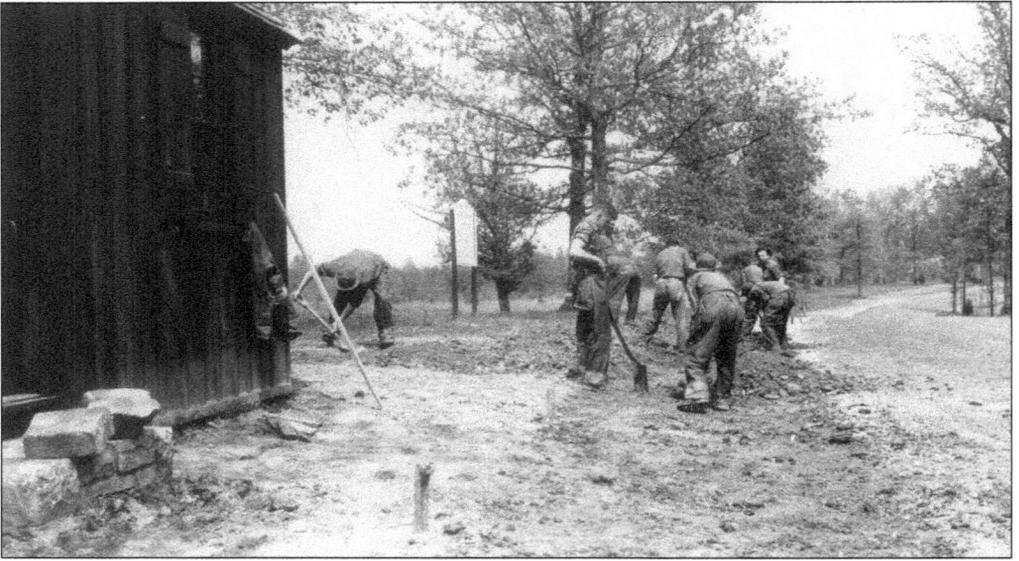

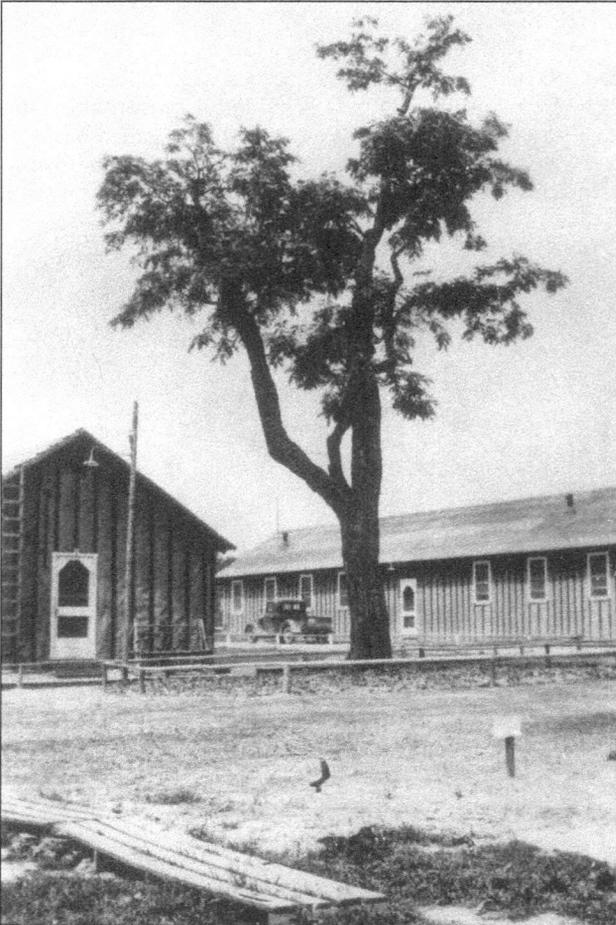

An extensive macadamized road system was necessary to navigate the conjoined small farms that had once been relegated to desolate battlegrounds. Now united as a national military park, the roads would provide seamless access for the motorist visitor. The automobile had become the great equalizer and provided a significant upswing in tourism. Here, CCC crew members perform grading work near the newly built contact station at Spotsylvania. (Courtesy of NPS.)

This giant locust tree was salvaged by careful pruning and nurturing at Camp MP-1, the Bloody Angle Camp. MP-1 serviced both the Spotsylvania and Fredericksburg Battlefields, performing work duties such as tree surgery, ditch cleaning, reducing fire hazards, and providing guide services. In November 1934, the company did extensive tree surgery in the National Cemetery on Willis Hill, afterwards fertilizing the trees with five and a half tons of tree food. (Courtesy of NPS.)

This photograph shows the interior of the vehicle maintenance garage. Senior project superintendent William K. Howard reported, "Mechanic May is kept continuously busy on the repairs of trucks of the three camps, being assisted by Mechanic Beasley from Camp MP-4." (Courtesy of NPS.)

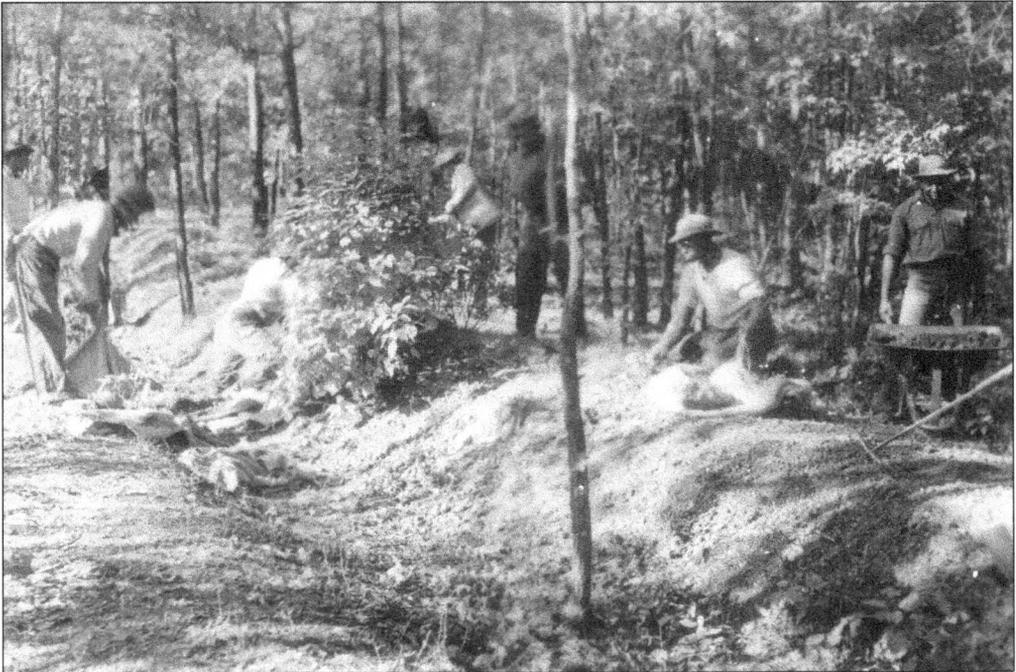

Enrollees of Chancellorsville Camp MP-3 are seen here in September 1935 "sodding a trench" to prevent further surface loss from erosion. Howard detailed in his report that the "grass used in establishing this trench cover is a wild woods fescue, native to this section, able to withstand drought and shade, requires practically no maintenance and forms a very attractive cover." (Courtesy of NPS.)

Members of Camp MP-1 cut grass near the apex of the Muleshoe Salient. Most of the men appear to be using long-handled grass whips and grass hooks, while at least one reel mower is being used in the right of the photograph. John Apperson was the camp blacksmith, who kept all tools sharp and in good condition. (Courtesy of NPS.)

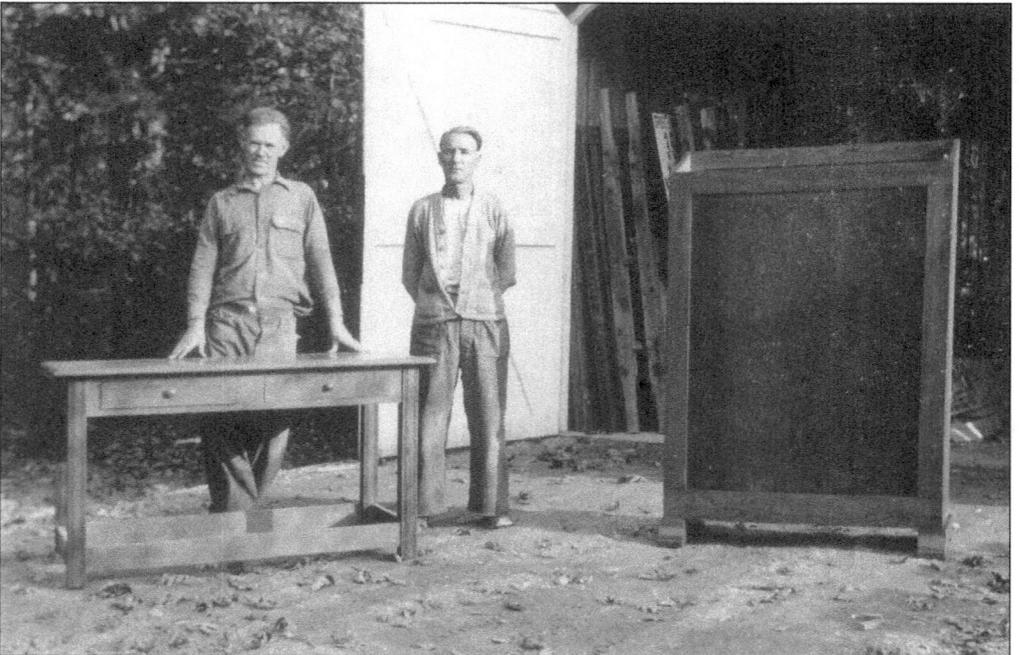

Camp MP-1 had many skilled craftsmen among their enrollees. Made up of military veterans, they were an older and more experienced camp compared to the average high school–age youths who formed the bulk of CCC enrollees. This photograph from October 1935 shows two cabinetmakers with examples of fine wood furniture they crafted for use in the ranger stations. (Courtesy of NPS.)

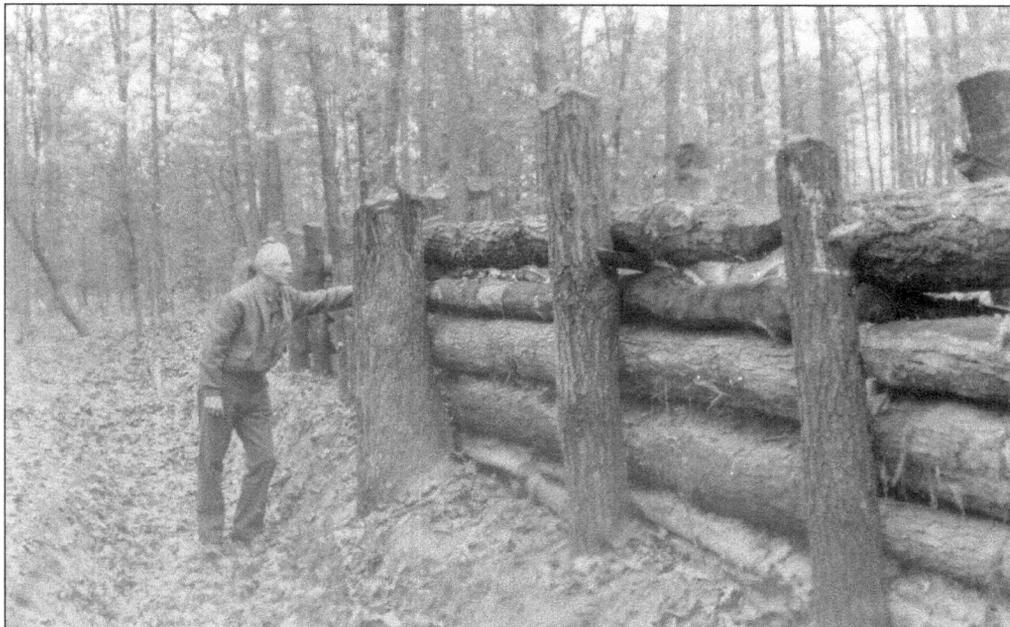

A section of secondary Confederate trench line that lies 100 yards behind the Bloody Angle is shown here in October 1935, soon after enrollees rebuilt it to its original depth with log revetment. Intended as an enhancement to the visitor experience, this effort was carefully thought out and was done on a simple, straight length of the works. (Courtesy of NPS.)

Two National Park Service historians construct the first orientation compass near the Bloody Angle. The postwar Landram house is visible just beyond the 49th New York Infantry monument. This compass was made in a laborious yet precise method of pouring concrete in a form and hand inscribing the information into the setting concrete. (Courtesy of NPS.)

Abandoned, overgrown, and fallen down, the Harrison house, just south of the CCC campsite, became one of the extensive projects undertaken in the establishment of the park. Once-fertile farm fields had now gone fallow and unkempt, and an aggressive woodland easily reclaimed what man had once tamed for his purposes. (Courtesy of NPS.)

Robert Fechner, director of the Civilian Conservation Corps, is seen here addressing an Armistice Day commemoration on Sunday, November 11, 1934. The elaborate ceremony took place at the Bloody Angle Camp. Fechner urged that "Our armies must become peace armies . . . engaged in constructive work, repairing damage to our natural resources and making this country healthier, better, lovelier and more productive for those who are to come." (Courtesy of NPS.)

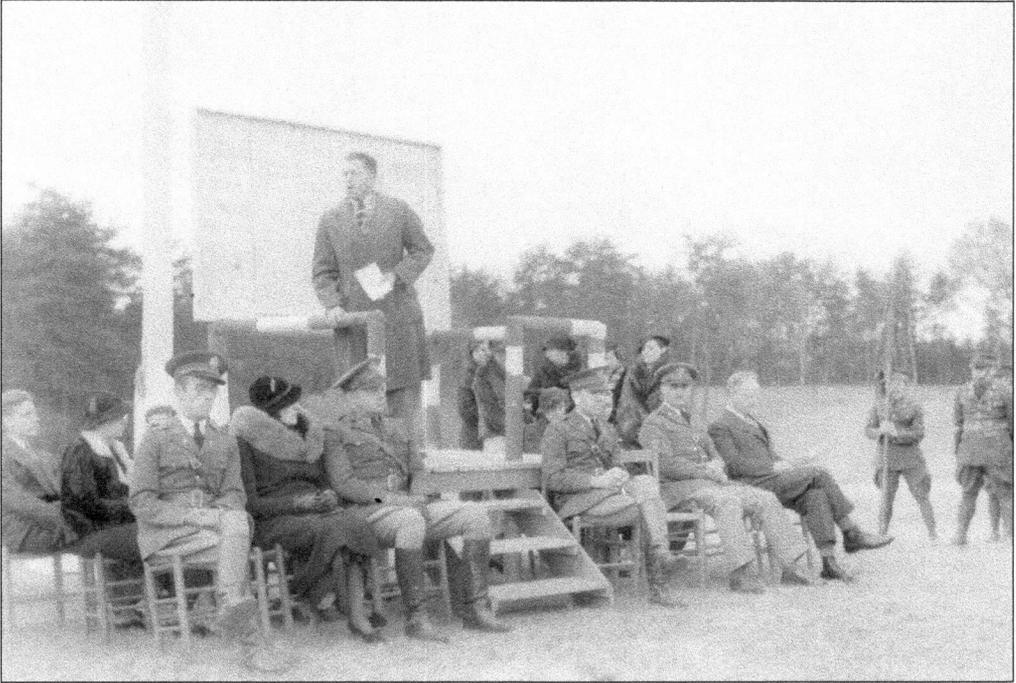

Army major William E. Brougher provided historical background of the Spotsylvania Battle utilizing the large map seen on the board behind him. He stressed that wars were useless and costly and could be avoided using preventative preparedness as a means of keeping out of them. Eight years later, Brougher had risen in ranks to a brigadier general and would experience the hardships of the Japanese capture of Bataan. (Courtesy of NPS.)

With the warmer weather of March 1936, construction of ranger contact stations and other interpretive facilities, such as this map shelter, began near the Sedgwick's monument. This corner on the Brock Road would also become a primary entrance into the park by way of a new, paved road named Grant Drive West. Until this point, access to the battlefield was by way of deeply rutted farm roads. (Courtesy of NPS.)

Enrollees of the Chancellorsville CCC Camp MP-3 tamed the wilderness, so to speak, around the Jackson Rock and Monument, creating a gentrified landscape with a manicured lawn and over 200 transplanted trees and shrubs. This photograph from May 1936 shows a crew watering a new tree from a tank aboard a stake truck. (Courtesy of NPS.)

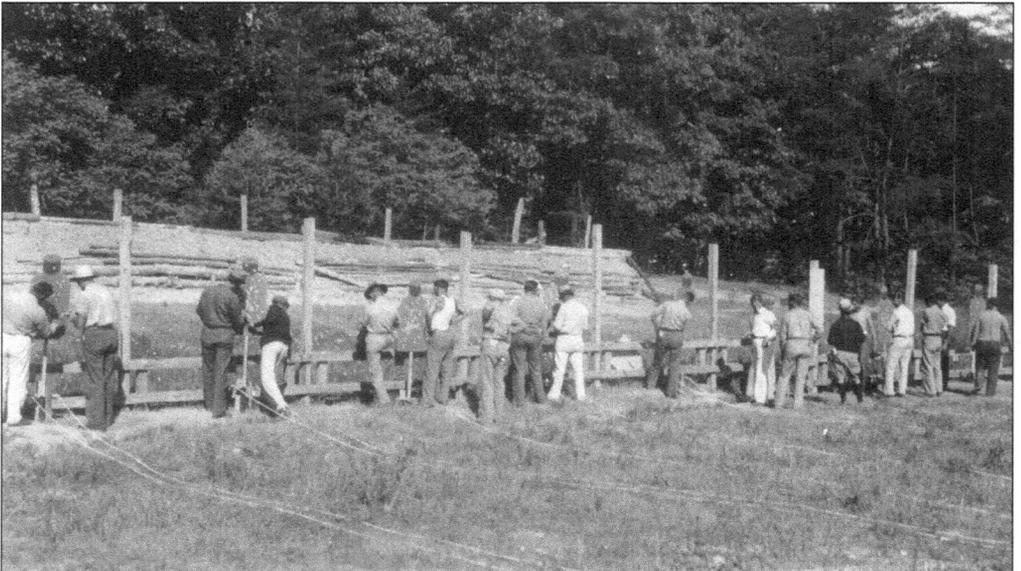

Camp MP-1 was vacated in April 1936. In May of that year, the Virginia State Police recruit school moved into the facility. The class included 124 aspirants, 50 of whom would receive positions with the police department upon completion of training. An expanded curriculum was introduced that year. Graduation was held on June 6, 1936. The photograph above shows the newly formed Virginia State Police Pistol Team on the firing range. (Courtesy of NPS.)

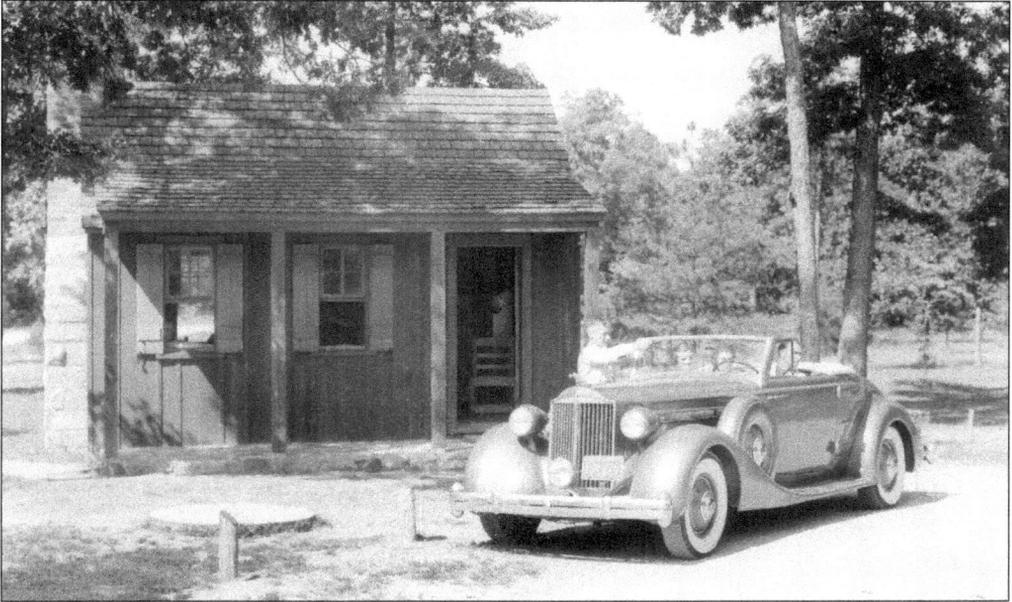

An onsite historian greets visitors at the Chancellorsville Contact Station in this 1936 promotional photograph. The historian gestures toward the Jackson wounding site, and all eyes are fixated on the subject matter. The contact station included displays of artifacts recovered from nearby and a conceptual watercolor painting of the Chancellor House. The painting by Stuart Barnette is still on display in the modern visitor center built on the ground seen behind the automobile. (Courtesy of NPS.)

In July 1936, restoration was done on an artillery lunette that was part of the Union position at Fairview. This effort was made to provide a better visual aid for park visitors. This lunette was situated alongside a section of Berry Paxton Drive that can be seen coming over the crest at right. That road section was removed in the 1980s, just as was Bloody Angle Drive at the Spotsylvania unit. (Courtesy of NPS.)

Acres of the open farmland surrounding the Confederate trenches at Spotsylvania were already in a state of natural reforestation when the park was being established. This 1936 photograph of the Muleshoe apex demonstrates how much the vista had been impaired. More than 40 years would pass before a concerted effort was made to restore Civil War–era timberlines under the direction of chief historian Robert K. Krick. (Courtesy of NPS.)

Much of the efforts of the CCC were naturally focused on conservation work and landscape enhancement. The emphasis was on creating a more traditional park rather than a full re-creation of a battlefield landscape. This photograph from 1937 shows a crew performing a tree moving, which was undertaken between January and April. (Courtesy of NPS.)

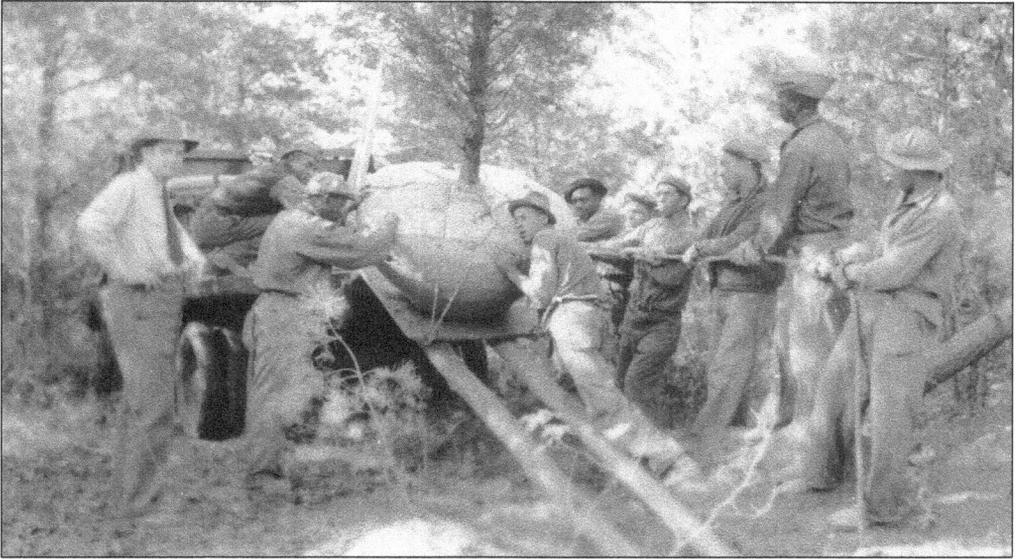

A sizable portion of the initial work performed by the men of Camp MP-3 consisted of landscaping along Route 3 in the area of Chancellorsville. Erosion control and beautification went hand-in-hand. The narrative report for the final quarter of 1934 detailed "planting and replanting of select pines, spruce, cedar and other evergreens and a general clean-up of the entire area." (Courtesy of NPS.)

One of the park historians from the formative years was Fredericksburg-born Ralph Happel. Happel authored several specialized booklets, wrote authoritative sign texts, and performed extensive map work in his 35-year career with the NPS. This photograph shows Ralph in 1937 providing an explanation of troop movements to visitors. This was his first summer at the Chancellorsville Contact Station. (Courtesy of NPS.)

In the summer of 1937, CCC enrollees continued to improve upon enhancements to the visitor experience. This picnic area is one such project. (Courtesy of NPS.)

Another enhancement project was the exhaustive landscape beautifications shown here. Federal budget cuts the year before had begun to reduce camps across the country, and the number of men assigned to a camp declined from 200 to 160. With the closing of Camp MP-1 in April 1936, the workload of the Wilderness and Chancellorsville Camps increased. (Courtesy of NPS.)

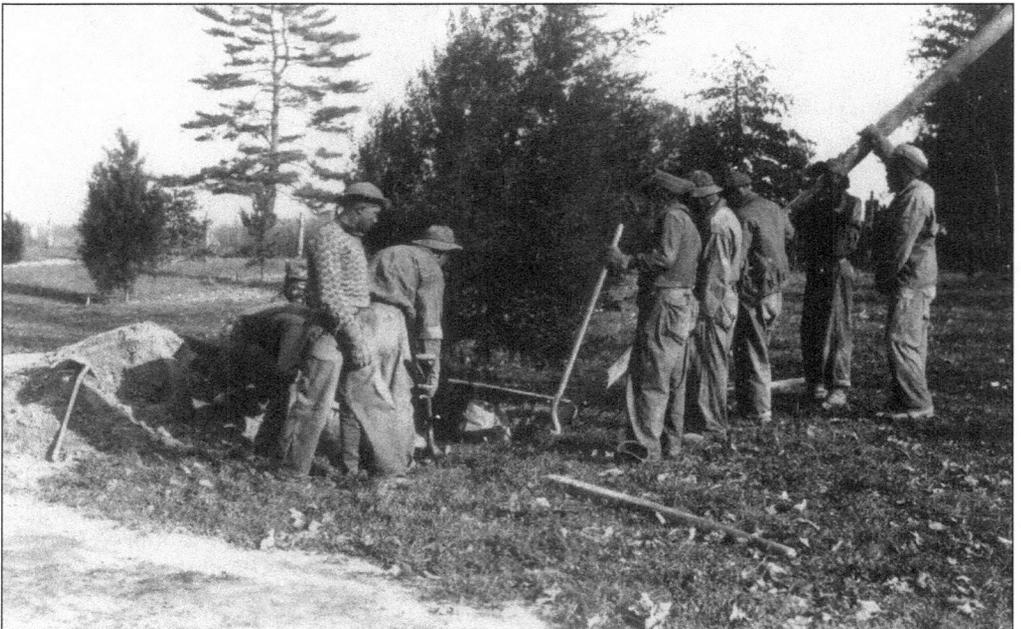

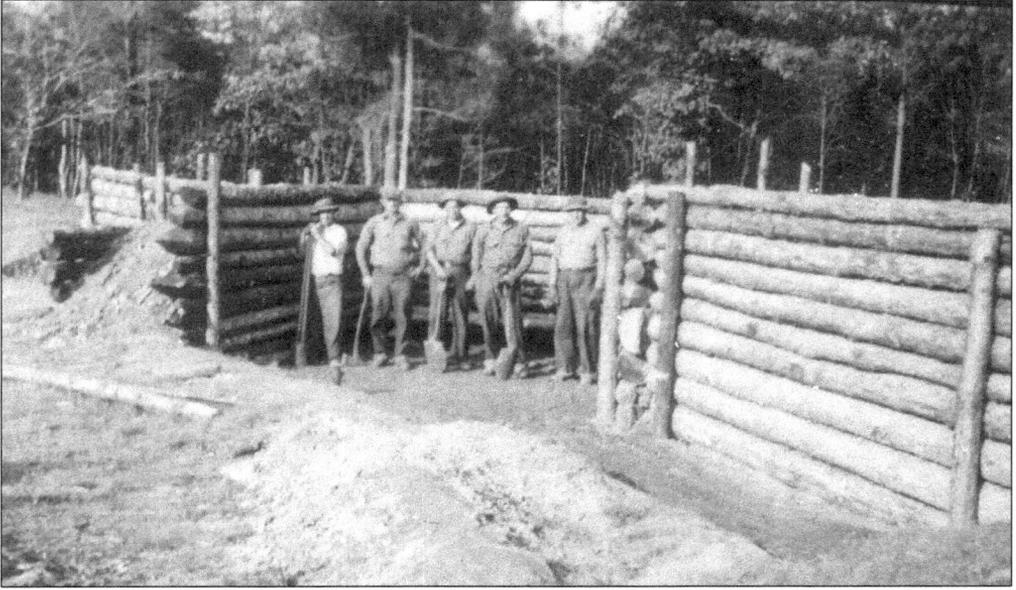

In October 1935, CCC workers neared completion of a trench restoration on a section of the Muleshoe Salient. Visitors are left to speculate on the degree of arbitrary features built into this particular restoration, despite documentation of a careful and studied process used at other locations. Constructed to emulate the perceived details of an 1866 photograph, no hard evidence existed to support the design in this specific location. A rendering of the photograph was later displayed nearby and undoubtedly led many visitors to believe they were witnessing a restoration of the genuine article. Exactly when this display was dismantled is not clear, but its misleading features—less the log revetment—can still be seen today. (Courtesy of NPS.)

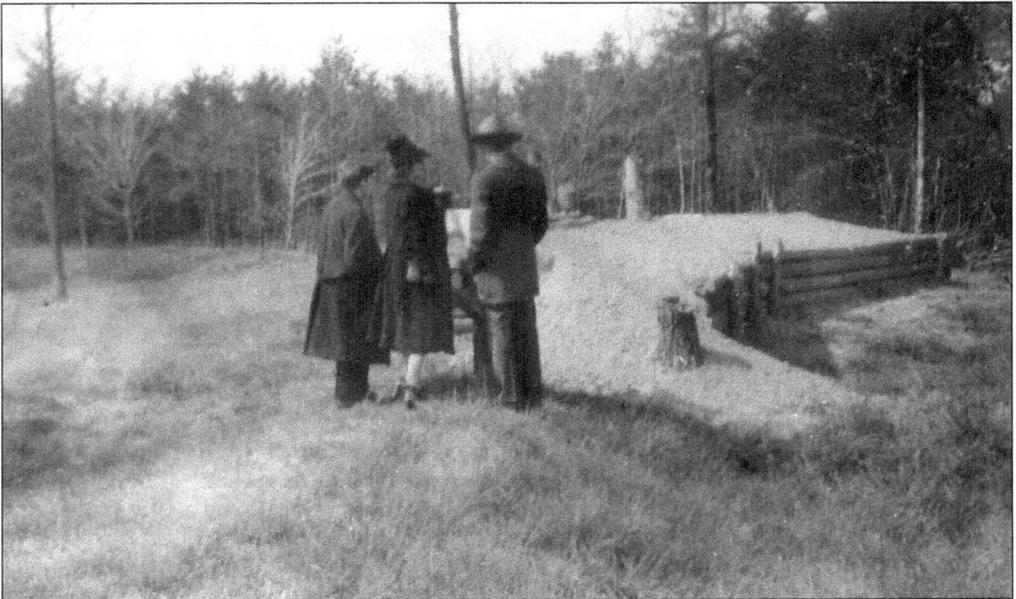

In this photograph, Martin Marder, who was a refugee from Nazi Germany, is provided a detailed inspection of the trench in April 1938. (Courtesy of NPS.)

Photographed in the spring of 1939 as a promotional image to be displayed at the New York World's Fair, the restoration from the previous page is seen from atop its parapet, looking south. In the background, some of the replanted dogwoods and laurels can be seen near the road's edge. (Courtesy of NPS.)

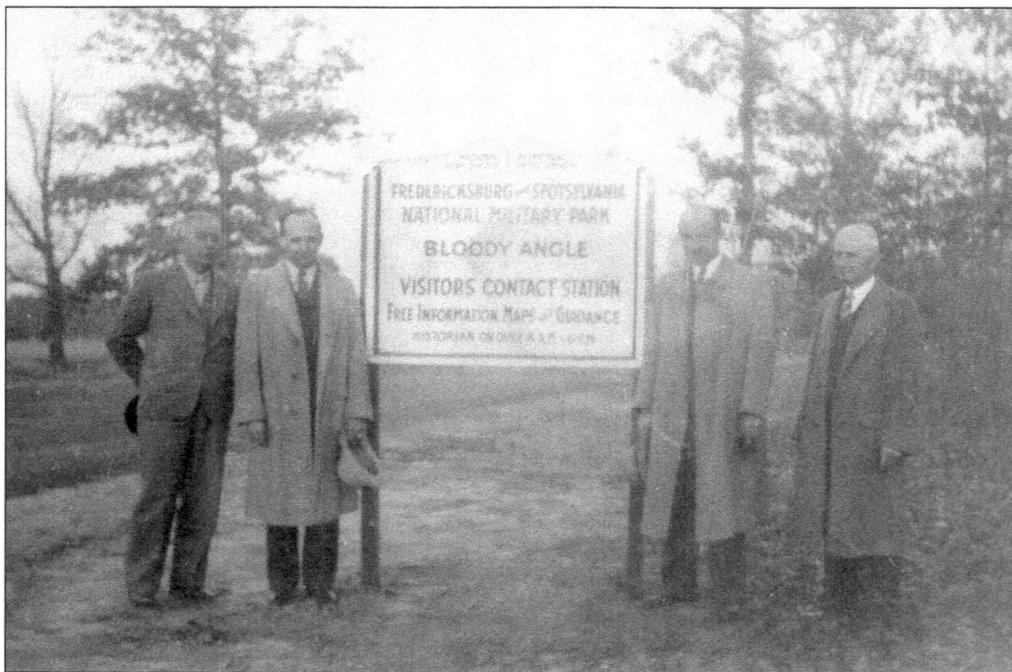

In December 1935, some of the area's high-ranking government officials and a foreign dignitary gathered at the Spotsylvania unit to witness the great strides the CCC had been making in the park. Standing beside a sign for the Bloody Angle Contact station are, from left to right, Commonwealth Attorney W.B. Cole; F&SNMP superintendent Branch Spalding; *obermagistratsrat* of Berlin, Germany, Dr. Gotthilf Paul Bronisch; and Fredericksburg city manager L.J. Houston. (Courtesy of NPS.)

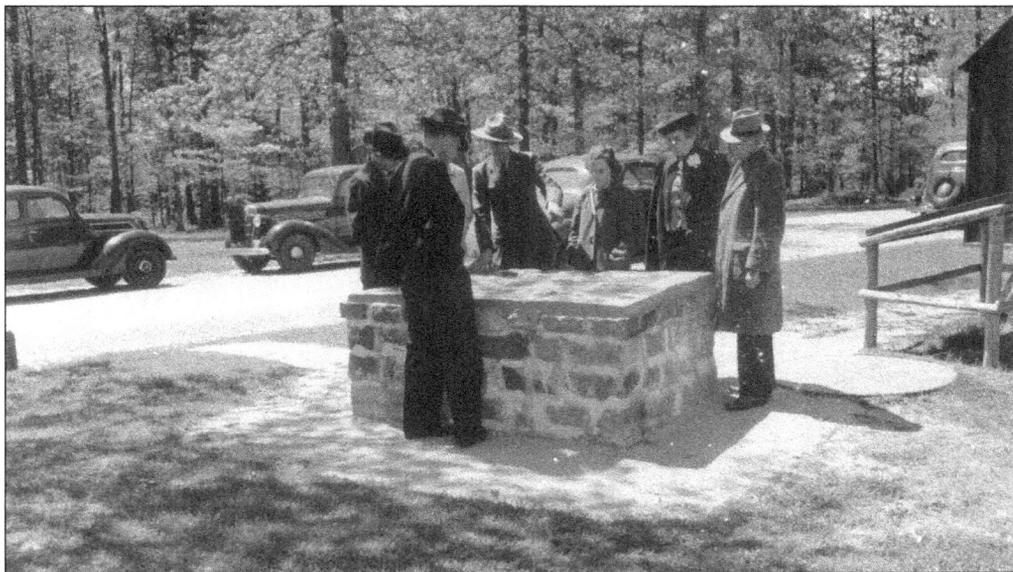

Over the last 70 years, a few things have changed with how visitors experience their tour of the Spotsylvania unit. The initial design for the park roads allowed vehicles to drive completely around the inside of the Muleshoe Salient. Today, two-thirds of that road has been removed, providing a much more pleasant and authentic pedestrian experience. In this photograph from 1938, a visiting couple is seen with a ranger, who is examining a relief map that once stood at the approximate location of an orientation compass today. On the road to the left are the visitors' cars, and behind them to the right is the contact station. (Courtesy of NPS.)

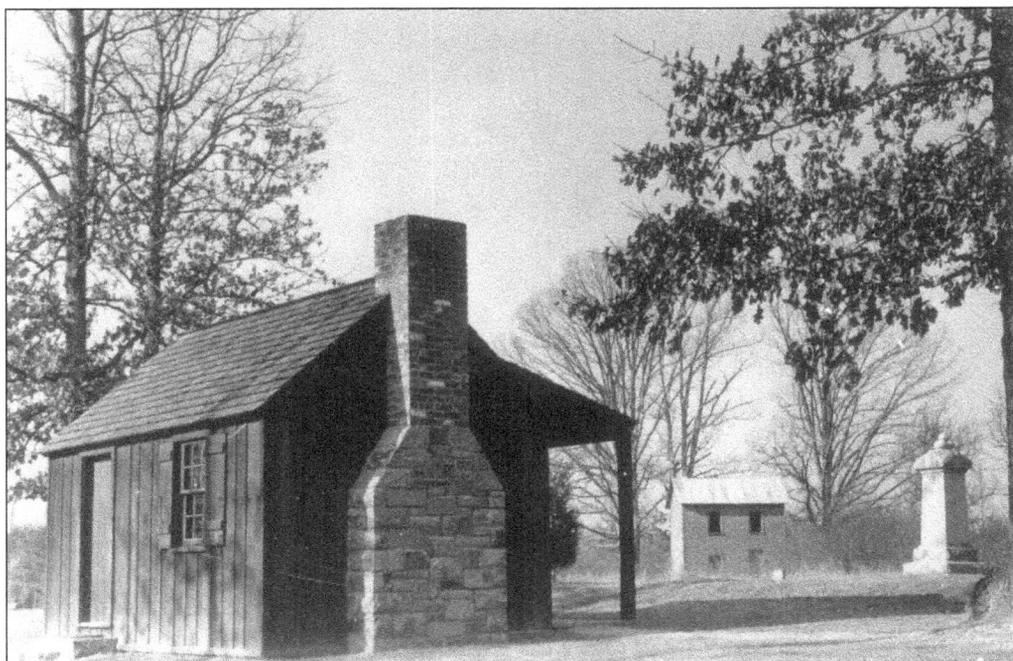

This photograph shows the contact station in greater detail as well as the second Landram house, which is also now removed. (Courtesy of NPS.)

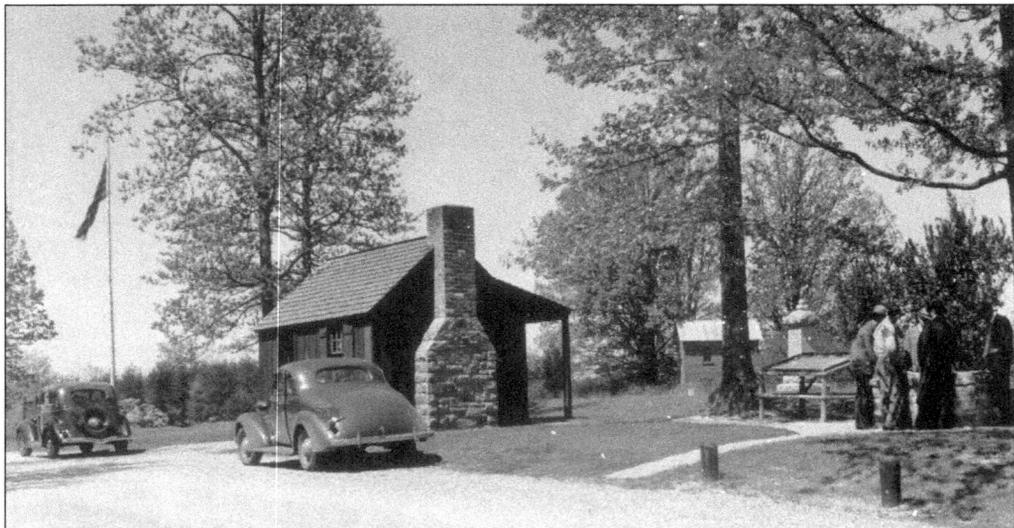

The Spotsylvania unit of the park has changed substantially since the 1930s and is in the midst of substantial interpretive changes as the Civil War Sesquicentennial approaches. The most profound change visitors may or may not realize when visiting the Bloody Angle is the absence of Bloody Angle Drive, seen in the immediate foreground of this photograph from 1938. Little remains to indicate the road's once-invasive swath. (Courtesy of NPS.)

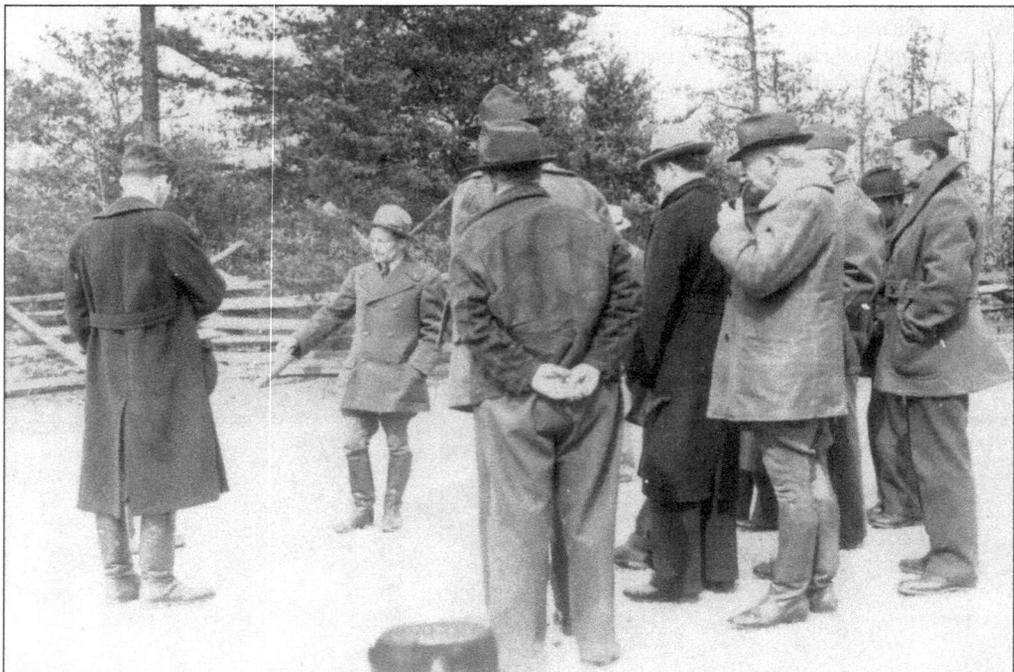

One of the park's earliest historians was assistant research technician Edward Steere. Steere is seen here near the site of Todd's Tavern conducting a lecture for visiting historical staff of other Virginia National Park Service battle areas. It can be said that Steere literally wrote the book on the Wilderness Campaign, a significant study first published in 1960 on the eve of the Civil War Centennial. (Courtesy of NPS.)

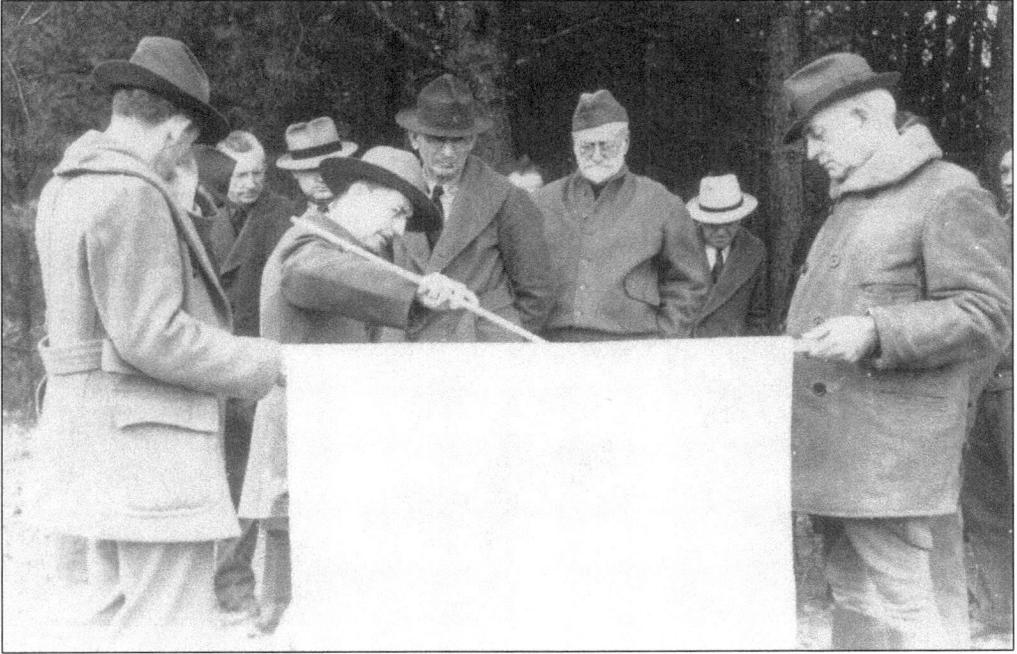

Edward Steere is conducting the Historical Monthly Meeting in this photograph from February 27, 1939. With him are staff members from other park units. Allowing visiting staff to acquaint themselves with the ongoing work of their peers and refresh their understanding of other battles is a practice that continues today. Steere eventually became the chief historian at F&SNMP, retiring in 1955. (Courtesy of NPS.)

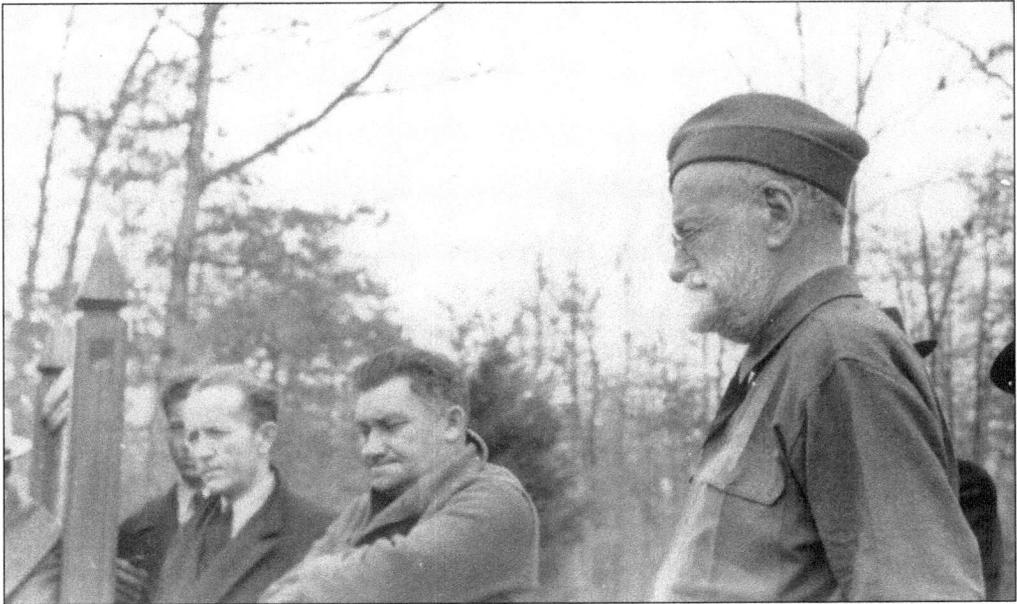

Shown in this photograph with a gray beard is Mr. Champion (right), an enrollee of the Petersburg Battlefield CCC camp. Champion was a veteran of the Spanish-American War, and he was 69 years old when this photograph was taken in 1939. (Courtesy of NPS.)

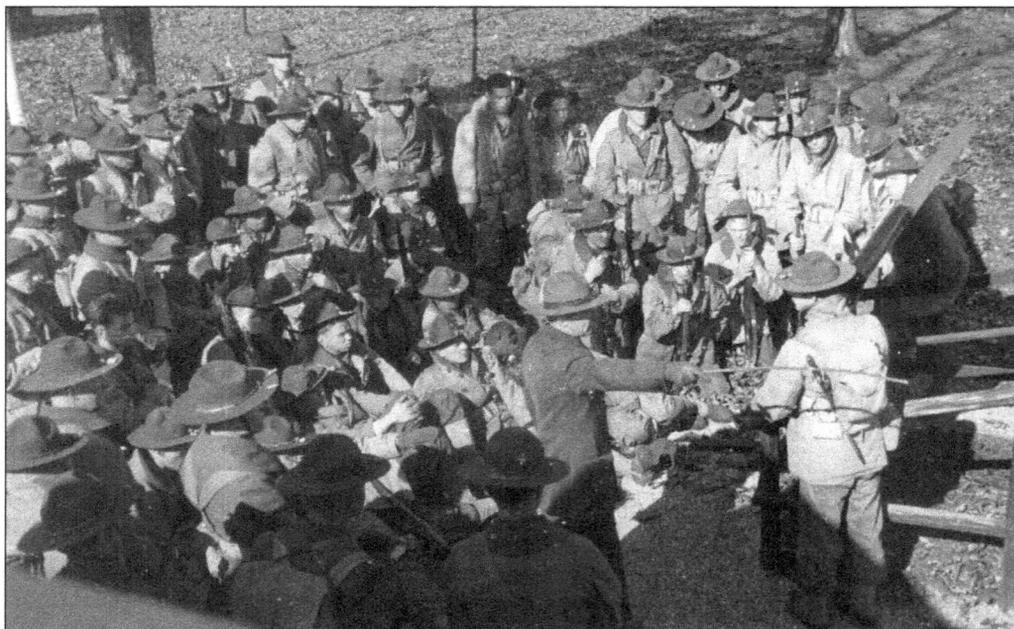

A valuable tool for students of military strategy is the ability to visit terrain upon which an action took place. Spotsylvania is one of Virginia's best-preserved battlefields, providing open ground that permits a pedestrian experience of the subtle land features that were so crucial in the course of the fighting. In this photograph from 1939, historian Edward Steere explains the tide of battle to the 5th Engineer Battalion, visiting from Fort Belvoir, Virginia. (Courtesy of NPS.)

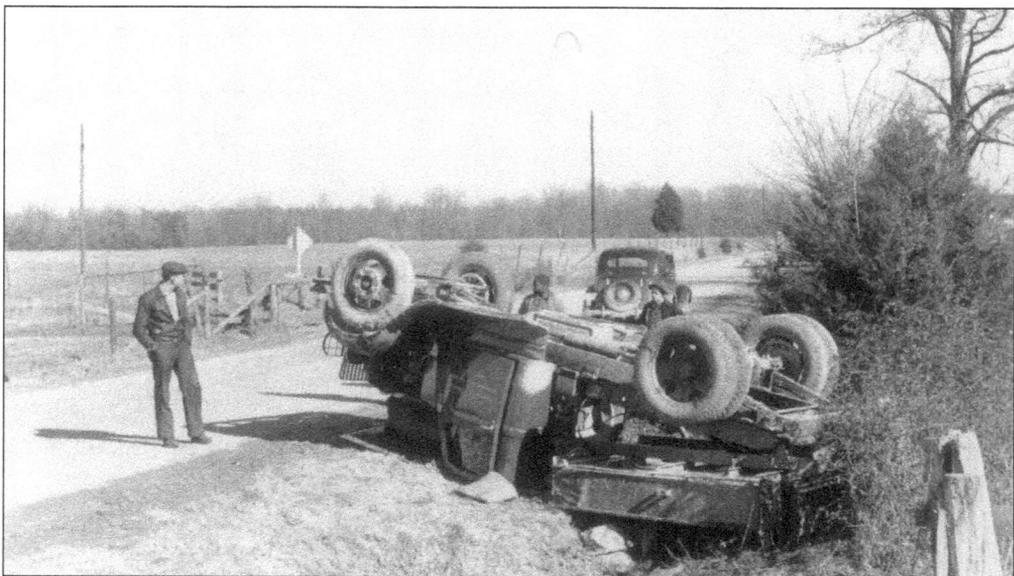

Around February 13, 1939, this National Park Service truck overturned near the site of Dowdall's Tavern on Route 3, about one-third mile east of Wilderness Church. Two enrollees from the Chancellorsville CCC Camp are visible standing on the other side of the wreck while an unidentified man looks on at left. No additional information was found with the image or any reference in the local paper. (Courtesy of NPS.)

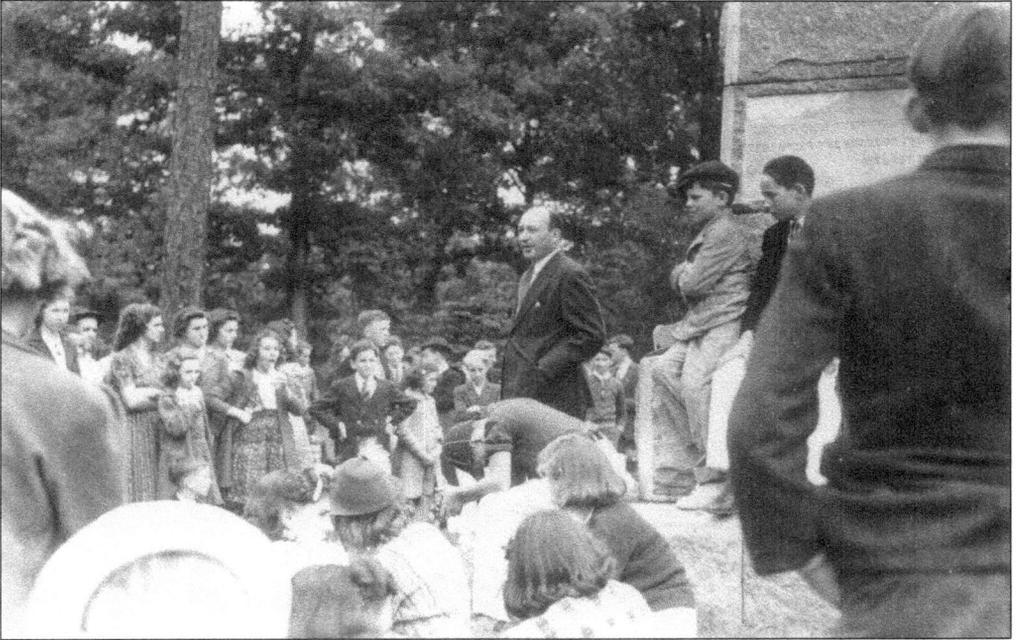

Without a doubt, one of the most attractive enhancements for the park was the area around Chancellorsville Contact Station, which is an inviting mix of historical and naturalist attractions. This photograph shows a gathering of a Virginia 4-H Club on June 19, 1939, as they view the Jackson monument. (Courtesy of NPS.)

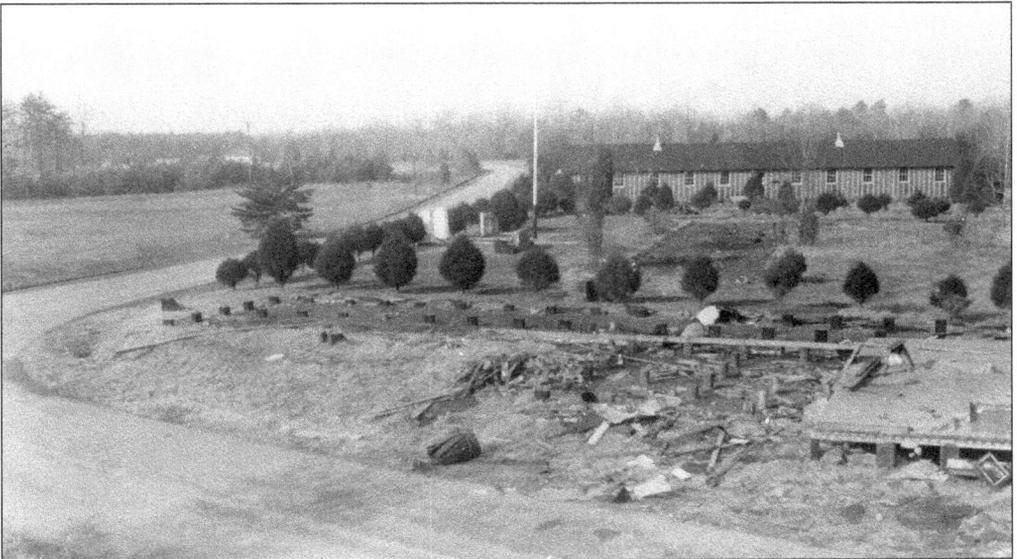

World War II brought the CCC to a close. Nearly two years after the termination of the CCC program, the structures of the former Chancellorsville camp are seen in various forms of disassembly above the intersection of Elys Ford Road and Hooker Drive. This photograph was taken looking northwest from the roof of the army garage on January 25, 1944. (Courtesy of NPS.)

This photograph, dated May 2, 1946, indicates that Edward Frederick Lindley Wood, the first Earl of Halifax and British ambassador to the United States, is seated amid Douglas Southall Freeman, Colonel Green, and others picnicking in front of the Chancellorsville Contact Station. (Courtesy of NPS.)

National Capital Parks (NCP), a division of the National Parks Service, has a long and complex history. It promotes the importance of having trained historians and naturalists explain the historical significance and natural history of the region's monuments. This photograph from August 25, 1957, shows naturalist Sullivan conducting a NCP tour at Chancellorsville. (Courtesy of NPS.)

Six

CENTENNIAL PREPARATIONS AND BEYOND

The America that emerged after World War II was a country renewed in the confidence that it was the greatest nation on earth. As the centennial commemoration of the Civil War approached, America embraced the wholesome goodness of a reunited country. At the same time, the country looked at the reasons it divided in 1861 with a bit less scrutiny. Popular culture had demonstrated via John Wayne and *The Horse Soldiers* that good history was dramatic and entertaining.

The Civil War Centennial Commission was established by Congress in 1957, despite the anxieties of the Cold War and festering reactions to racial integration. It was hoped by many that an embrace of the "brother's war" concept could get Americans over the hump. A new prosperity was making automobiles and road travel more accessible, and along with that urge to explore the past came the knowledge that the future would need to come to terms with its history.

Still in the grip of Jim Crow, expanding consciousness went to loggerheads with storied tradition, making it difficult to fully appreciate the significance of the common heritage both blacks and whites had experienced.

Stunted almost as soon as it got out of the gate, the Civil War Centennial lost all of its potential for a more meaningful reconciliation and instead kept open a chasm that rightfully should have been closed generations before.

In 1960, Spotsylvania County officials considered purchasing the historic hotel at the courthouse crossroads. Plans were formulated to convert the building into a museum, but funding did not materialize as initially anticipated, and the Berea Church was selected as an alternative structure. It was dedicated as a museum in May 1964 during centennial observances of the Battles of Wilderness and Spotsylvania.

Civil War roundtable organizations were one of the driving forces of the centennial commemoration. Park historian Ralph Happel is shown on top of the Bloody Angle with a visiting roundtable from Franklin, Virginia, on November 12, 1957. Everything was moving in full swing to usher in the centennial. (Courtesy of NPS.)

A troop of Boy Scouts from Alexandria, Virginia, had the privilege of camping overnight on the grounds of the McCoull Farm in 1957. Overnight camping has not been permitted in National Park Service battlefield parks since then, except under controlled circumstances. (Courtesy of NPS.)

As part of the Mission 66 Project, Spotsylvania parks were going to get a face-lift with the aim of creating fresh accommodations for an increasing visitor flow. In this photograph, the interior framework for the Chancellorsville Visitor Center is being assembled. Park historian Ralph Happel documented the progress along the way. The opening-day goal was May 3, 1963, the centennial of the battle. (Courtesy of NPS.)

This photograph should certainly look familiar to regular visitors of the Chancellorsville unit. The unmistakable hard-lined entrance was a voguish reflection of contemporary residential structures that appeared in that decade, with large glass openings, a multidirectional shed, and flat gable roofs. Economy and ease of construction were said to be the driving element for Mission 66. Trying to blend in with the surrounding nature would be the trick. (Courtesy of NPS.)

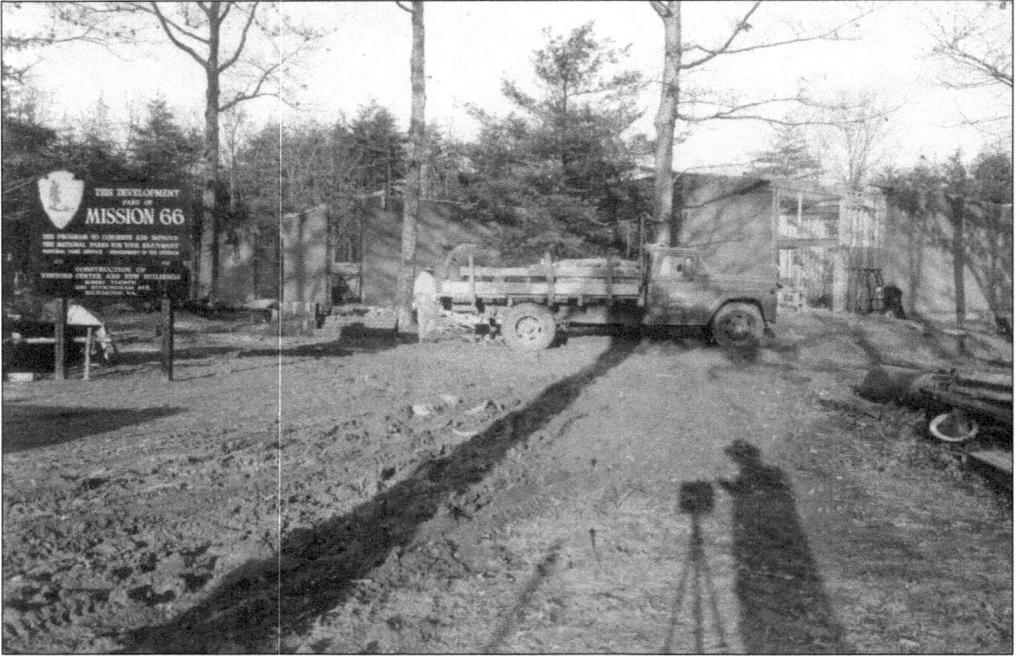

Along with the trappings of the construction project, historian Ralph Happel caught his own shadow in the foreground of this rear view of the new center. A large sign at left explains the mess and the credo of the Mission 66 Program for passersby. (Courtesy of NPS.)

This photograph from August 1963 looks east across the manicured lawn inherited from the enrollees of CCC Camp MP-3. There stands a showpiece made of steel and masonry, making obsolete the warm, rustic ranger contact stations. Today, this view has been reclaimed by the woods and underbrush. At far right, the white wooden cross that was erected at the reburial site of the unknown Union soldier discovered by the CCC in 1935 can be seen. (Courtesy of NPS.)

The goal of opening on May 3, 1963, was achieved, and the community turned out with great fanfare and a host of dignitaries from the national and state Civil War Centennial commissions. Many of the names who made the park shine in the formative years returned, too, as honored guests. Some of the old-timers who returned included George Palmer, the first historian, and Branch Spalding, the first park superintendent. (Courtesy of NPS.)

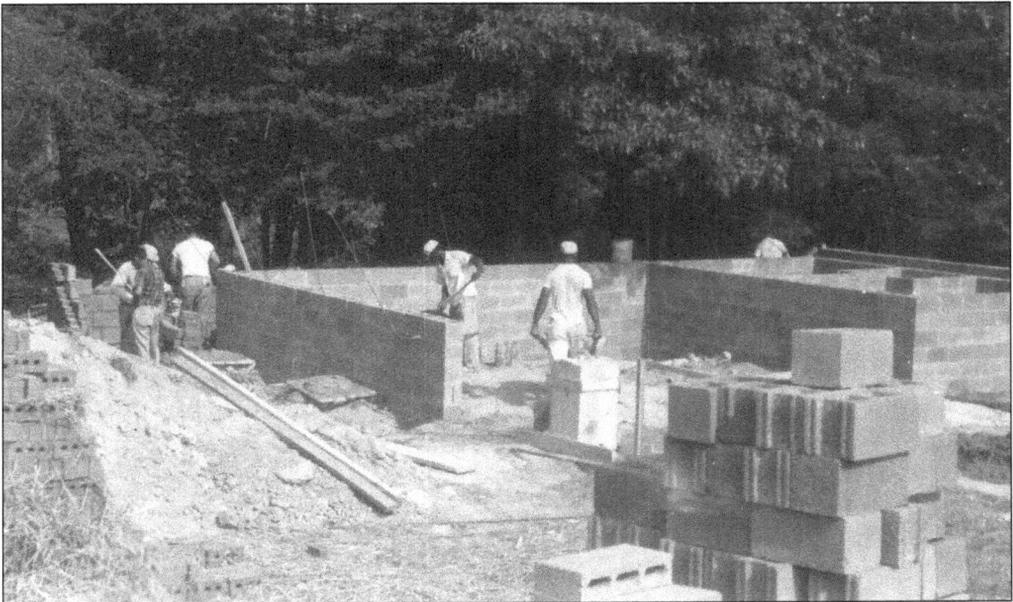

In keeping with the streamline method prescribed by Mission 66, as one project was nearing completion, the next was underway. This photograph from July 1963 details the cinder block foundation going in for the Spotsylvania Interpretive Shelter on Grant Drive. Disappearing would be the map shelter, built in 1936 at the intersection Grant Drive and Brock Road. (Courtesy of NPS.)

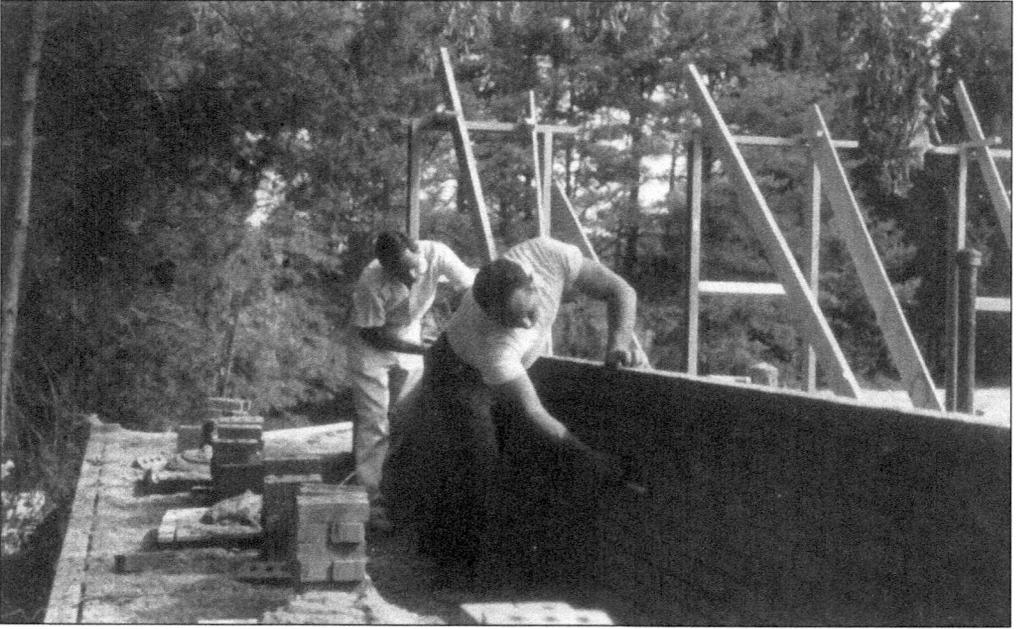

By September 1963, brick masons had arrived to build the exterior walls. After the steel framework for the roof had been set, large rolls of reinforcing mesh were laid out before the pouring of the concrete floor inside the open-air shelter (Both courtesy of NPS.)

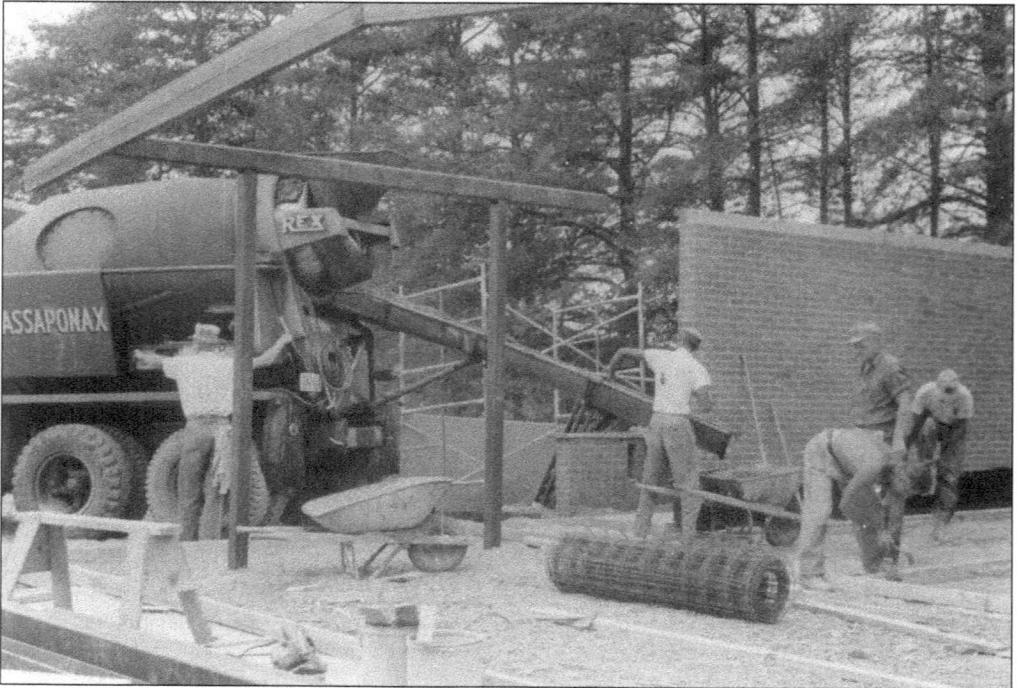

Here, the ceiling inside the shelter is being finished and sealed with a varnish coat near the end of September 1963. Years later, the ceiling was painted over. Skylights were included to allow for natural ambient lighting throughout. (Courtesy of NPS.)

By the end of April 1964, with the anniversary less than a month away, park service employees from the branch of museums arrive, ready to install the interpretive panels designed by Ralph Happel. Assisting is Freddie Paytes of the F&SNMP maintenance crew. (Courtesy of NPS.)

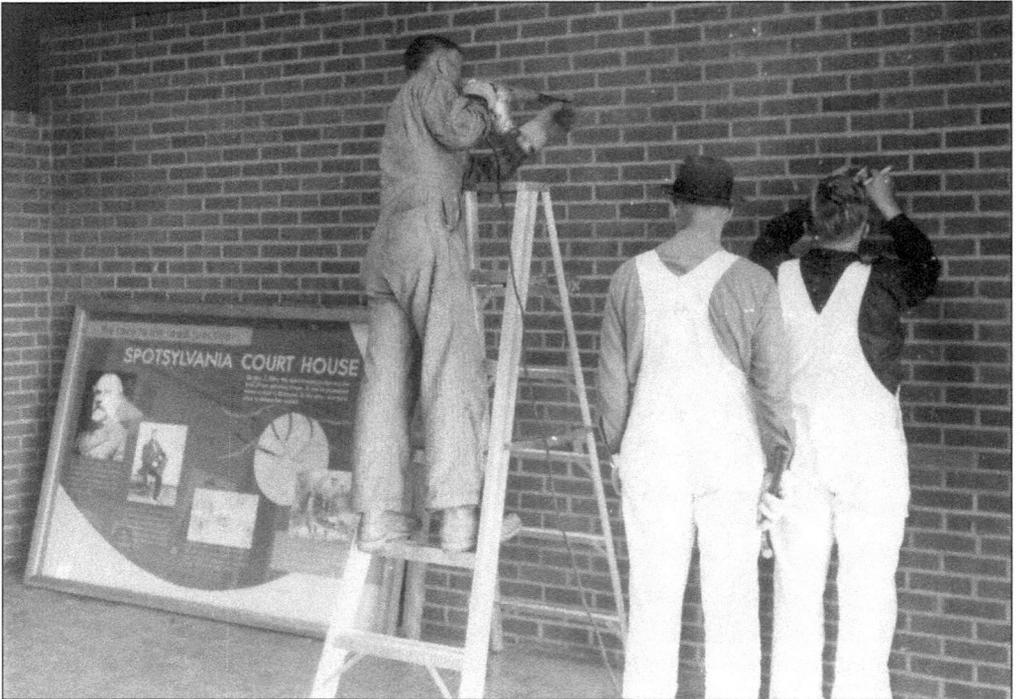

From left to right are Freddie Paytes, Frank Philips, and Peder Kitti. Kitti retired in 1978 from the branch of exhibit production. Frank Philips is now the head of construction management for all National Park Service museums and exhibits. (Courtesy of NPS.)

Peder Kitti (left) and Frank Philips stand behind a Department of the Interior truck in this posed photograph for Ralph Happel's documentary efforts on April 28, 1964. The shelter was very near completion and has stood resilient over 46 years. Recently, some improvements have been made to the electrical and sewer systems that feed into the shelter. (Courtesy of NPS.)

National Park Service historian Ralph Happel took this photograph in March 1964 for inclusion in the exhibit panels for the Spotsylvania Shelter. It can be seen as part of the left-hand panel beside the ladder in the bottom image on page 107. These panels have since been donated to the Spotsylvania County Government for the use of its welcome center staff. They were replaced in the shelter by newer graphic panels. (Courtesy of NPS.)

As soon as the guns fell silent, Spotsylvania became an attractive place to hunt for artifacts. For nearly a century, many of the artifacts found were sold as scrap metal. During maintenance operations of the CCC in the 1930s, truckloads were raked out of the trenches and woods by enrollees. It is illegal to hunt for relics on federal park property. Artifact hunters may only do so on private property and only after they get the owner's permission. (Courtesy of JFC.)

These photographs were taken in July 1975 at a living history presentation of the Fredericksburg and Spotsylvania National Military Park. Situated in the woods near the Chancellorsville Visitor Center, the camp was designed to portray pickets of Company C of the 2nd North Carolina Infantry. The park sponsored this display for several years. It was also featured in an article in a November 1974 issue of *National Geographic*. (Courtesy of JFC.)

A sign at the head of the trail leading to this display explained that after the Confederate victory at Chancellorsville in May 1863, small detached picket posts like this were placed strategically across the vicinity to monitor Union army activity along the Rappahannock River. Volunteers for these camps consisted of seasonal park employees, some of whom ended up making a career with the National Park Service. (Courtesy of JFC.)

Two major hotel chains have sought to service the tourist trade in Spotsylvania. The Holiday Inn location pictured in this vintage postcard was right off the Interstate 95 exit at Route 1 near Massaponax. The structure was remodeled several times and is now a Ramada. (Courtesy of JFC.)

The location of the Sheraton has become a prime example of the effects of commercial sprawl. Located just off the Interstate 95 exit for Route 3, the Sheraton was once situated in the middle of a farm and golf course. In the 1980s, the entire corridor at this exit began to undergo tremendous commercial growth. The site is now within a mega shopping complex called Central Park and has been annexed by Fredericksburg. Traffic along this stretch has become a major concern. (Courtesy of JFC.)

111

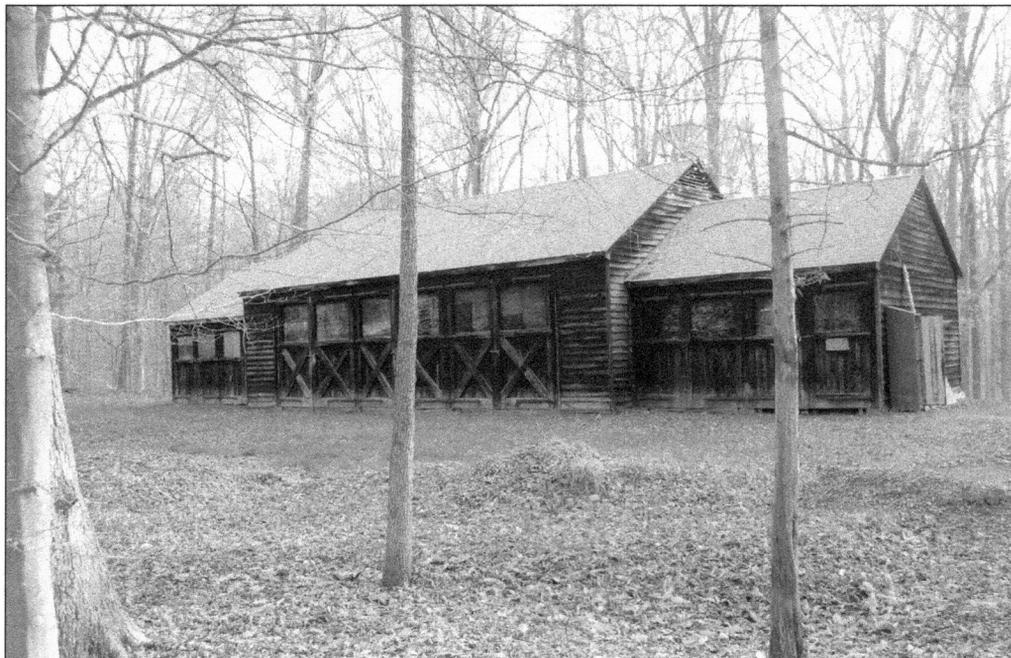

One of the few remaining CCC structures in continued use is this maintenance building by the National Park Service. It is located near the site of the McCoull house on the Spotsylvania unit. (Courtesy of JFC.)

A new bridge along the Muleshoe Salient was installed in June 2010 by volunteers from Boy Scout Troops 748 and 1048. Eagle Scout David Mattes designed it and supervised. Strict guidelines requiring the bridge to sit on the ground surface were provided by the NPS chief of maintenance. The bridge was supported by large stones that were brought in for this purpose. (Courtesy of JFC.)

Seven

DECADE OF CONSCIENCE?

No one can deny the impact the Civil War made on Spotsylvania County. It is etched upon the landscape and burrowed deep into the heart of humanity. Now, 150 years later, can humanity not examine it for what it was and do so without rupturing a well-healed wound? The important thing to be mindful of is that there are no longer any true stakeholders in this war's outcome. Everyone who was alive then has left this earth. The soldiers of Blue and Gray lie in eternal camping grounds. Every slave who bore the manacles has slipped the surly bonds and entered the land of jubilo. Accepting this is difficult in the face of the very alive passion with which so many pursue a study of that era. Be it strictly as a military historian or as a student of social or political science, the Civil War years are compelling in a way that many cannot define. And it surrounds Spotsylvania.

It is said that familiarity breeds contempt, so perhaps the inundation has made it meaningless to many. Even so, is there anything worse than throwing out the baby with the bath water? And perhaps that is the point entirely? Where are we if we have forsaken our past?

As a new century began, the pace of development resembled wholesale slaughter. If the land under development hadn't been a family farm after a hundred-plus years of sowing and harvesting, it was a vast tract of woodland that had provided repeating generations of timber. This time around, the land was done for. Once subdivided with tightly packed homes, the only thing left to reap would be the annual tax revenues. (Courtesy of JFC.)

This Native American projectile point, made of white quartz, dates to around 2500 BC, which was around the time of the Early Woodland era. Soil disturbances today often yield the evidence of indigenous populations. Before European conquest, the bounteous land provided abundant game and rich soils to develop primitive agricultural methods. By the time Europeans arrived in the New World, the Algonquian tribes had developed a structured social order, and villages had begun to replace nomadic camps. (Courtesy of JFC.)

In May 2000, the administration of the F&SNMP provided a VIP tour of the four battlefields. From left to right are retired chief historian Robert K. Krick; former superintendent Sandy Reeves; and current chief historian John Hennessy. Here, Reeves and Krick are detailing the acquisition of Hamilton's Thicket, a vital terrain that witnessed General Longstreet's flank attack at Wilderness. (Courtesy of JFC.)

In September 2001, archaeologist Josh Duncan led a team of students from Mary Washington College in examining remains of some of Spotsylvania's 18th-century settlers, missed during an earlier relocation of graves from St. George Church and the market square in Fredericksburg. In this view, the excavation is bounded by the organic evidence of a decayed wooden coffin. In all, the remains of six bodies were reinterred. (Courtesy of JFC.)

In July 2002, the Civil War Preservation Trust (CWPT) held a press conference to announce the forming of the Chancellorsville Coalition. Composed of various special interest groups allied to oppose the Town of Chancellorsville, the debate became a serious point of contention between preservationists and county landowners. CWPT president Jim Lighthizer is seen here addressing the media at Salem Church. (Courtesy of VS.)

In March 2003, a candlelight vigil was held in front of the county administrative offices to further deliver the coalition's message of opposition to the Spotsylvania County Board of Supervisors, who were meeting inside. Media coverage was significant, as the challenge had become a national issue. Answering questions after the vigil are, from left to right, noted reenactor and preservation advocate Rob Hodge; author John Cummings; and celebrated historian Brian Pohanka. (Courtesy of VS.)

Pictured from left to right, political activist Larry Gross, Committee of 500 founder Merl Witt, and the author gather outside an area coffee shop after a review of current events and strategies. The Committee of 500 had been formed as a political action committee to help give a voice to the members of several nonprofit groups in the county. The committee is still an active and vocal group today, nearly 10 years after its organization. (Courtesy of JFC.)

In September 2003, two months before the board of supervisors election, the Committee of 500 endorsed candidates gathered in front of the Holbert Building to declare their positions within the agenda of the committee. From left to right are Mark Kuechler, Hap Connors, Bob Hagan, Vince Onorato, and Gary Jackson. (Courtesy of JFC.)

Historian Virginia Wright Durrett is seen here with the old courthouse bell that had been discovered in storage by county employees. The bell, cast in 1880, had at one time hung in a cupola atop the historic courthouse building but was removed around 1900 during renovations to the structure. On Sunday, December 7, 2003, Durrett had the honor of ringing the bell in the opening ceremony of the event known as A Courthouse Christmas. (Courtesy of JFC.)

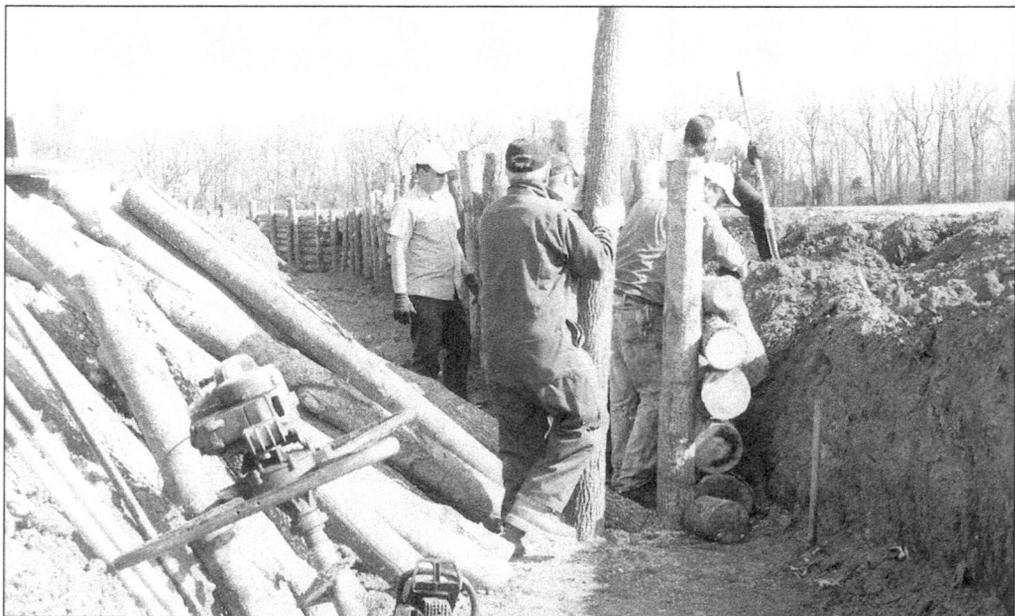

In preparation for the large commemorative reenactment of the Battle of Spotsylvania, a group of County Public Works employees dug a quarter-mile entrenchment, recreating a section of the Muleshoe Salient. Supervised by department chief Ed Carneal, the team dug the trench and reinforced it with log revetments. Located at Belvedere Plantation, the event provided a realistic depiction of the conditions of the actual battle of May 1864. (Courtesy of JFC.)

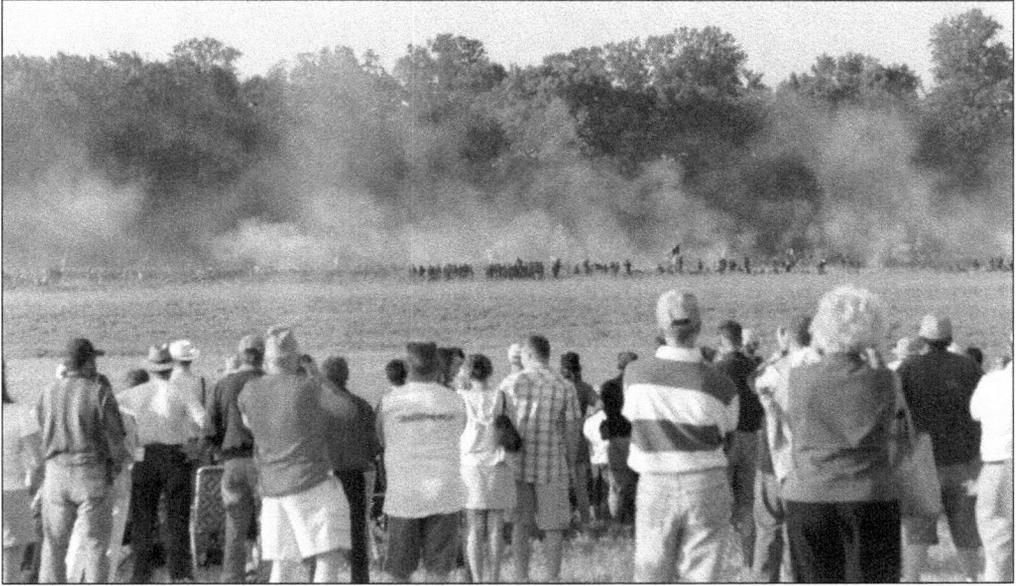

On Saturday, May 8, 2004, thousands of spectators gathered to witness the reenacted Union attack on the Confederate defenses behind the entrenchment. The realistic clash was carried out on similar terrain as that of the battle in May 1864 and was laid out to depict the same distances the soldiers traversed 140 years previously. (Courtesy of EB.)

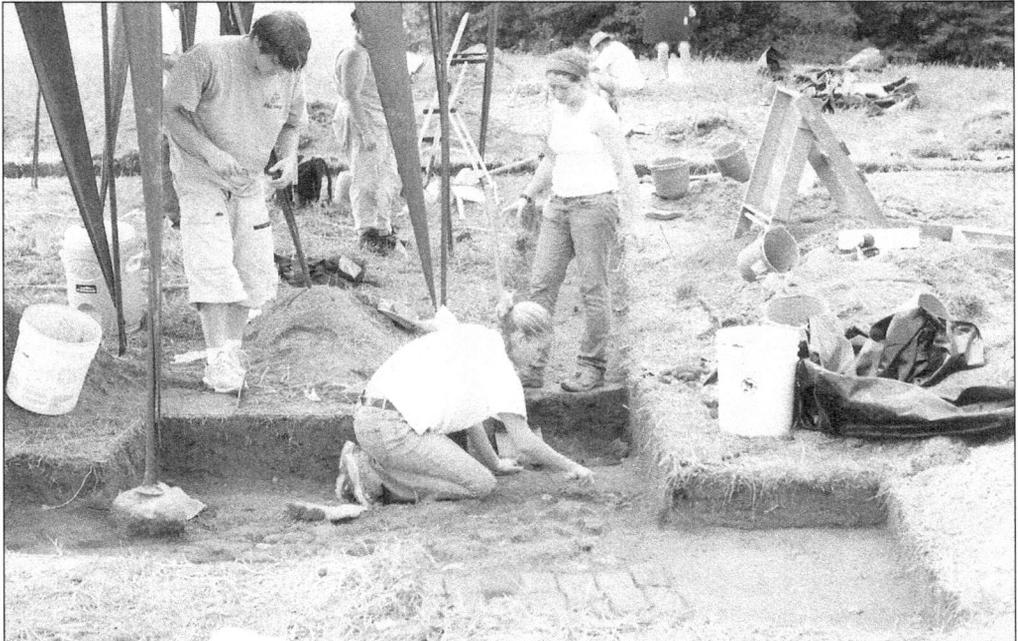

The National Park Service has long questioned the precise location of the Spindle House on the Spotsylvania Battlefield. The structure, destroyed on May 8, 1864, was never rebuilt. At least two attempts to find its buried foundation have been made, most recently in August 2004, by students from James Madison University. Evidence of some structure was revealed, but there is continuing speculation that this may simply have been an outbuilding. (Courtesy of JFC.)

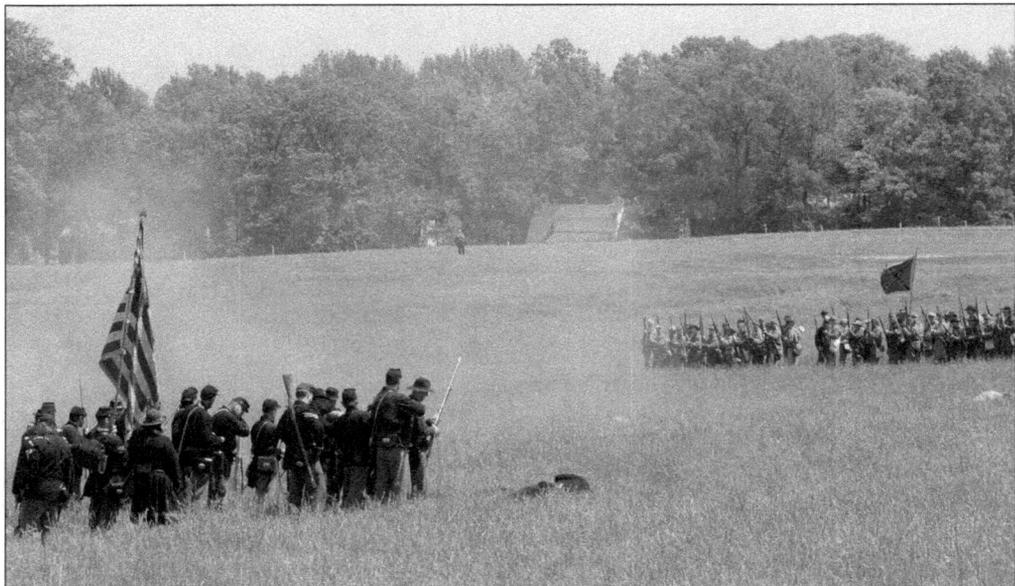

In May 2008, reenactors had the opportunity to portray on the actual field of battle the opening engagement of the May 1, 1863, fighting at Chancellorsville. The ground was part of the significant preservation victory on Route 3. This event marked the 145th anniversary of the fight and drew thousands of spectators to witness the significant commemoration. Rooftops from an older neighboring subdivision can be seen on the horizon. (Courtesy of JB.)

On March 24, 2009, Virginia governor Tim Kaine addressed a press conference on the Slaughter Pen Farm near Fredericksburg to highlight the achievements of the Virginia Historic Battlefield Preservation Fund. Pictured from left to right are Virginia's director of historic resources Kathleen Kilpatrick, Governor Kaine, CWPT president Jim Lighthizer, Speaker of the Virginia House of Delegates Bill Howell; and state senator Edd Houck. (Courtesy of JFC.)

In attendance at the press conference were Tricord Homes partner Craig Jones (center) and Spotsylvania County administrator Doug Barnes. It has only been through the generous assistance of Tricord Homes that the Slaughter Pen Farm and the Chancellorsville Battlefield on Route 3 have been saved. Their willingness to step forward and take these properties off the market demonstrates a tremendous community conscience. (Courtesy of JFC.)

Archaeologists monitor the presence of cultural resources that might be disturbed during the installation of a new trail system near the Muleshoe Salient on the Spotsylvania Battlefield. This particular crest yielded a heavy concentration of debris from a house built by the Landram family but nothing that would significantly impact future analysis of the military engagement there in May 1864. (Courtesy of JFC.)

The Old Rules Baseball league came to Spotsylvania Courthouse on September 13, 2009, as the closing event for Spotsylvania's poorly promoted 1859-Era County Fair. The teams playing were Maryland state champs Elkton Eclipse against the newly formed Williamsburg Pastimes. This photograph features members of the opposing teams moments before the game began. (Courtesy of JFC.)

The fair was the first in a proposed series of commemorative programs leading up to the observance of the Civil War Sesquicentennial. In addition to baseball, participants included a medicine show, political debates, and a concert and lecture pertaining to spiritual songs of field slaves. Additionally, some displays were a bit out of place, primarily the inclusion of antique gasoline fire engines and a petting zoo of three alpacas. This photograph shows the winning Elkton Eclipse posing for wet plate photographer Terry Thomann of the Civil War Life Foundation. (Courtesy of JFC.)

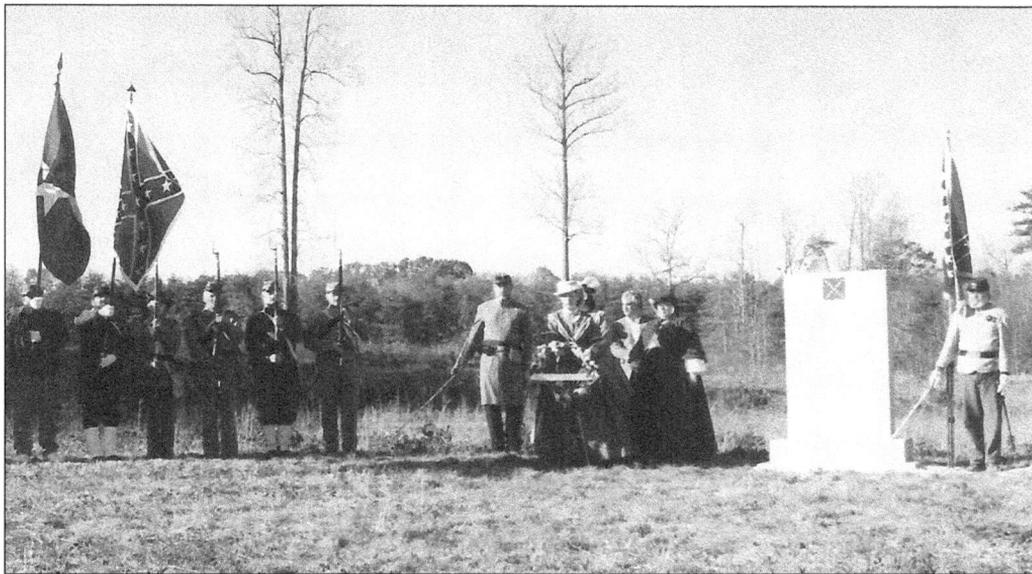

The first Confederate monument to appear on the Spotsylvania Battlefield came 137 years after the guns went silent. Marking the advance of Ramseur's North Carolina brigade during the May 12, 1864, attack of the Muleshoe Salient, a modest ceremony was held in September 2001. (Courtesy of JFC.)

In May 2010, a historically themed bar and restaurant in Spotsylvania County made national headlines when a mural featuring both Union and Confederate flags was being painted on the wall of an outdoor seating area. An employee had suggested that the image would imply a racist agenda and he alerted the media. Within days, the mural was redesigned to exclude the flags. This photo shows the unfinished original artwork. (Courtesy of JFC.)

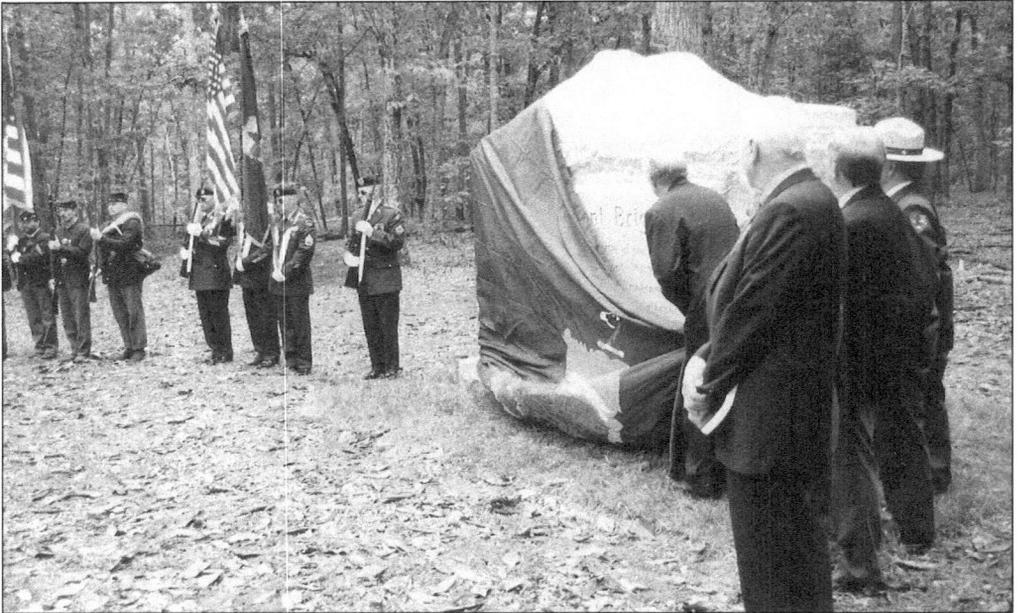

US senator James Jeffords is seen here unveiling the Vermont Brigade Monument on September 16, 2006, at the Wilderness Battlefield. The brigade sustained 1,269 casualties during two days of fighting and played a vital roll in repelling a Confederate thrust on May 5 along Orange Plank Road. (Courtesy of JFC.)

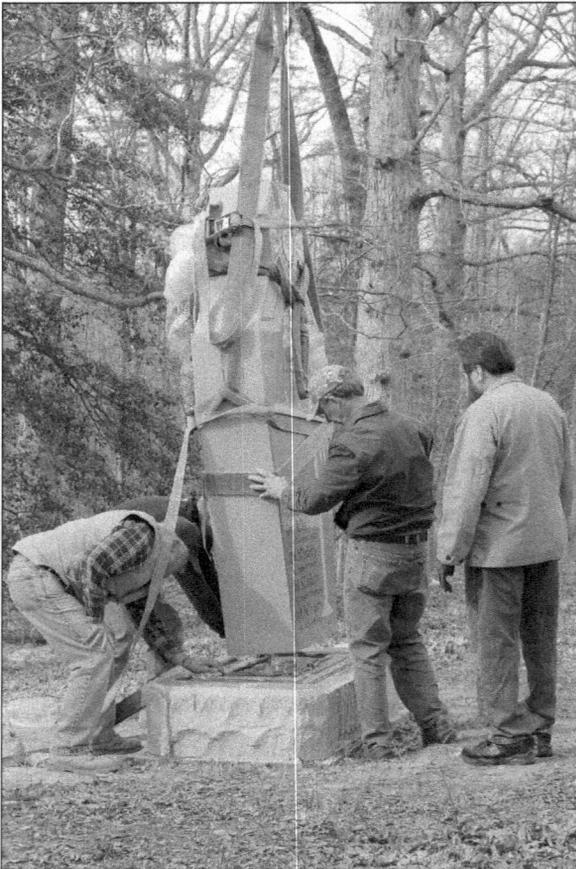

In April 2009, a monument to McGowan's South Carolina brigade was installed inside the Muleshoe Salient. McGowan's brigade had helped to defend Muleshoe Salient on May 12, 1864. Members of the Sons of Confederate Veterans raised the needed funds and provided the manpower for its installation, seen here. A dedication ceremony followed on May 9, 2009, with a large gathering. (Courtesy of JFC.)

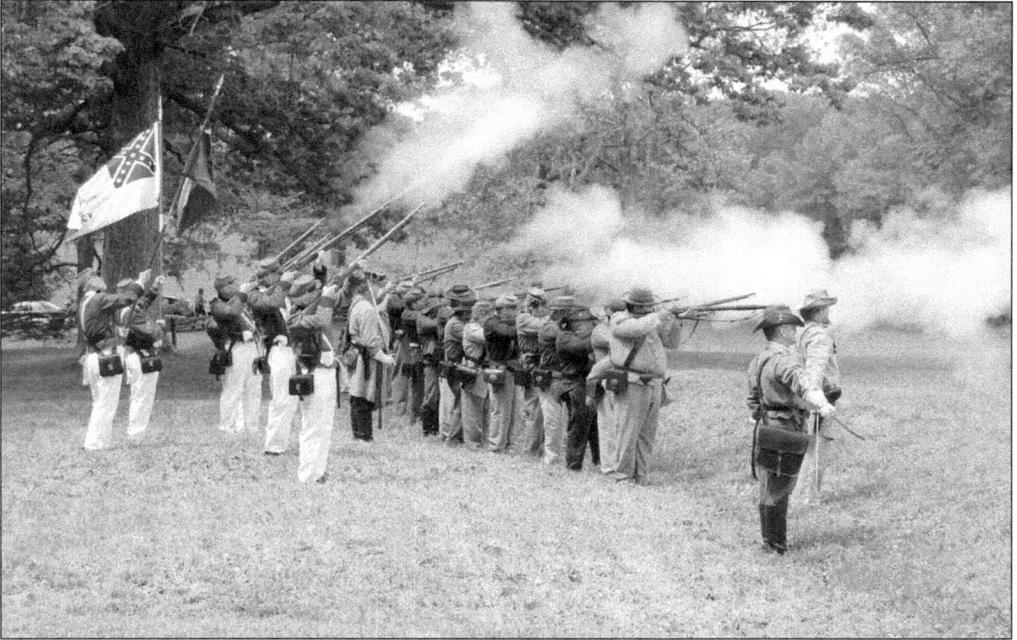

Standing within the section of the Muleshoe Salient their ancestors had defended, an honor guard from the Sons of Confederate Veterans fires a salute after the unveiling of the McGowan monument on May 9, 2009. (Courtesy of JFC.)

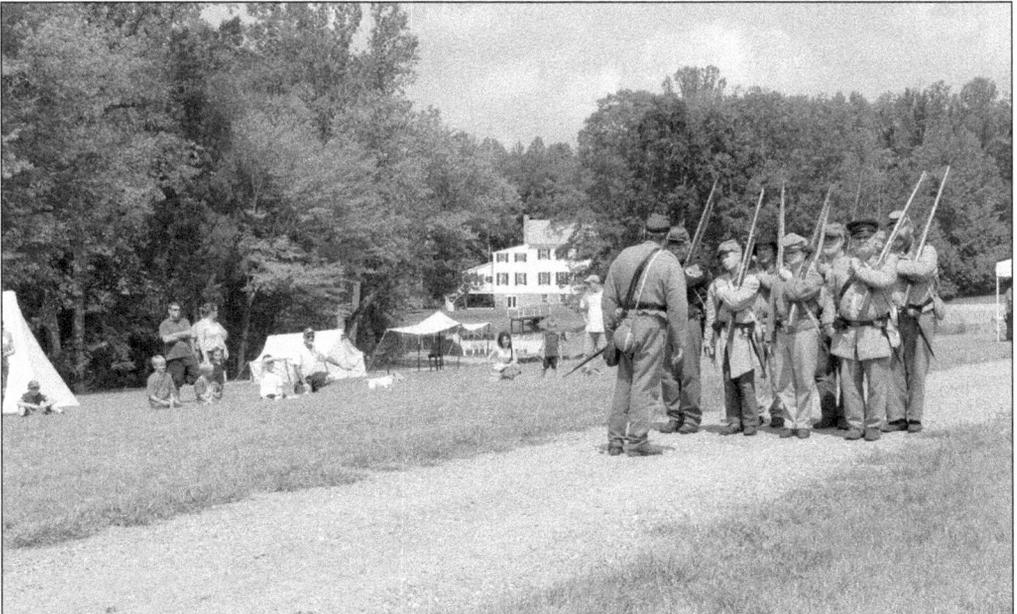

As the Civil War Sesquicentennial approached, local government faced a lack of significant funding due to the nation's economic unrest. Private sector efforts stepped up to fill the void. Locally owned lodging and special events center Stevenson Ridge has been a stellar example of how quality historical tourism can set the pace. On August 28, 2010, hosts Dan and Debbie Spear welcomed history enthusiasts to the site's pastoral setting. (Courtesy of JFC.)

BIBLIOGRAPHY

Darter, Oscar H. *Colonial Fredericksburg and Neighborhood in Perspective*. New York: Twayne Publishers, 1957.

Frasanito, William A. *Grant and Lee, The Virginia Campaigns 1864–1865*. New York: Charles Scribner's Sons, 1983.

Harrison, Noel G. *Fredericksburg Civil War Sites, April 1861–November 1862*. Lynchburg, VA: H.E. Howard, Inc., 1995.

———. *Fredericksburg Civil War Sites, December 1862–April 1865*. Lynchburg, VA: H.E. Howard, Inc., 1995.

Mansfield, James Rogers. *A History of Early Spotsylvania*. Spotsylvania, VA: Spotsylvania County Board of Supervisors, 1995.

Matter, William D. *If It Takes All Summer*. Chapel Hill: The University of North Carolina Press, 1988.

O'Reilly, Francis Augustin. *The Fredericksburg Campaign*. Baton Rouge: Louisiana State University Press, 2003.

Quinn, S.J. *The History of the City of Fredericksburg*. Richmond: The Hermitage Press, Inc., 1908.

Rhea, Gordon C. *The Battle for Spotsylvania Court House and the Road to Yellow Tavern, May 7–12, 1864*. Baton Rouge: Louisiana State University Press, 1997.

———. *To The North Anna River, Grant and Lee, May 13–25, 1864*. Baton Rouge: Louisiana State University Press, 2000.

Sears, Stephen W. *Chancellorsville*. New York: Houghton Mifflin Company, 1996.

Shibley, Ronald E. *Historic Fredericksburg, A Pictorial History*. Norfolk: The Donning Company, 1976.

Steere, Edward. *The Wilderness Campaign, The Meeting of Grant and Lee*. Mechanicsburg, PA: Stackpole Books, 1960.

Trowbridge, J.T. *The South: A Tour of Its Battlefields and Ruined Cities*. Hartford: L. Stebbins, 1866.

INDEX

Visit us at
arcadiapublishing.com

www.ingramcontent.com/pod-product-compliance
Lightning Source LLC
Chambersburg PA
CBHW050702150426

42813CB00055B/2378